CH00801275

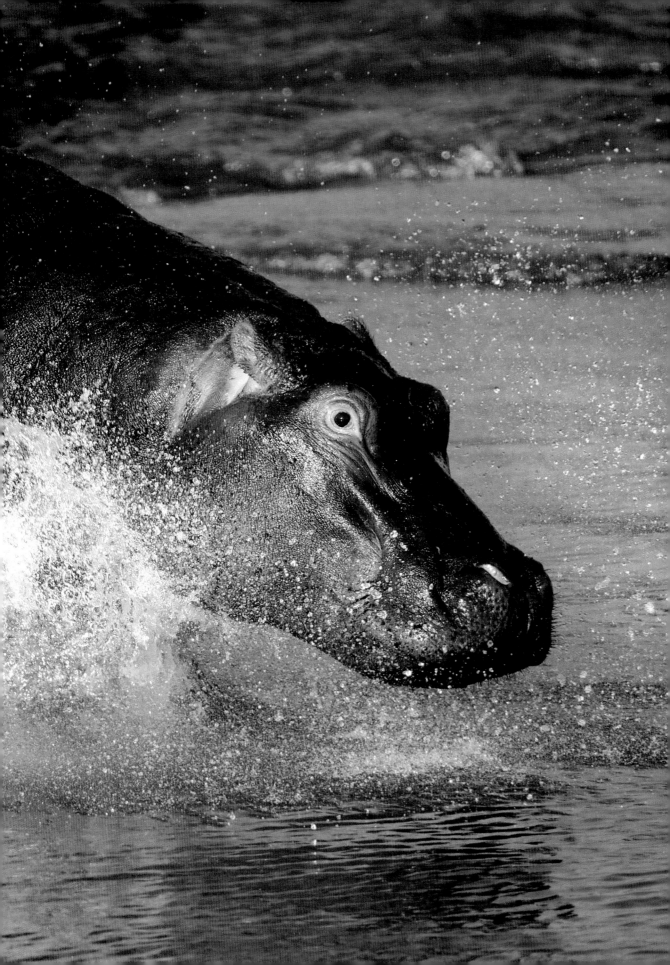

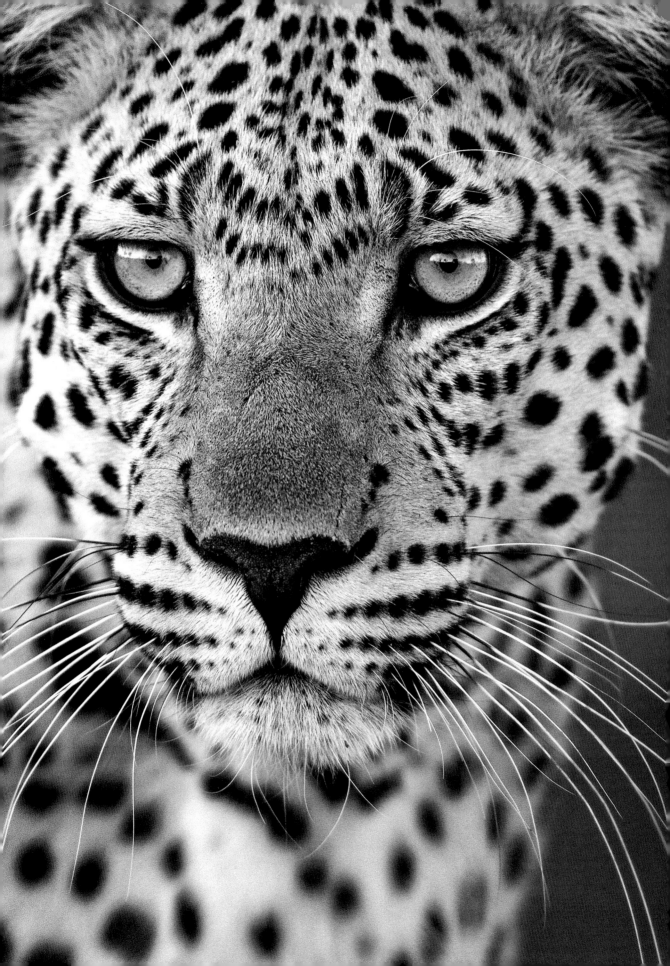

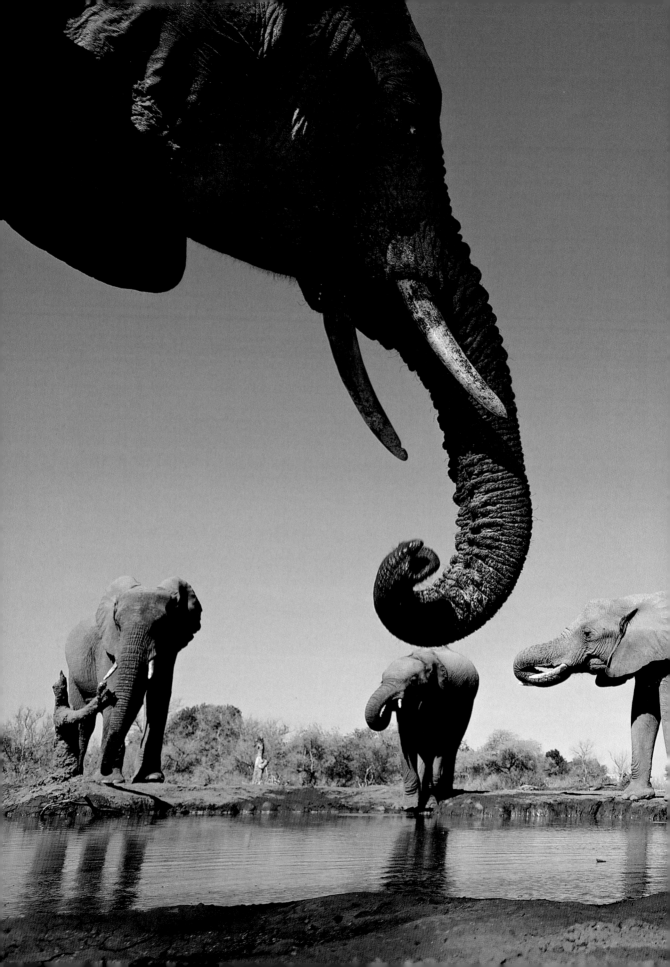

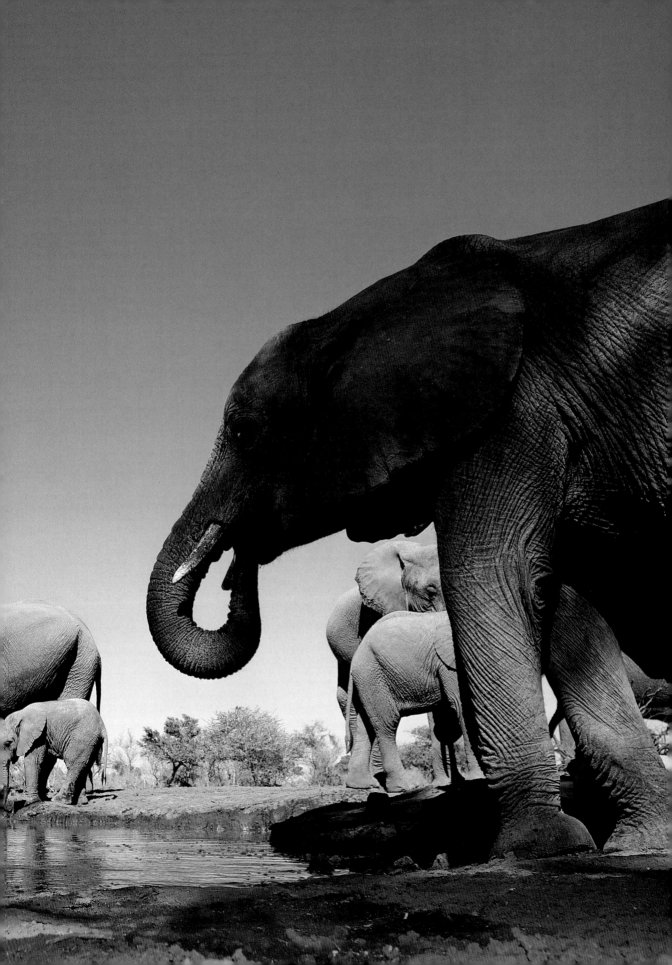

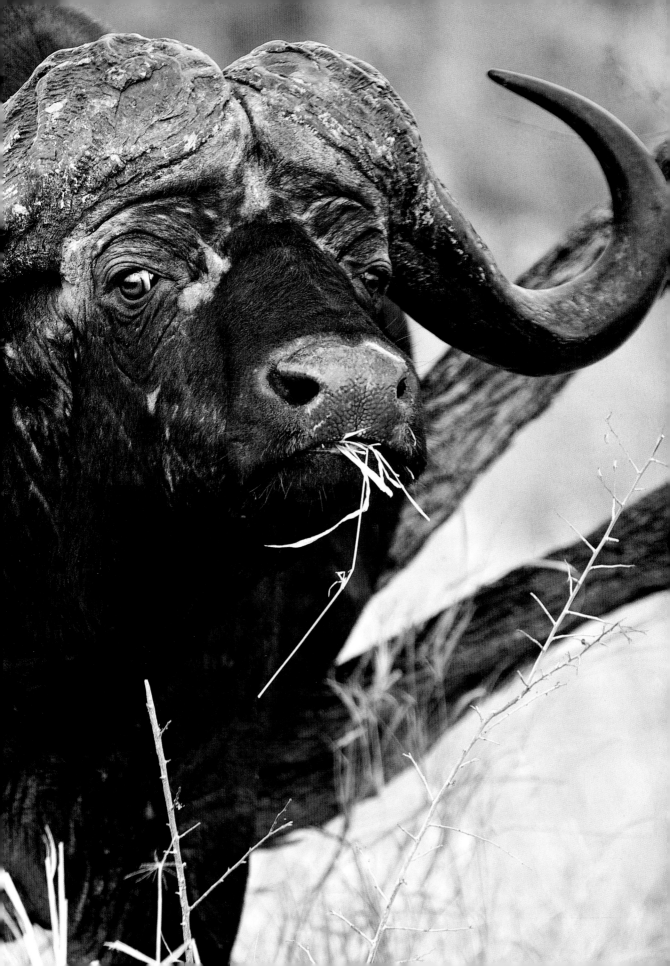

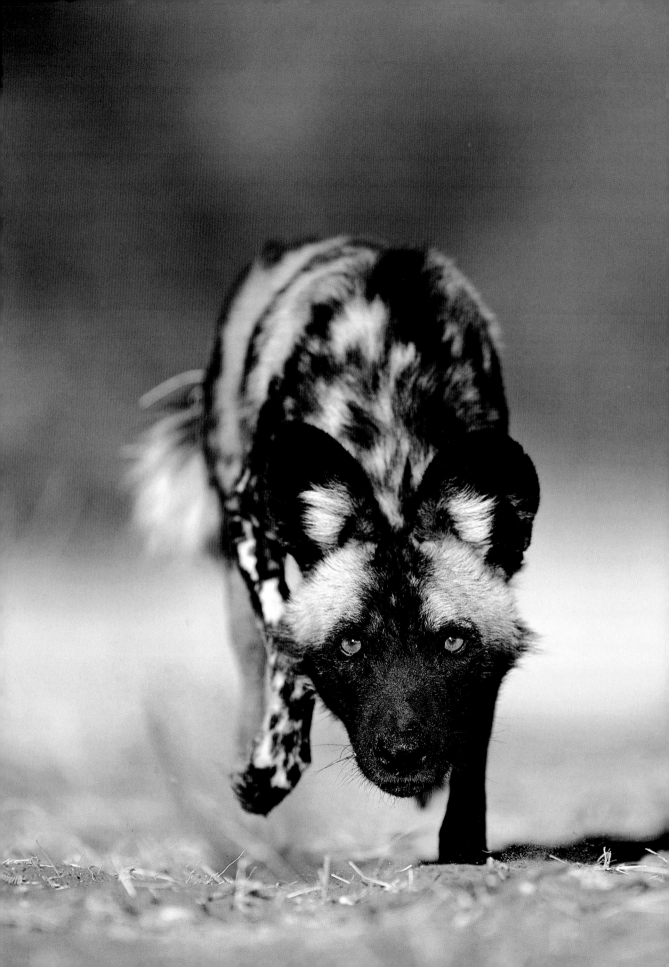

game drive
MAMMALS
of southern Africa

Photography by:

Heinrich van den Berg

Philip & Ingrid van den Berg

Text by:

Ingrid van den Berg

Published by:

HPH Publishing

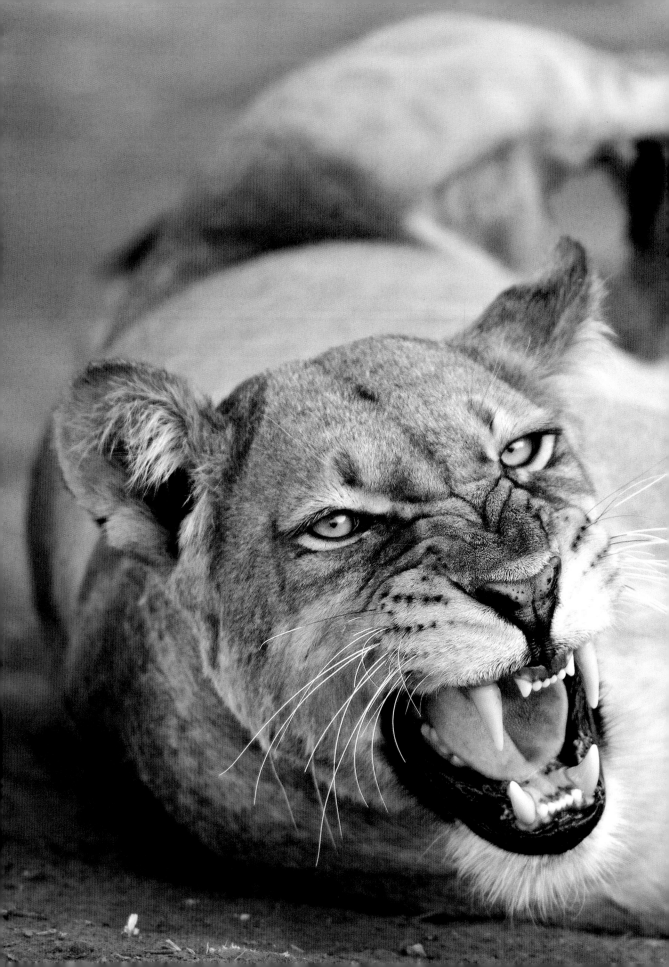

Contents

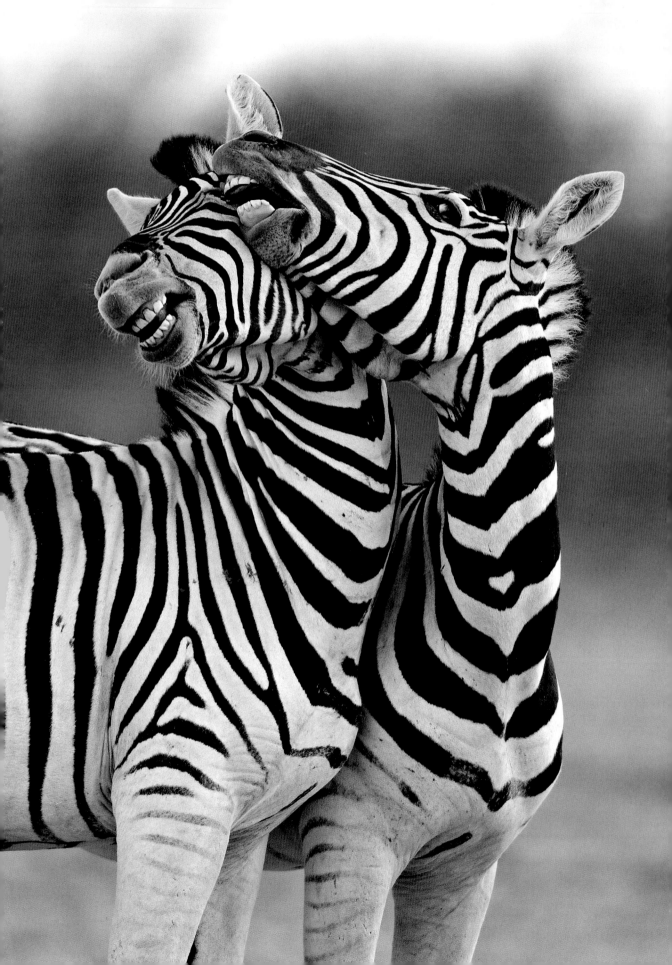

Introduction

Game drives are associated with game reserves and other conservation areas that are most favourable for viewing wild animals. Mammals are not the only animals you may encounter; they form only a small part of the web of life. To include the entire spectrum of wild animal life would fill volumes and therefore this book deals only with the larger mammals that you may encounter in reserves in the seven countries that constitute the southern African sub-region.

This sub-region is the part of the continent south of the Kunene and Zambezi rivers, and includes South Africa, Lesotho, Swaziland, Namibia, Botswana, Zimbabwe and part of Mozambique. For brevity, the text simply refers to the sub-region.

While there are almost 300 mammal species inhabiting this sub-region, most will never be seen on game drives and have therefore not been included. The mammals omitted include the many bat species, most rodents, and the marine mammals. However, this book features 90 different animal species you may sight on a game drive.

The main emphasis is on the visual representation so the species information is bite-size, brief and features a few interesting snippets. At the end of the book there are maps, summaries and comparative tables that may interest you. Several excellent books with comprehensive information on the different species are listed in the reference section. Understanding the behaviour of a species will enhance your interest and pleasure when you observe it in the wild.

Mammals, like all other animals and plants, prefer certain habitats and can tolerate specific environmental conditions. Their preferences are basically determined by the geology and climate of the region, which in turn determine the kind of vegetation that may occur. Plant feeders can be quite specific in their preferences. Some will feed on a broad range of plant species, while others are partial to specific types. Carnivores will follow plant feeders and are found wherever there are enough of them to prey upon.

Some animals have a high tolerance for environmental factors and may occur in all types of habitats in different ecosystems and biomes. Others have a low tolerance and are found only in habitats that meet their specific needs.

Eight biomes may be distinguished within the sub-region. If you look at the map of biomes and ecosystems at the end of the book, you will notice that the savannah biome is the largest biome of all. The savannah biome varies from wet savannah in the north and northeastern lowlands to extremely dry savannah in the northwest of the sub-region. More than 40 savannah types exist and savannah herbivores each have their own specific preferences. Most of the larger game reserves that offer game drives are situated in different parts of the savannah biome.

The text accompanying the photographs of each animal species is concise and covers a few aspects such as its preferred habitat, the food it eats and its distribution range. Other aspects such as average size, mass, gestation period, life expectancy and active period during the day are dealt with in a comparative table at the end of the book.

The order in which the different species are represented does not necessarily follow taxonomic principles but instead deals with the carnivores first (killers and scavengers), then the larger plant feeders (giants), followed by the antelope, and the final chapter includes those mammals also likely to be viewed on a game drive but that have not previously been mentioned. Most of the groups that are taxonomically related have, however, been kept together.

Nature conservation authorities in the sub-region aim to ensure that all the ecosystems in the different biomes, with their specific plant and animal components, are part of the international effort to protect and conserve mankind's natural heritage for generations to come.

Apart from the game reserves in each country in the sub-region, a relatively recent initiative (since 1999) by the Peace Parks Foundation is facilitating the establishment of various transfrontier conservation areas called Peace Parks or Transfrontier Parks (TFPs). The principle is that areas or components of large ecological regions that straddle the boundaries of two or more countries should be developed together as conservation units to protect wildlife across international borders.

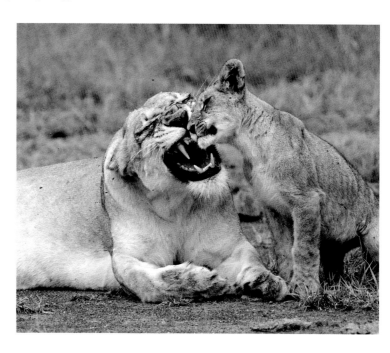

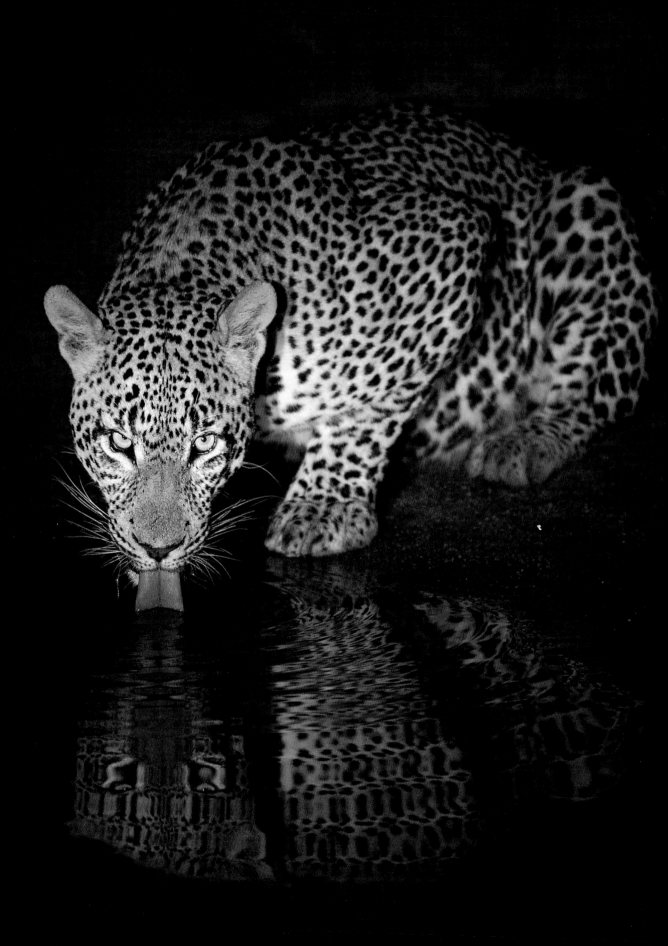

Killers and Scavengers

Carnivores are all flesh-eating mammals with characteristic long and supple bodies, muscular limbs and acute senses. Eyes are placed for forward looking and three-dimensional vision. In most cases their teeth are adapted for gripping, slashing, stabbing, cutting and crushing, and unlike plant-feeders, they have a relatively short digestive tract. Although most hunt, a few feed exclusively on insects. The carnivores you may encounter on game drives in the sub-region include cats, hyenas, civets, genets, suricates, mongooses, foxes, wild dogs, jackals, otters, honey badgers, polecats and weasels. Most meat eaters prey on creatures smaller than themselves and that are easiest to catch, thus promoting the survival of the fittest.

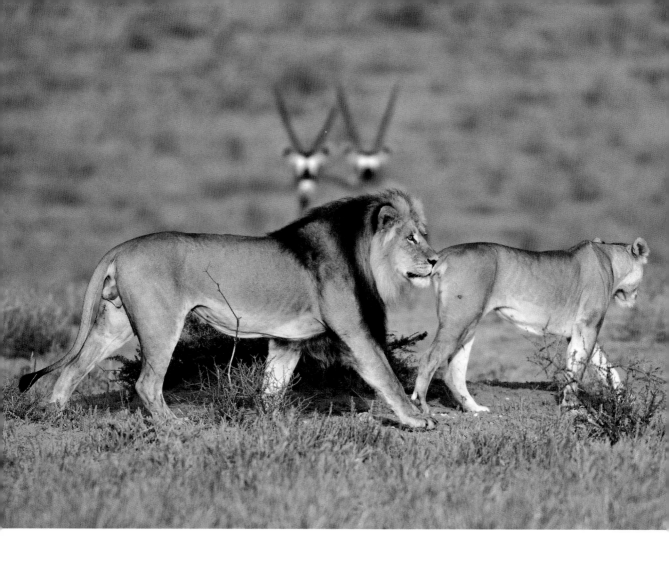

The cat family (felids) includes lion, leopard, cheetah, serval, caracal, black-footed cat and African wild cat.

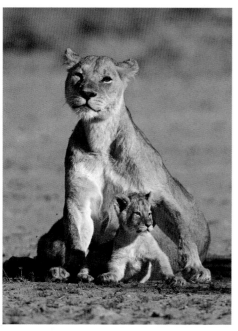

Lion
(Panthera leo)

Lions have no specific habitat preference and can be encountered anywhere, except in forests. In the early morning they often rest on the road or are found on a kill. Different prides have different hunting preferences and patterns. The commonest prey is impala, zebra and wildebeest, but some prides regularly kill buffalo, giraffe, and in Savuti, even elephant.

In a lion pride, all the females are related and the cubs and subadults fathered by the male coalition in control of the pride. When a new male coalition takes over a pride, they usually kill all the cubs of the previous males, so that the females can come on heat sooner to bear the new coalition's own offspring.

Distribution: The natural distribution range has shrunk dramatically during the last few centuries and lions are now mainly restricted to conservation areas. They still occur naturally in the northern and northeastern parts of the sub-region, but they have been reintroduced in many of the larger savannah game reserves where they formerly occurred.

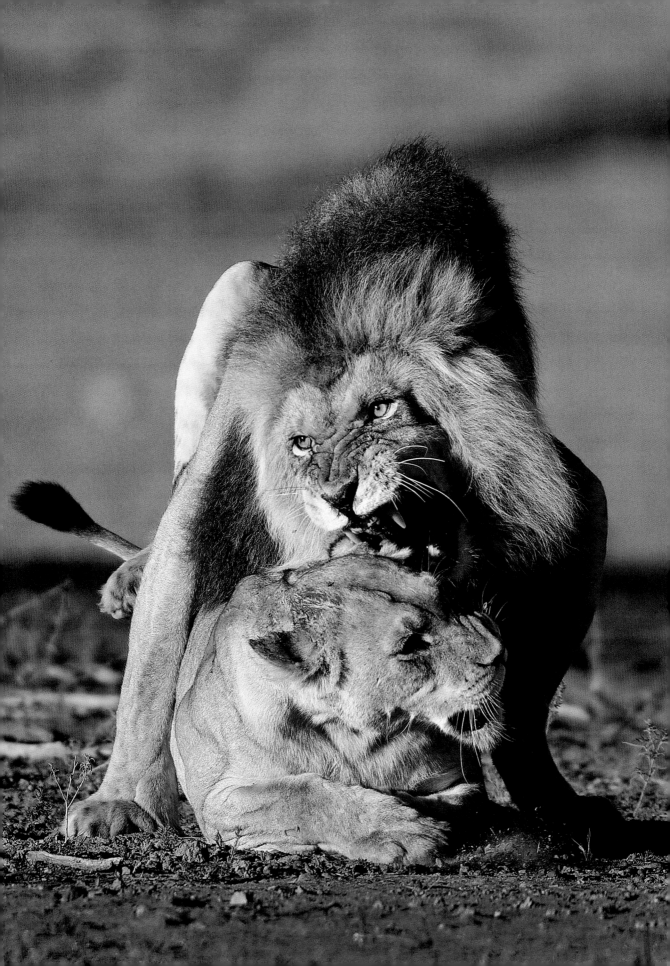

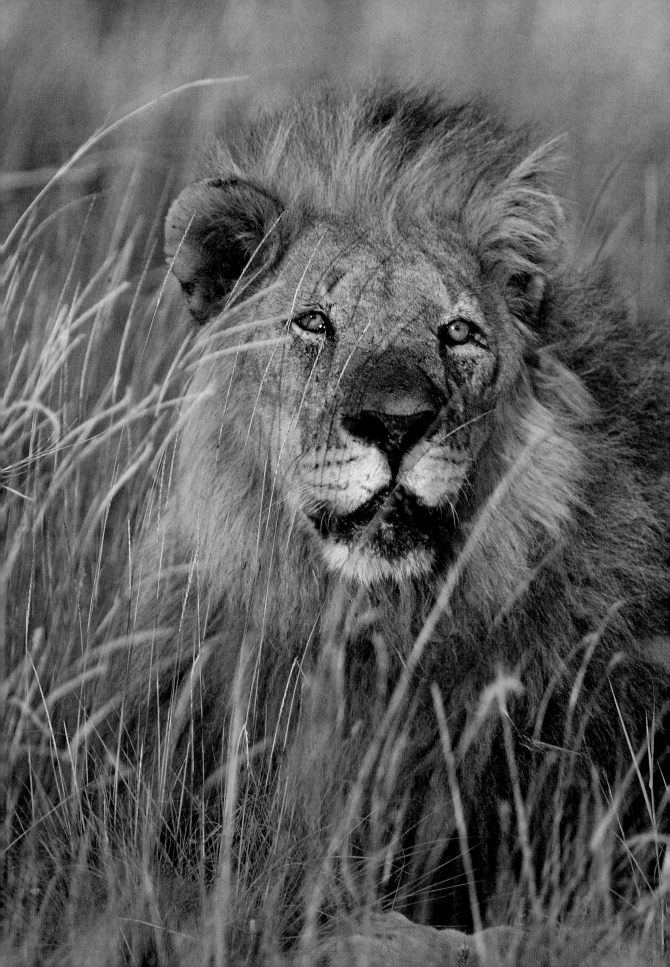

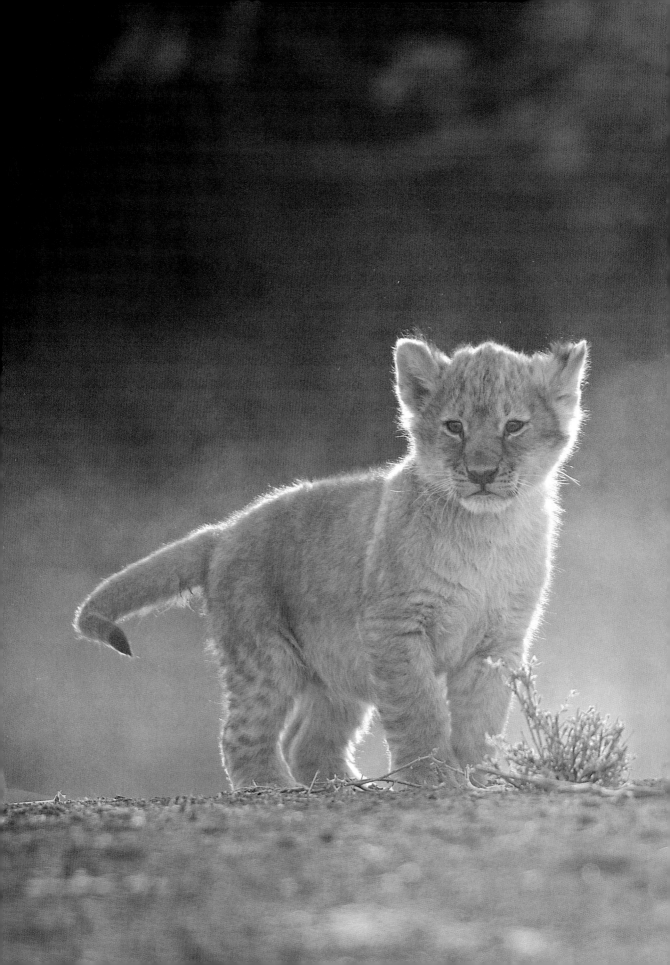

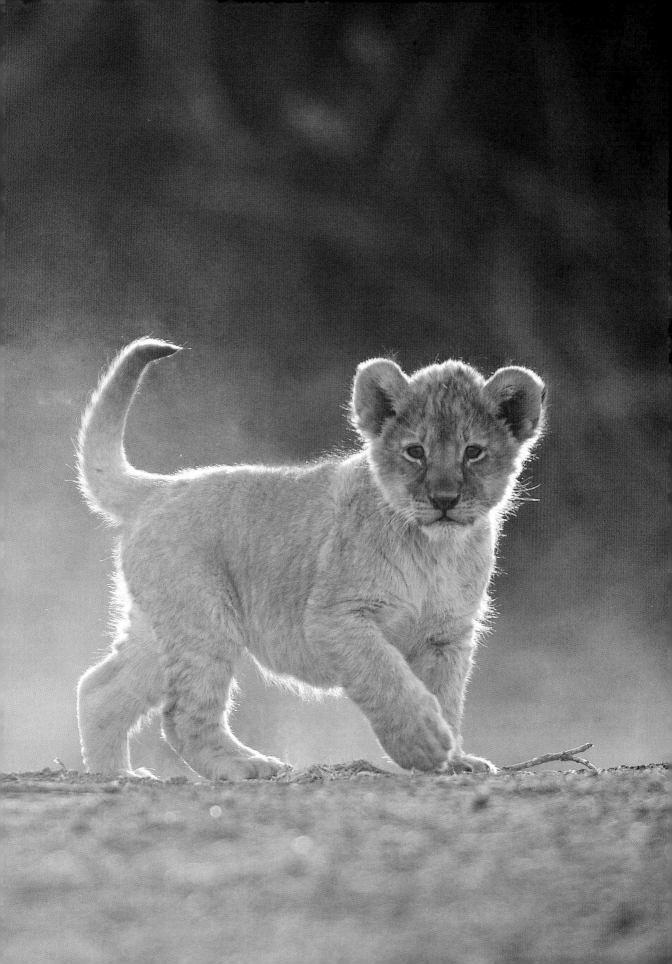

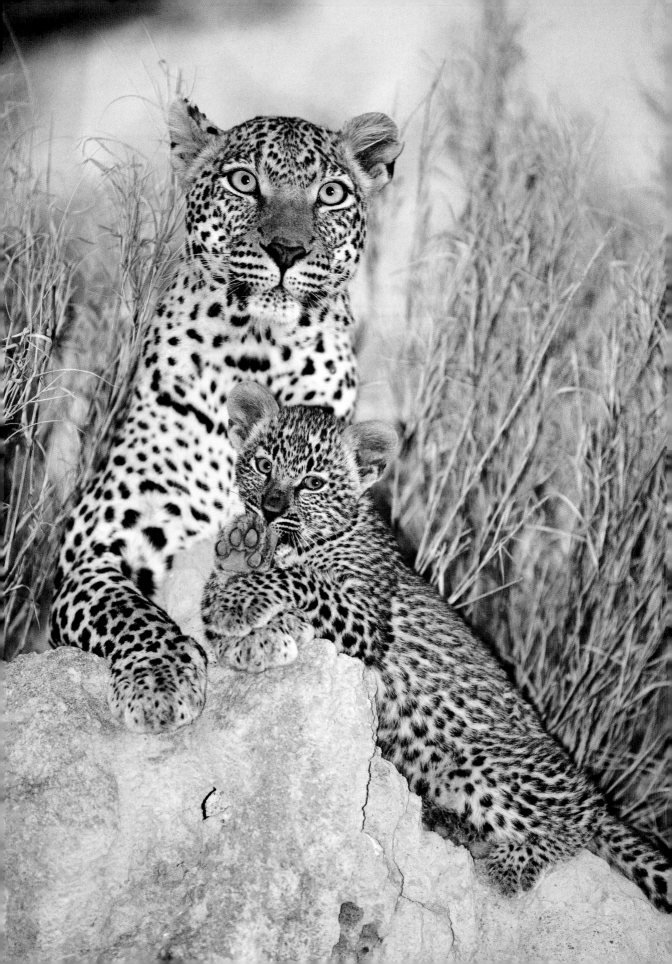

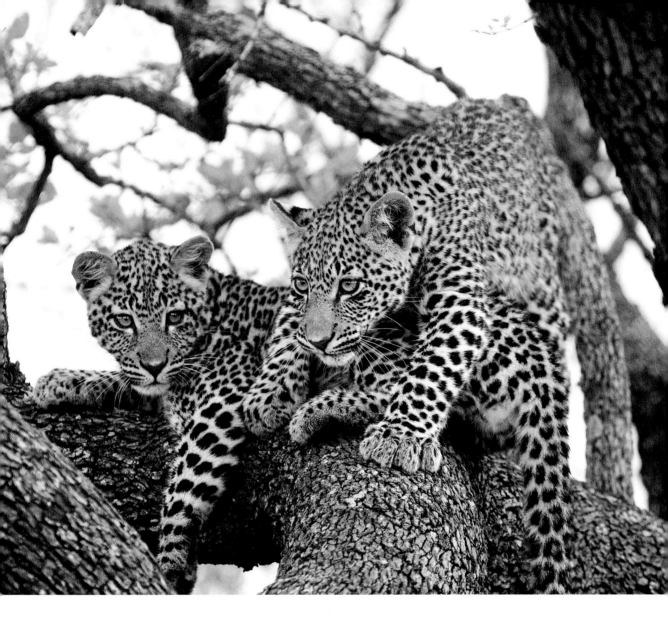

Leopard
(Panthera pardus)

Although well represented in places, the leopard's shy secretive ways and mainly nocturnal habits are reasons for it being only rarely sighted. This is the most widespread of all predators since it has the broadest habitat tolerance of all the cats. Beautiful, powerful and stealthy, it surely is the prize encounter on all game drives.

The leopard's method of hunting is stalking and then pouncing on to the prey, taking it by surprise. The large head and neck are essential for holding and subduing the kill and hoisting it up a tree to get it out of the reach of other predators.

Distribution: Leopards are widespread in the sub-region except in the central sector and desert areas. They are usually found in broken country or forest. Individuals in the southern parts are generally smaller than those in the northeastern sections.

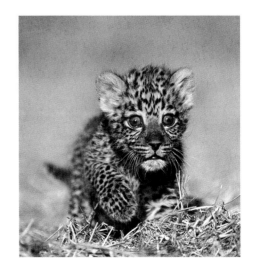

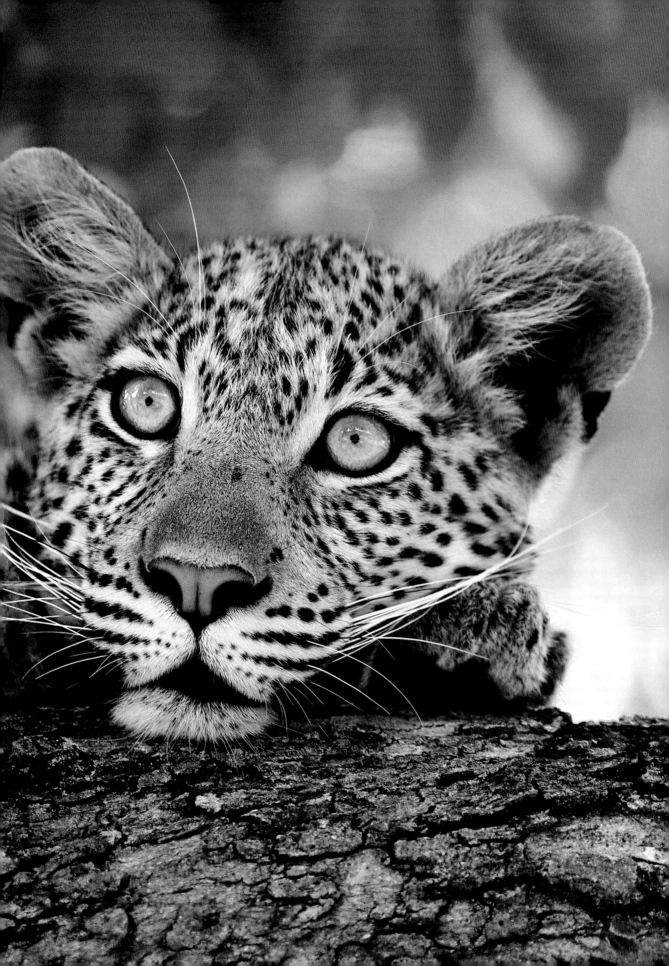

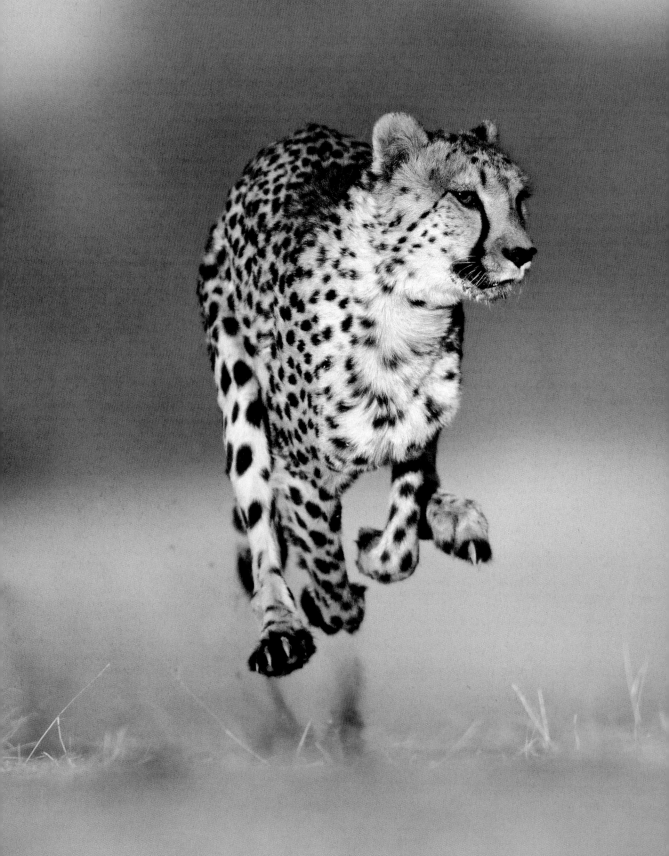

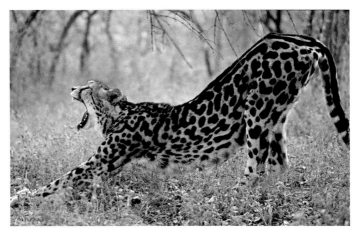
King Cheetah

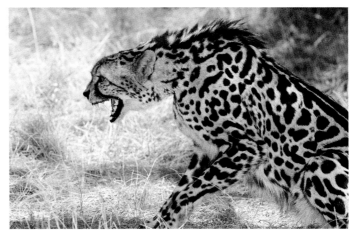
King Cheetah

Cheetah
(Acinonyx jubatus)

The cheetah needs bushes, grass or other cover to get within sprinting range of its prey. Its light-boned slender body, long thin legs, short neck and long tail make it built for speed. It can attain a speed of up to 100km per hour, making it the fastest mammal on land.

The unsheathed claws are less retractile than those of other cats, to give the cheetah grip when chasing prey. Unlike other cats, the cheetah has a unique bird-like chirp or whistling call.

Distribution: Historically cheetah occurred from the Cape of Good Hope to the Mediterranean. Although they still occur naturally in parts of Namibia, Botswana, the Kruger National Park and the Kgalagadi TFP, their numbers have dwindled dramatically due to various factors. They are presently mainly restricted to conservation areas. Breeding centres for endangered animals have embarked on a successful breeding programme and animals have been reintroduced into suitable game reserves.

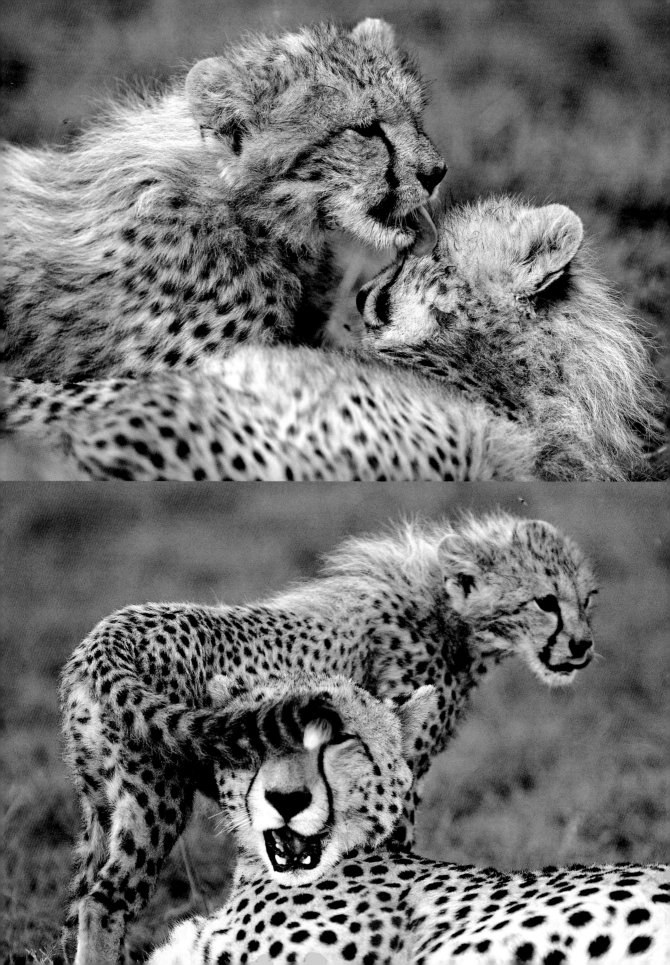

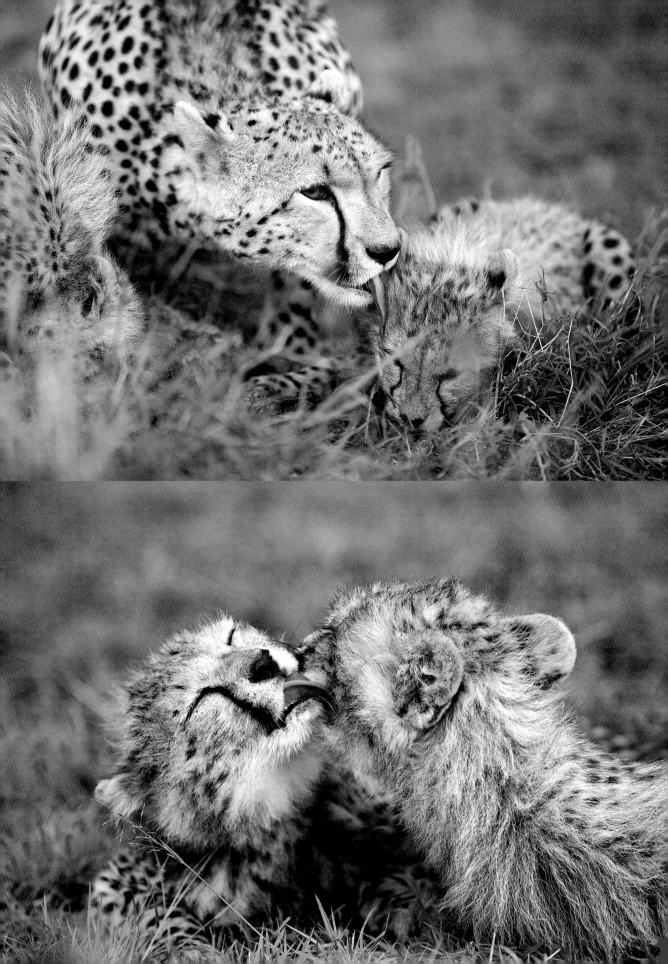

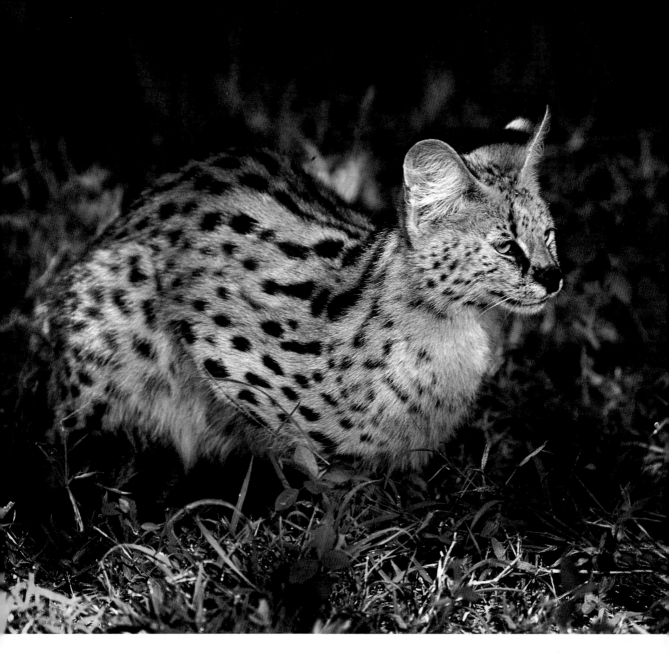

Serval

(Leptailurus serval)

The best place to see servals is along wetlands where there is tall grass for cover and plenty of rodents for food. They start foraging in the early evening and are often still active after sunrise. It is the tallest of the small African cats with long legs, slender build and a long neck.

It is exceptionally quick and agile, and captures its prey by pouncing – first locating and pinpointing the sound made by its prey by moving its large ears, listening, and then leaping high in the air and coming down with both front feet on its victim. Prey includes mainly rats and mice, but also other rodents, reptiles, birds and mammals.

Distribution: Serval are found in wetlands of the northern and northeastern savannah as far south as KwaZulu-Natal.

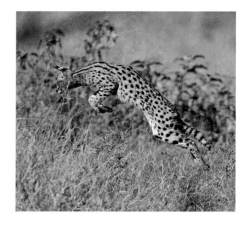

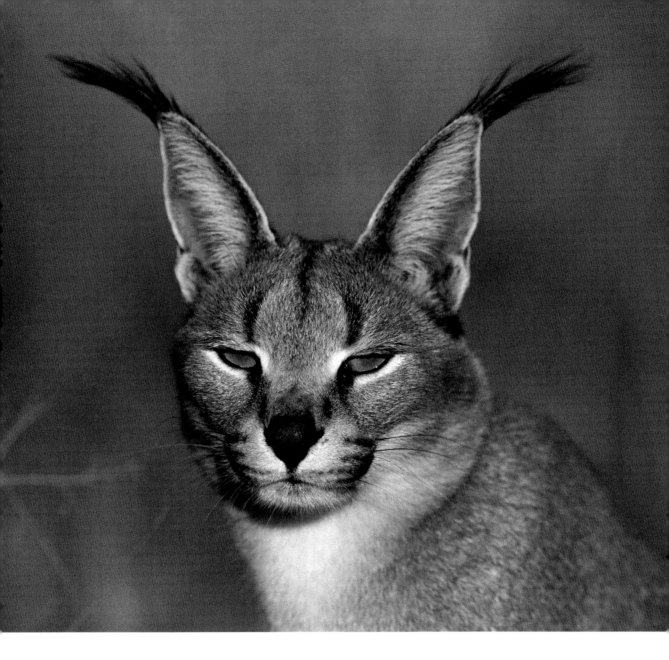

Caracal/Desert Lynx
(Caracal caracal)

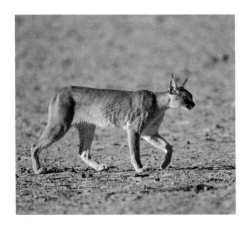

A sighting of caracal in the wild is always special. Being shy, well camouflaged and nocturnal, it is not often seen, although it is plentiful. It inhabits plains, mountains and rocky hills, and seems to need woody vegetation for cover. A good climber and jumper, it is an impressive predator, often killing prey much larger than itself.

This is the heaviest of the small cats and is the African version of the lynx. The tufts at the ends of the ears are distinctive and probably serve to accentuate the ears in interaction with other individuals. In farming areas, it is regarded as a problem animal.

Distribution: Caracal occur widely in the entire sub-region and are regarded as vermin by farmers. They are not found in the low-lying south-east.

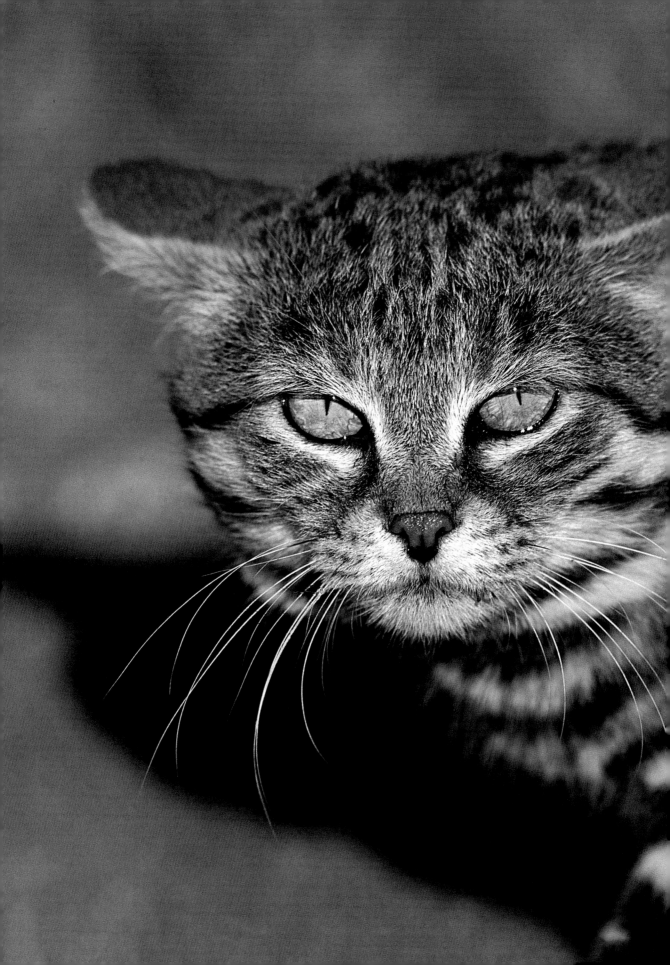

Black-footed Cat
(Felis nigripes)

Also known as the spotted cat, this beautiful endemic animal is the smallest of all southern African cats. Its three throat rings are distinctive. It also has other rusty-tinged markings on the shoulders and upper parts of the limbs. The background colour is cinnamon buff to tawny or even off-white. It has short legs and a short black-tipped tail which is less than half the body length.

The black-footed cat occurs mainly in arid regions such as the Nama-Karoo and Succulent Karoo, but it is not common anywhere. It hides in termite mounds or spring hare burrows during the day and is strictly nocturnal. Its prey includes mice and other small rodents, gerbils, birds, lizards and invertebrates.

Distribution: This cat is endemic in the south-western arid zone of the sub-region. Uncommon.

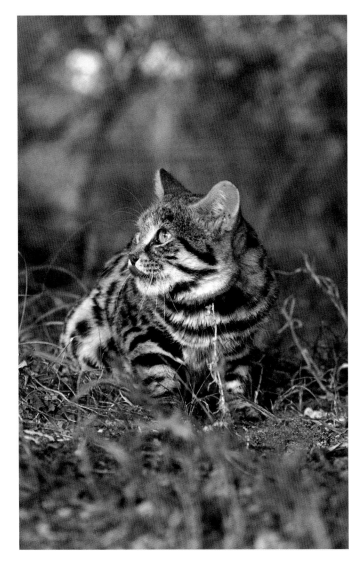

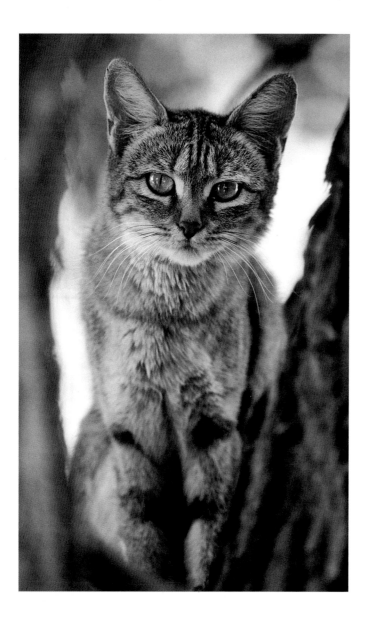

African Wild Cat

(Felis silvestris)

Expect to see the African wild cat wherever mice and rats thrive – perhaps even close to lodges and in camps. When other predators are abundant, sightings will occur strictly at night. Occasionally you may find an African wild cat in the early morning on its way to its resting place, or sunning itself.

This is the closest relative to the domestic tabby and can easily be mistaken for it. Its long legs, bright rufous-brown, orange to chestnut markings on the back of its ears and its more upright posture when sitting, distinguish it from its domestic counterpart.

Distribution: The African wild cat is widespread throughout most of the sub-region but is not found in the Namib Desert and low-lying coastal regions of KwaZulu-Natal.

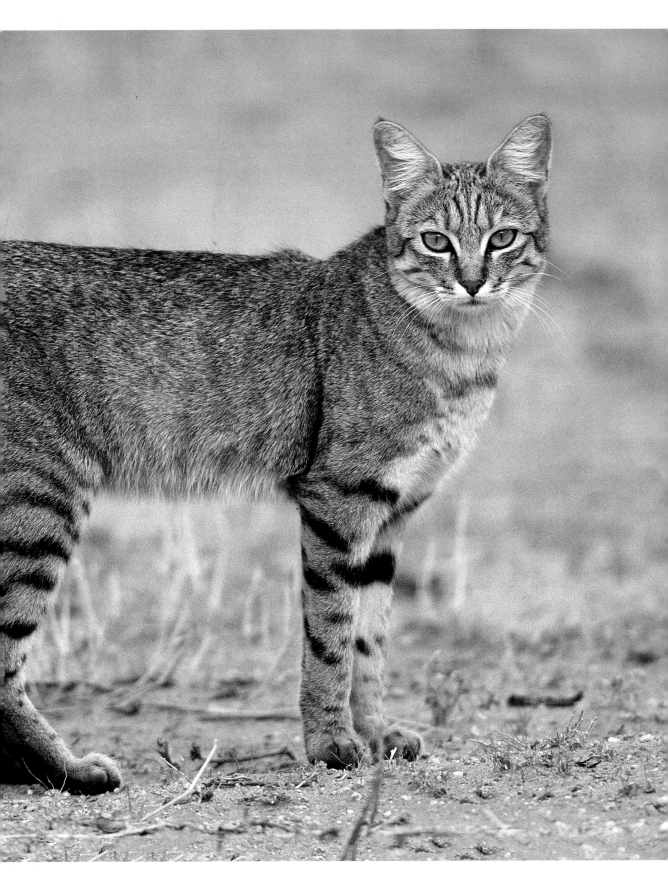

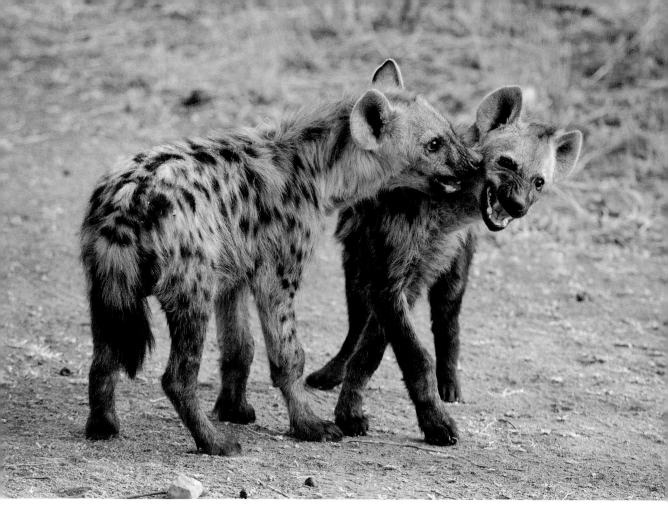

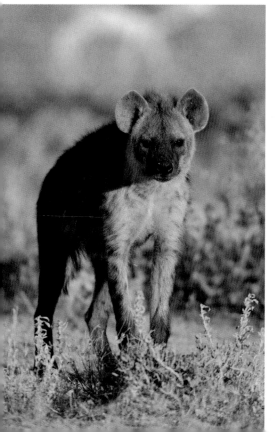

There are three related species in the hyena family – the spotted hyena, brown hyena and the aardwolf. Although related, the aardwolf bears the least resemblance to the other two. Hyenas are the second smallest family belonging to the carnivores.

Spotted Hyena
(Crocuta crocuta)

This sturdily-built, large, formidable scavenger and predator is often encountered early in the morning, walking along the road returning to its den. The clan is a matriarchal society with the dominant female and the other females being larger than the males. It is untrue that these animals are bisexual, but a flap of skin that resembles the male organ covers the reproductive tract of the female.

Hyenas serve a vital purpose in the ecology of an area because they help to clear the bush of decomposing carcasses and prey on dying or infirm animals. This helps to maintain healthy animal populations.

Distribution: This hyena is widespread in the northern savannah parts of the sub-region and the central Namib Desert. It is also common and widespread in Botswana and Zimbabwe, but in Mozambique the numbers have dwindled. In South Africa it occurs mainly in the larger protected savannah areas of Limpopo, Mpumalanga, KwaZulu-Natal, North-West Province and the Kgalagadi TFP.

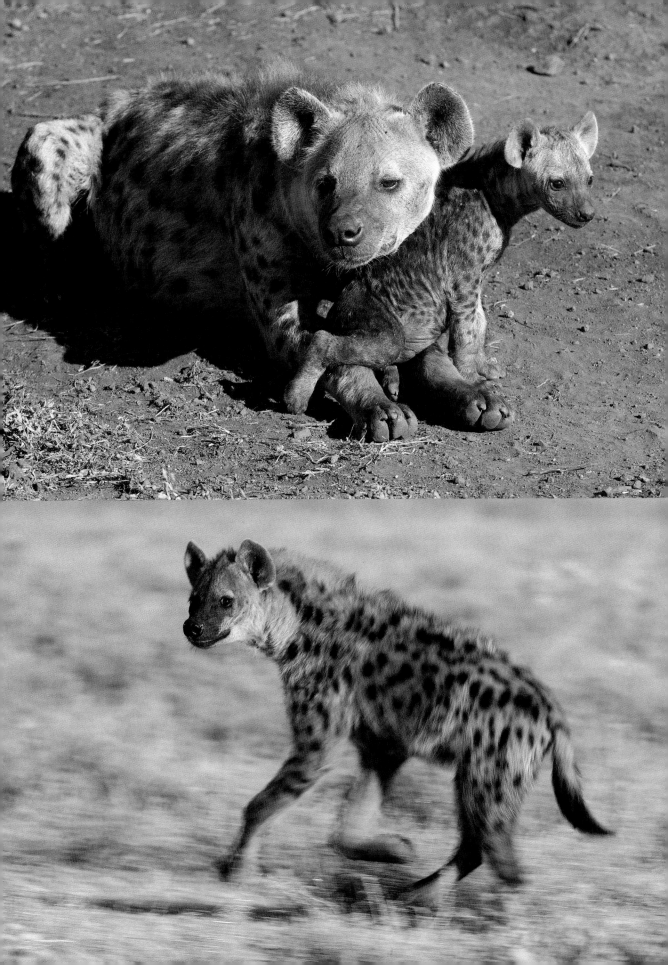

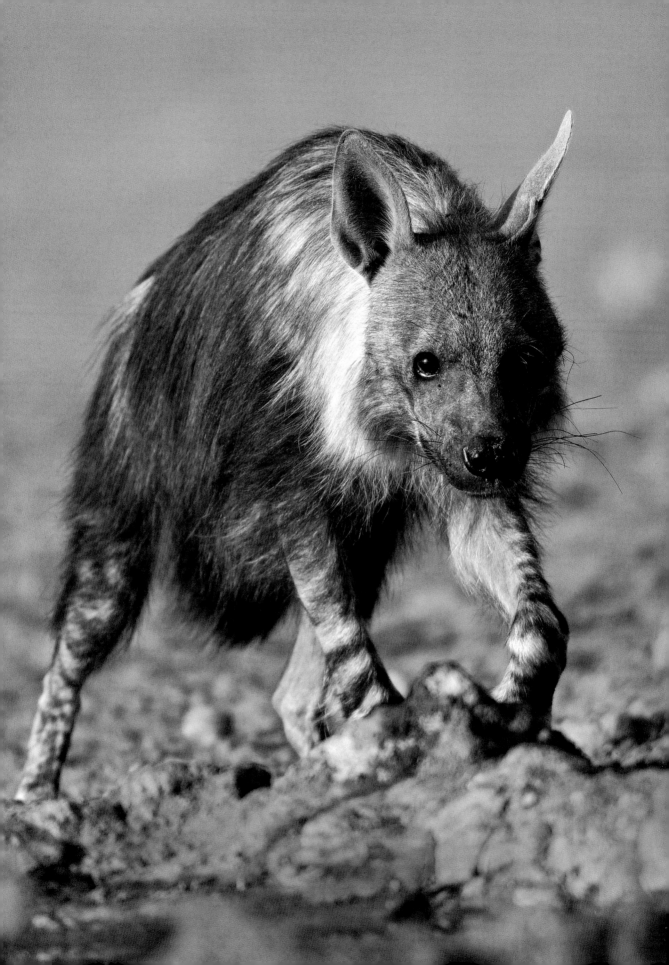

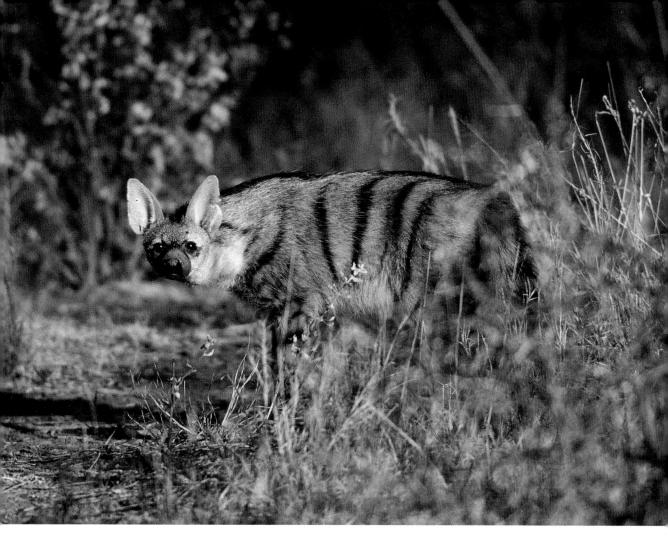

Brown Hyena (opposite)
(Parahyaena brunnea)

Brown hyenas occur over most of the drier regions of south-ern Africa and widely in Botswana except for the extreme northern part. They do not need to drink water and are there-fore capable of surviving in very arid areas. They rely to a great extent on scavenging and cover vast distances in search of carrion, making use of their exceptional sense of smell. They are not good hunters and only catch smaller animals and invertebrates. They also eat eggs and their strong jaws even enable them to break open ostrich eggs.

Brown hyenas live in groups but normally forage alone. The clans, consisting of males and females, occupy a huge territory. Many males are nomadic and do not belong to a clan.

Distribution: They are common in Namibia and Botswana but occur marginally in the south-western parts of Zimbabwe and the Banhine Flats of Mozambique. Widely distributed but sparse in the Limpopo, North-West, Mpumalanga and Gaut-eng provinces, their distribution remains sparse too in the Free State Province and north-western parts of KwaZulu-Natal.

Aardwolf (above)
(Proteles cristatus)

The aardwolf is widespread but seldom seen because of its nocturnal habits. This slender animal looks like a miniature striped hyena but it eats insects, particularly grass-eating termites on overgrazed areas. It gathers the termites with its broad sticky tongue.

Due to their specialised diet, they have small weak teeth that are not capable of dealing with larger prey. Some stock farmers ignorantly believe that they are a threat to livestock and they are therefore relentlessly persecuted. Although they mostly hide in abandoned aardvark holes, they are able to excavate their own burrows, where they rest during the day.

Distribution: The Aardwolf is widespread in most of the sub-region but absent from central and eastern parts of Mozam-bique and forested areas of the south coast.

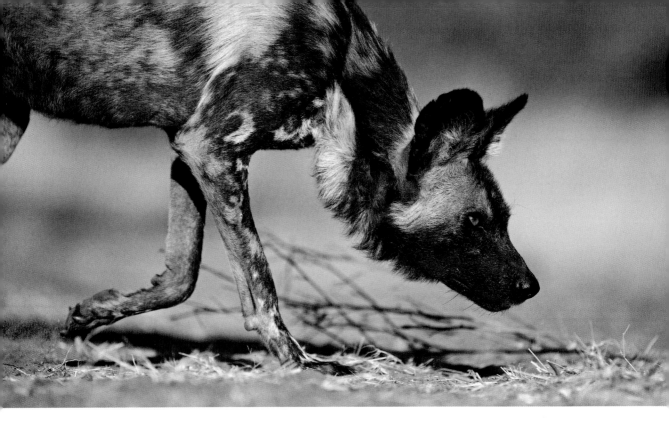

The canid or dog family includes five species in the sub-region – the African Wild Dog, Black-backed Jackal, Side-striped Jackal, Bat-eared Fox and Cape Fox or Silver Jackal. They vary in size but there is a clear resemblance among them – all have conspicuous erect ears and a long muzzle that ends in a naked fleshy area that encloses the nostrils; they all have bushy tails and long slender legs. The wild dog is the only one that feeds entirely on flesh. All the others either supplement their diet with insects or even vegetable matter, for example bat-eared foxes are mainly insect-eaters.

African Wild Dog
(Lycaon pictus)

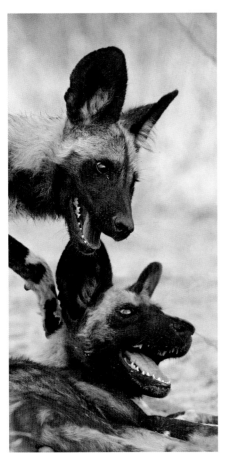

Wild dogs can be encountered unexpectedly anywhere and at any time. It is the most specialised of all dogs, hunts in packs and preys on medium-sized antelope. When they make a kill, they will swallow whole pieces of meat, which on their return to their den will be regurgitated for the pups and injured individuals that stayed behind.

Only the alpha pair in the pack reproduces and leads the pack. The males of the pack are related and stay in their birth-pack, while females move out when the pack gets too big. Each member has a rank order and helps to raise the young.

Distribution: Wild dogs need large territories and have become rare and endangered. Restricted to the north-eastern parts of Namibia, they also occur naturally in northern Botswana and the Central Kalahari as far south as Khutze, in larger conservation areas of Zimbabwe, Mozambique's Gaza Province and parts of South Africa such as the Kruger National Park and adjacent protected areas. They were introduced into Madikwe, Pilanesberg, Venetia, Marakele, the Eastern Cape and Zululand in KwaZulu-Natal.

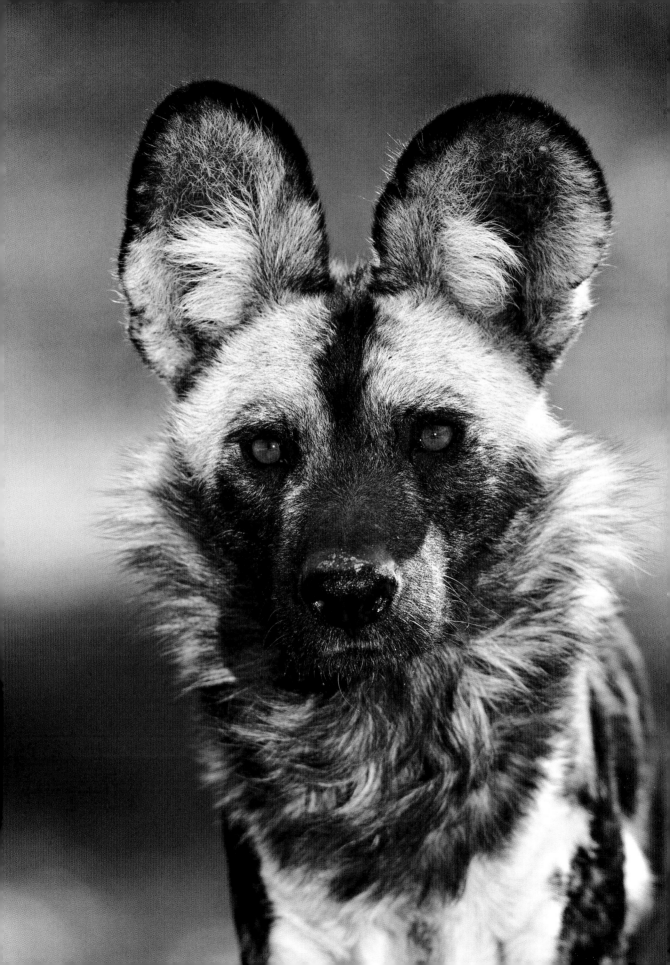

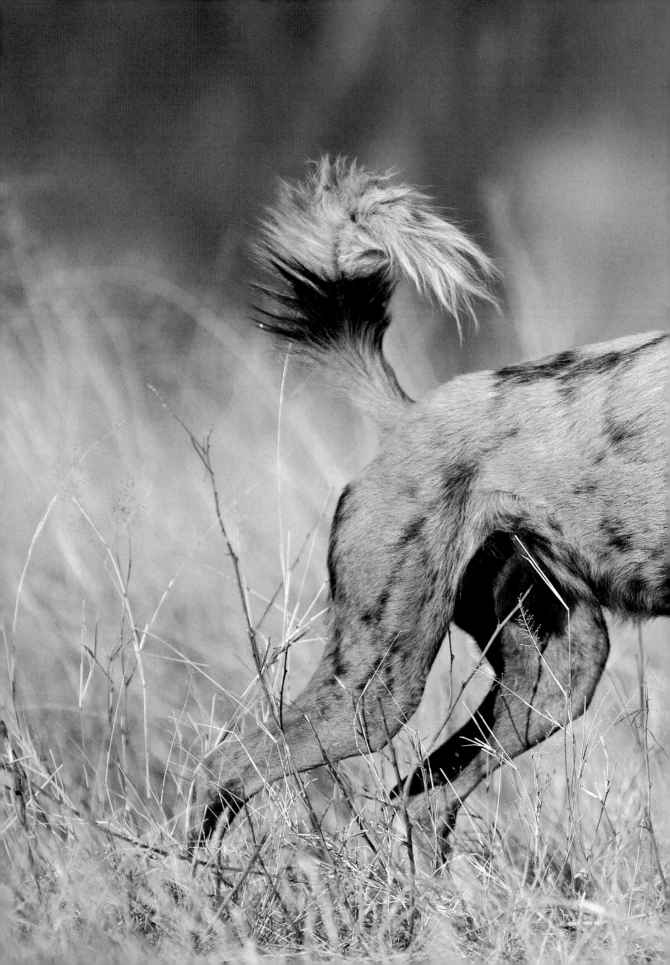

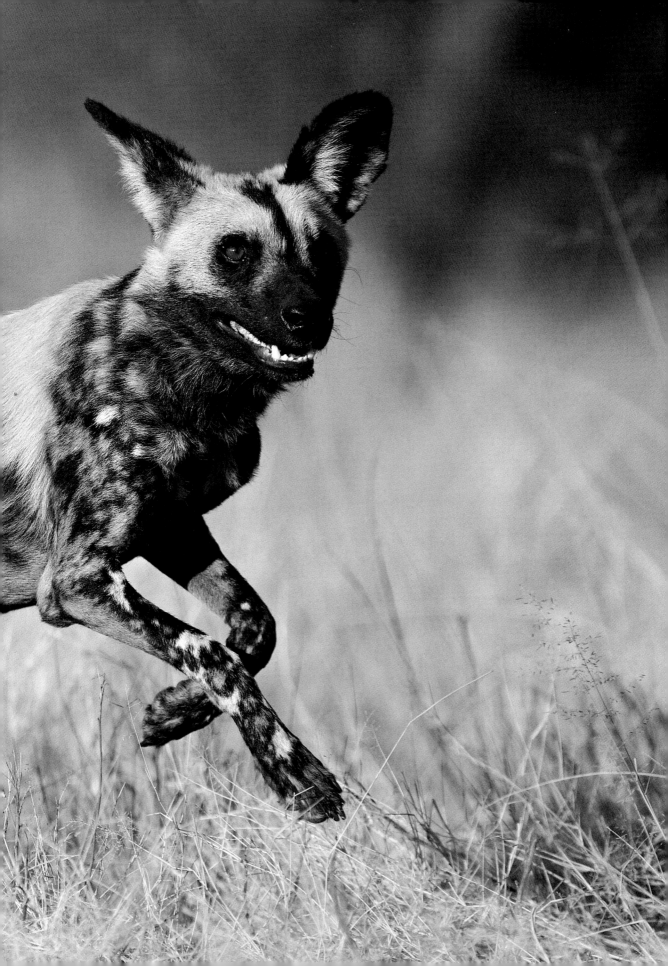

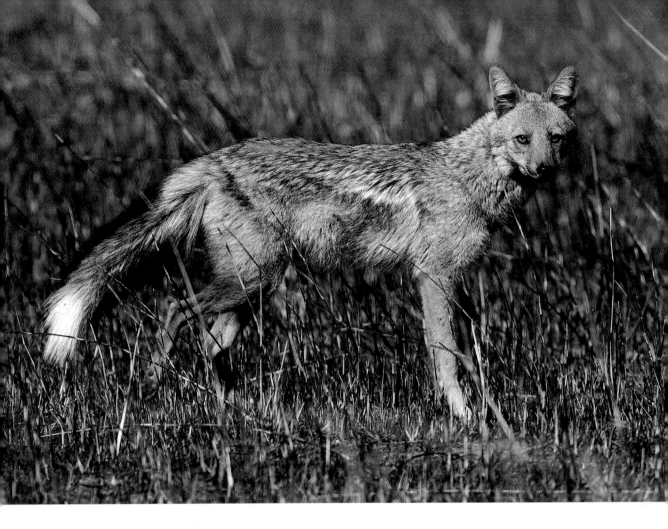

Side-striped Jackal (above)
(Canis mesomelas)

Although side-striped jackals have a much wider distribution than black-backed jackals in Africa, they are not common in the southern African sub-region. They prefer wetter, wooded areas and avoid open country. In Botswana they are restricted to the extreme northern part and are often seen in the Okavango Delta.

This jackal appears overall grey from a distance but many have a distinctive off-white lateral band and a broad white tip to the tail. It is slightly larger than the black-backed jackal. The side-striped jackal is omnivorous and eats a variety of plants as well as warm-blooded animals, reptiles, insects and carrion.

Distribution: This jackal occurs in the extreme northern parts of Namibia and Botswana, throughout Zimbabwe except the drier western and southern parts and is widespread in Mozambique except in the drier areas of the Banhine Flats. In South Africa it is confined to the wetter north-eastern parts and marginally in Swaziland and KwaZulu-Natal at elevations lower than 100m. The side-striped jackal is rare but not threatened.

Black-backed Jackal (opposite)
(Canis mesomelas)

The black-backed jackal is widely distributed and not very popular with farmers because it may kill small livestock such as sheep and goats. Its characteristic saddle of black and silver hair distinguishes it from the side-striped jackal, which is particularly shy and seldom seen.

A jackal pair forms a partner bond for life and an individual will only find another mate should one partner die. Both sexes mark and defend a territory and help to raise the young. The mated pair often forages together or shares food when foraging singly.

Distribution: It is common and widespread throughout the sub-region except in the extreme north-east, the forested areas near Knysna and the developed regions near Cape Town.

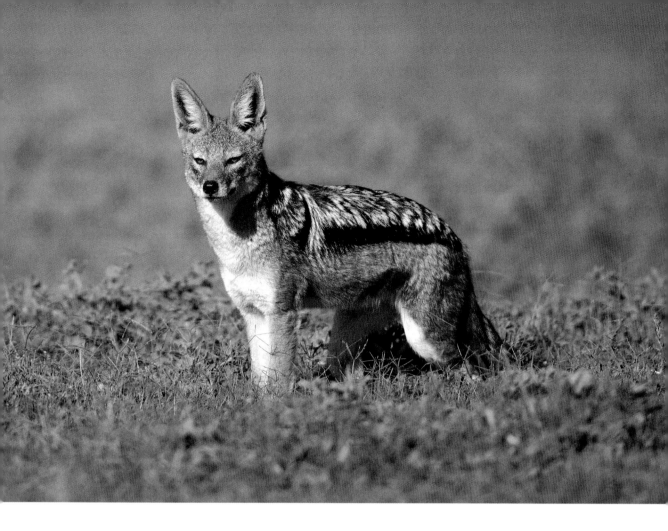

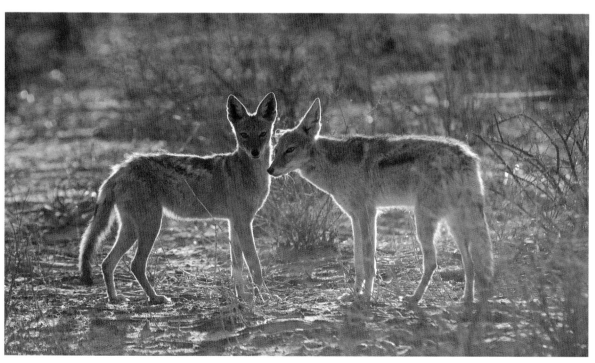

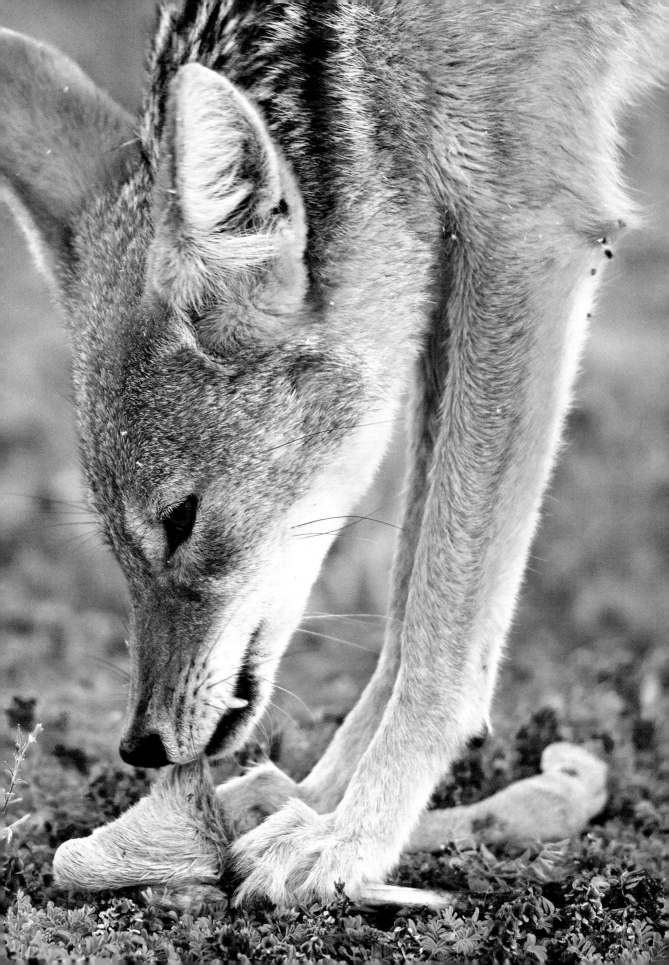

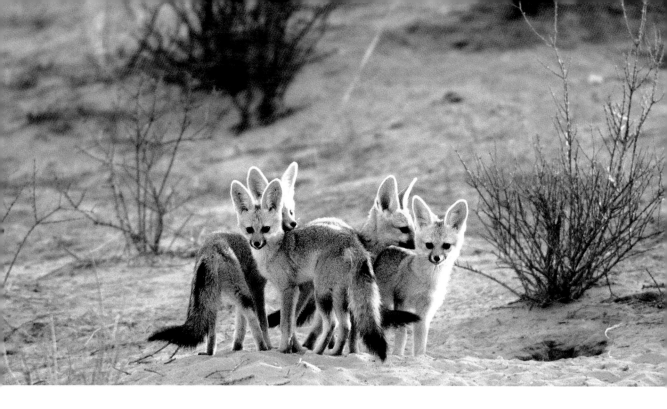

Cape Fox (above and left)
(Vulpes chama)

The only true fox found in Africa was formerly hunted for its beautiful coat. It is quite small, even with its thick fur coat. At dusk and dawn it feeds on mice and insects and spends the remainder of the day resting in a thicket or in a burrow that it digs for itself.

When alarmed it will bark, spit and growl to show aggression. It also vocalises, emitting a high-pitched howl. Sometimes a pair will howl and bark in duet, especially in the breeding season. When they get excited the tail is raised – the elevation indicates the level of excitement.

Distribution: The Cape fox is widespread in drier western parts of the sub-region. They favour open country.

Bat-eared Fox (opposite)
(Otocyon megalotis)

Bat-eared foxes prefer to eat harvester termites, but they also feed on other insects, smaller mammals, reptiles and even plant material. They avoid dense bush and hilly areas and favour open grassland.

The bat-eared foxes' enormous ears play an important part in obtaining food. They can often be seen holding their ears low and horizontal to pick up the sounds made by underground insects, which are then dug up and eaten. When not feeding, they rest in the holes of aardvarks or springhares. In summer they tend to be nocturnal, but during winter they spend more time feeding during the day.

Distribution: Widespread in drier western parts of the sub-region, the bat-eared fox favours open country. It is not threatened.

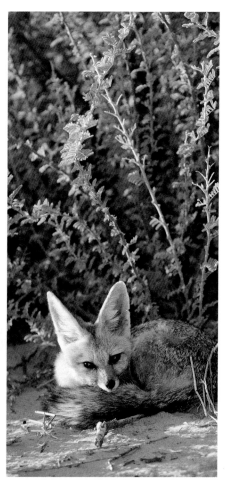

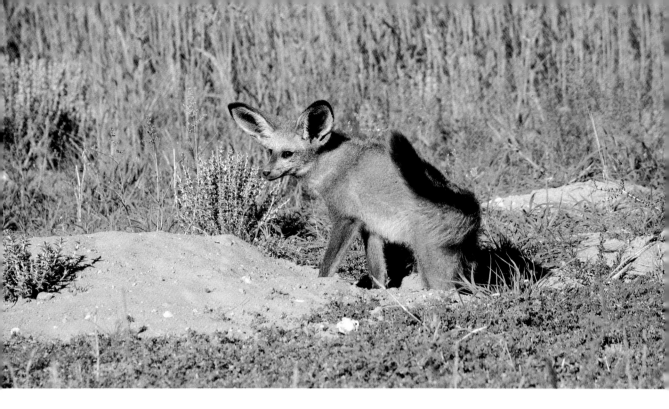

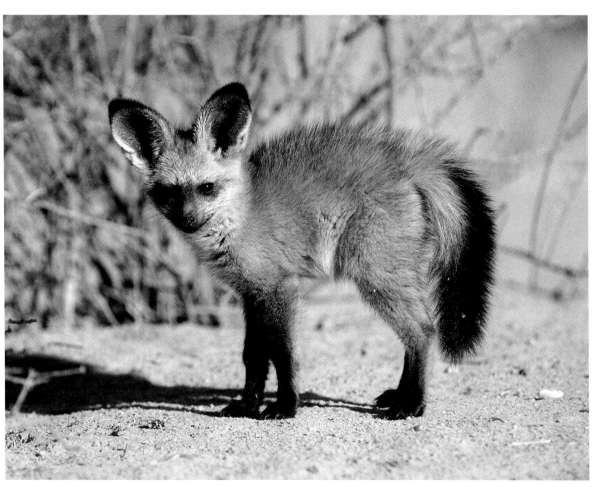

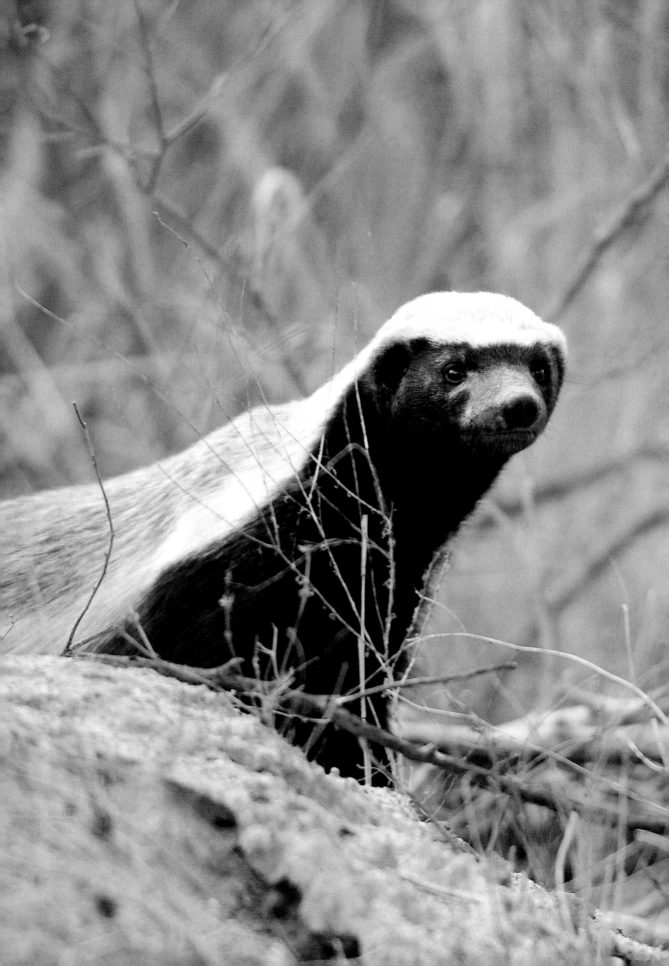

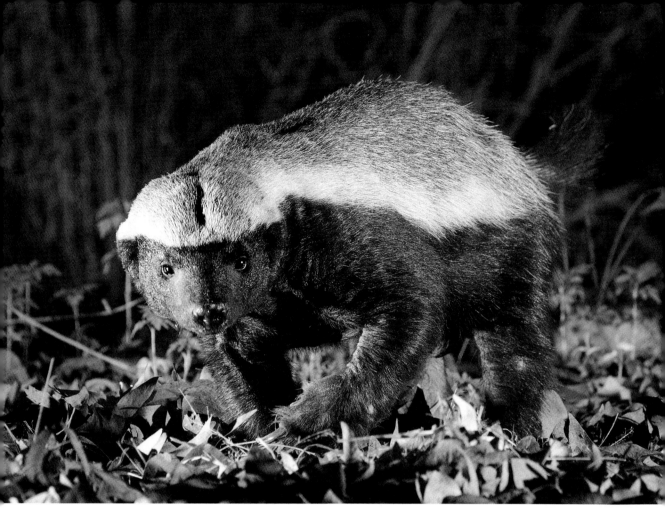

The mustelids, often called the weasel family, are an odd combination of flesh eaters and fierce hunters, preferring freshly-killed flesh and seldom eating carrion. They are the largest and most diverse family of the carnivores. Typically, most are short with short legs, short round ears and thick fur. Solitary and mostly active at night, they have scent glands which are used for sexual signalling and to mark territories.

Honey Badger
(Mellivora capensis)

Although badgers are mainly nocturnal, they are often encountered during the day. This is a very tough and fearless predator that will attack any other animal it perceives as a threat, even a lion. They feed on insects, spiders, reptiles, birds, mice and rats, and will unearth any prey with their powerful forelimbs, which are adapted for digging.

Badgers are also particularly fond of honey and bee larvae. The predation on bees and its association with a particular bird, the Greater Honey Guide, is particularly fascinating. The bird regularly invites people and other animals such as badgers to follow it to the nearest beehive. The co-operation offers mutual benefits.

Distribution: They are widespread over the sub-region but sparse in numbers and absent in the Namib Desert and forested areas.

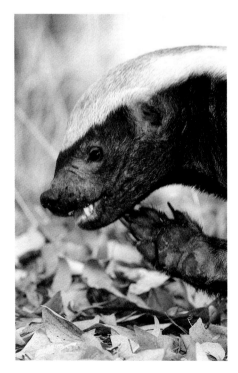

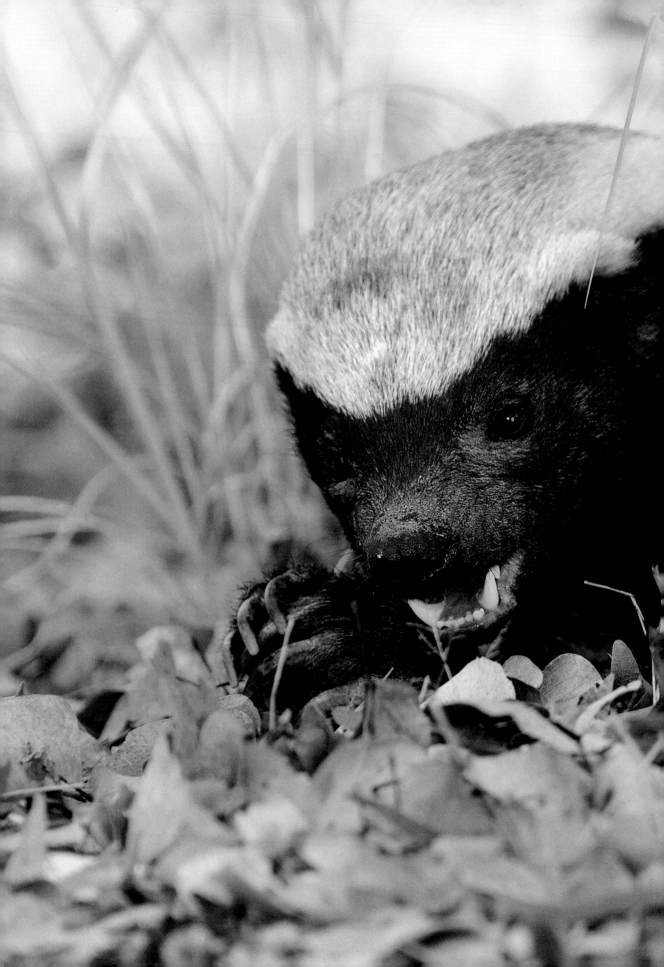

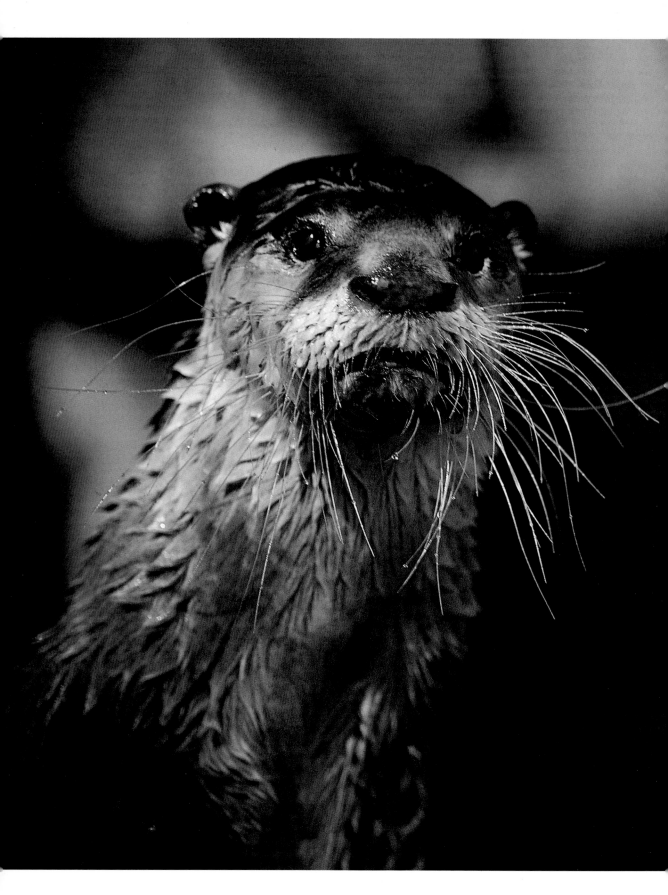

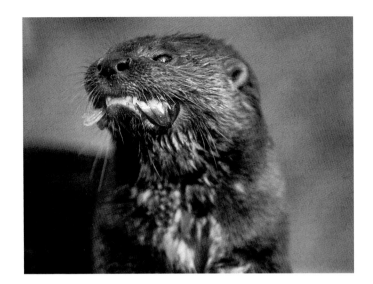

Spotted-necked Otter (above)
(Lutra maculicollis)

The smaller spotted-necked otter is more closely confined to water than its close relative the Cape clawless otter. It differs from the clawless otter in that its throat and upper chest are mottled and creamy white. The under and upper parts are the same chocolate brown to reddish colour but it has a slimmer build.

Both kinds of otter swim very well with their broad webbed feet and tapered flattish tail. The nostrils are slit-like and are closed when the animal dives to feed under water. The spotted-necked otter lives mainly on fish and crabs but supplements its diet with snails, frogs and insects. It rests and hides its young in holes along river beds and in rock crevices or reed beds in secluded areas.

Distribution: It occurs in suitably well-watered habitats in the eastern part of the sub-region. Although rare, they are also located in the Okavango swamps and Chobe and along the Zambezi River.

African Clawless Otter (opposite)
(Aonyx capensis)

Look out for the otter where it may be spotted in streams, rivers, lakes, ponds, swamps and estuaries, and even on rocky sea shores. It finds its prey in water and eats crabs, fish, frogs or whatever is readily available. The prey is captured with its hand-like forefeet while foraging under rocks and stones. Interestingly, otters are known to be either left- or right-handed when feeding, carrying prey, infants or other items.

Stones are used as anvils to smash freshwater mussels too hard for its jaws. After eating, it washes its face and paws in water in an elaborate ritual. It is often seen playing and diving for pebbles, chasing sticks or using its tail to scoop objects within reach.

A characteristic feature is its white chin, throat, upper chest and sides of the neck.

Distribution: This otter occurs throughout the sub-region in suitable habitat. It is absent from the arid west and is not common anywhere.

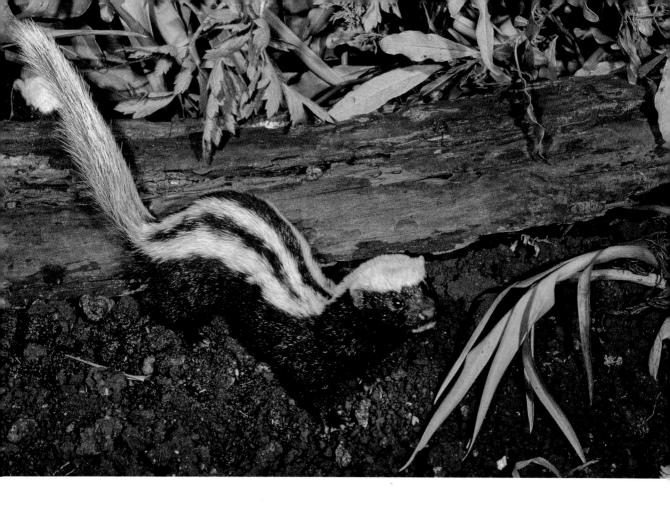

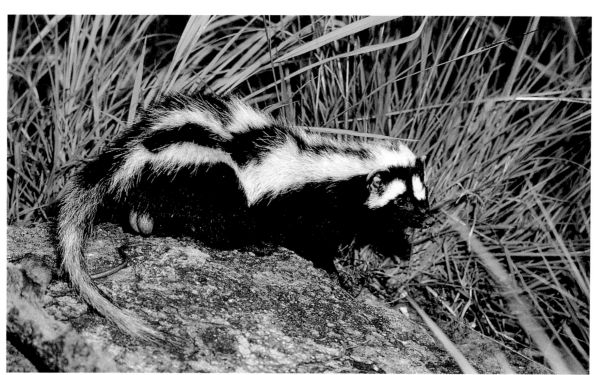

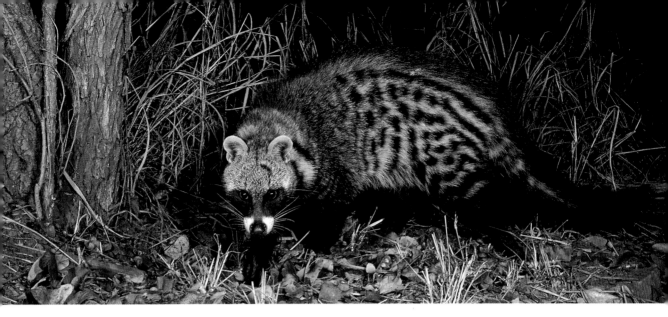

African Striped Weasel
(opposite top)
(Poecilogale albinucha)

This small mammal is seldom seen, although it is both diurnal and nocturnal. The striped weasel resembles the striped polecat – it is also jet-black with four longitudinal white or off-white bands along the back, but the forehead and top are white and the fur is much shorter than that of the polecat. The tail is about a third of the total length of the elongated body and the legs are very short.

The striped weasel occurs in moist savannah grasslands with a high rainfall where it hunts mice and mole rats, capturing them in its burrows. Being an avid digger, it digs and constructs its own burrow with a chamber in which it bears and raises up to three young at a time.

Distribution: This weasel occurs in the eastern part of the sub-region, except in Mozambique. It is rare and its numbers are dwindling.

Striped Polecat
or Zorilla
(opposite bottom)
(Ictonyx striatus)

The polecat is well-known for its evil-smelling and highly persistent secretion from the anal glands that it uses for self-defence. The jetblack body with its white patches on the forehead and cheeks and the four longitudinal white bands down the back looks similar to that of the striped weasel. However, the bushy white tail and the longer hair, longer legs and sinuous body with the pointed snout distinguish it clearly from the weasel.

Distribution: The polecat is widespread throughout the sub-region.

The African civet and the two genet species belong to the viverrid family. They resemble long-nosed cats and have retractile or partly retractile claws, excellent hearing and vision and are mostly solitary. They differ mainly from other carnivores in that their teeth patterns and structures are different, adapted for slicing, breaking and crushing food.

African Civet (above)
(Civettictis civetta)

This large, striking but secretive relative of the genet is very common in the bushveld but only occasionally seen. Its habit of scavenging attracts it to places like camps and lodges where it prowls around at night, often overturning rubbish bins.

This is the only predator that seems to thrive on eating unpleasant tasting or even toxic millipedes and toads. They even consume poisonous snakes like the puffadder, but they also scavenge and supplement their diet with a variety of fruit. The musk secreted as a territorial marking has been used in the past as an ingredient of perfume.

Distribution: The civet is widespread in northern and north-eastern parts of the sub-region. It occurs as far south as Swaziland and extreme northern KwaZulu-Natal.

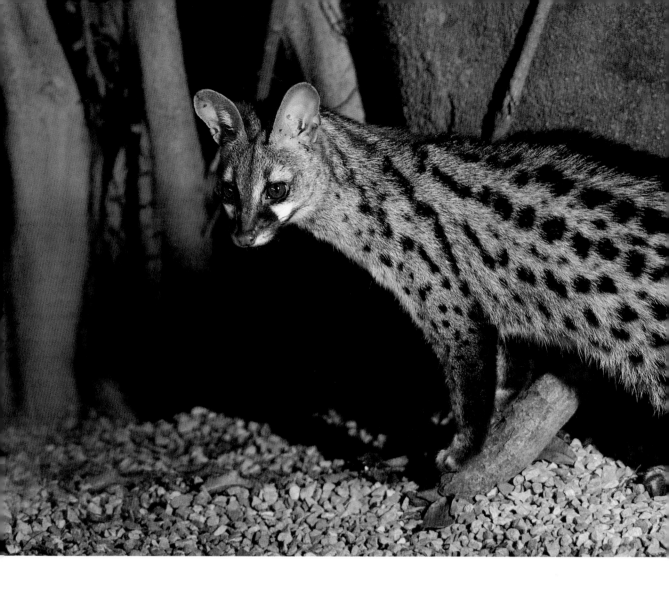

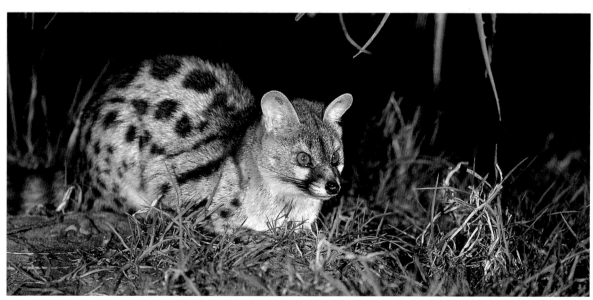

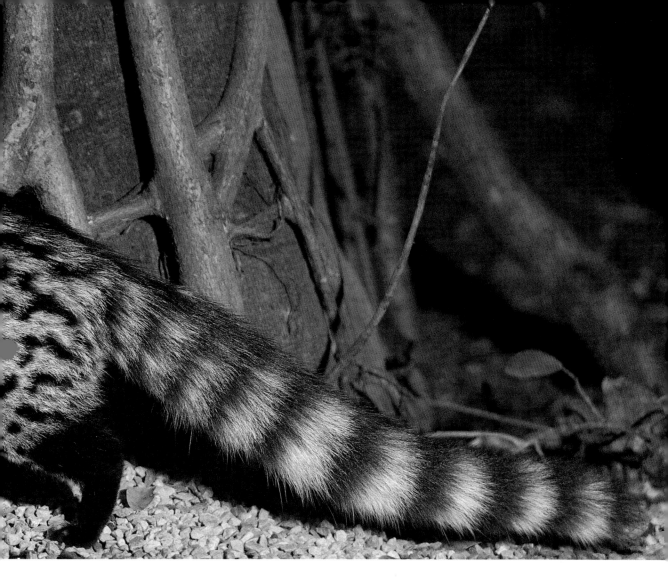

Large-spotted Genet (opposite)
(Genetta tigrina)

During night drives, look for genets on the ground or in trees of densely wooded areas close to water. The large-spotted genet only occurs within the higher rainfall areas. In some parts the large- and small-spotted genet may occur together.

The tail of the large-spotted genet is long and banded and can be distinguished from the small-spotted genet by the black-tip. The limbs are off-white to buffy white as opposed to the smaller one's black lower hind legs. The black to rusty-coloured spots and blotches are also larger than in the small-spotted genet.

The face is a distinctive dark brown with white markings and the hair is soft without a dorsal crest.

Distribution: Absent from arid areas and confined to the northern, eastern and south-eastern parts of the sub-region.

Small-spotted Genet (above)
(Genetta genetta)

The small-spotted genet has an overall greyish colour, numerous spots and bars and a long white-tipped and ringed tail. The facial markings are black and white and the ears are rounded. There is a distinct erectile crest of long black hair down the mid-back.

It hunts in trees and on the ground. When walking, the tail is held in a horizontal position. A proficient climber, it quickly takes to a tree when disturbed. It forages on rodents, insects, birds and wild fruit.

Distribution: Widespread throughout central and western regions, it prefers wooded and riverine areas.

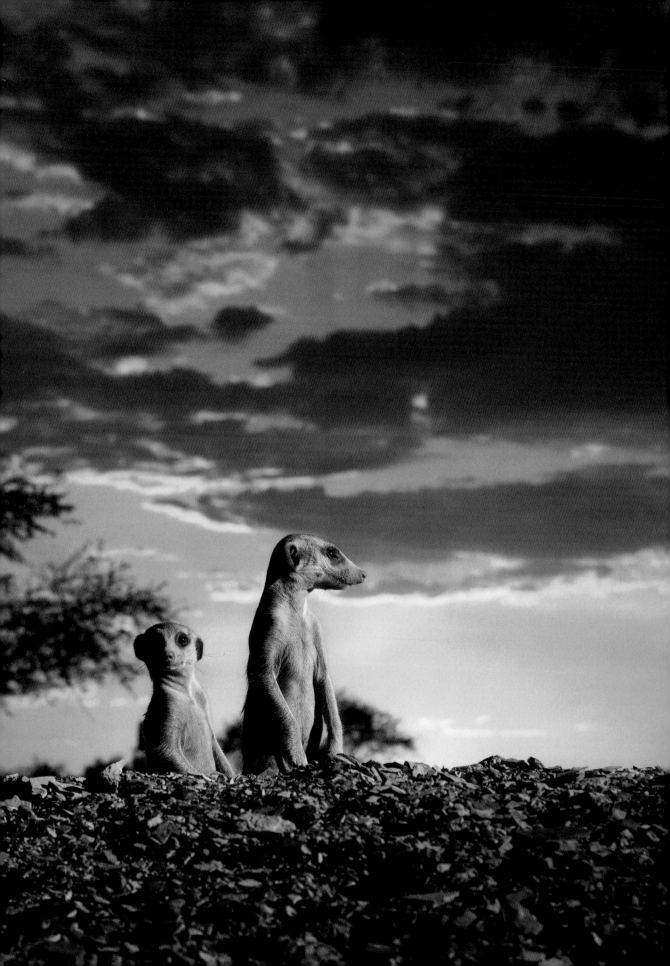

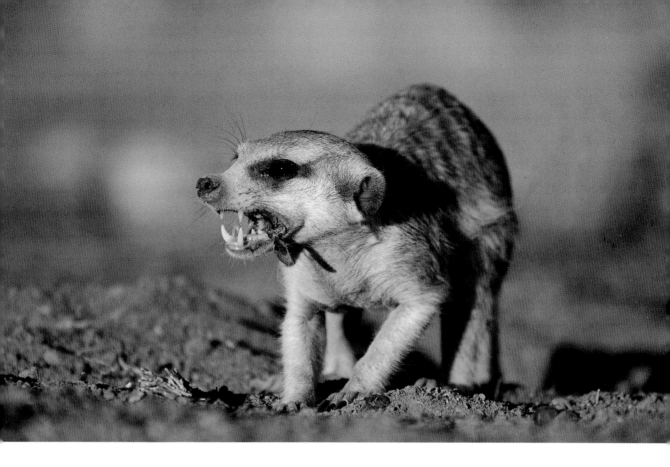

The 13 members of the mongoose family all have the same distinctive body shape – long and lithe, elongated rather than broad heads, sharp muzzles, long tails and short legs, and feet with five digits and claws. Six of these species are predominantly nocturnal and the others are seen only around sunrise and sunset. Mongooses are known for their well-developed scent glands, in particular the anal glands. The bushy-tailed, Meller's and Selous's mongooses are not featured here since they are rarely seen.

Suricate
(Suricata suricatta)

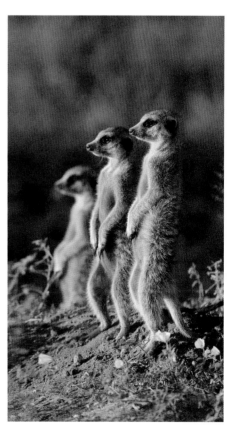

This odd-looking mongoose inhabits the most open and driest parts of the country and particularly favours hard ground on alkaline pans and stony river banks. It lives in warrens housing up to 30 individuals and often shares the warrens with ground squirrels and yellow mongooses. Because it occurs in places where the temperatures often soar beyond 40°C, it has a way of cooling itself down by lying flat on its belly in the cooler sand in the shadow of trees.

A suricate group is a multi-male, multi-female society. In the early mornings after sunrise, the band or group will emerge from the warren to sunbathe, groom and socialise before leaving for foraging.

Non-breeding members of the pack help with babysitting while mothers forage. The suricate feeds on underground invertebrates, insects, spiders, scorpions and smaller vertebrates.

Distribution: The suricate is widespread and common in the semi-arid parts of the sub-region and as far south as the Western and Eastern Cape.

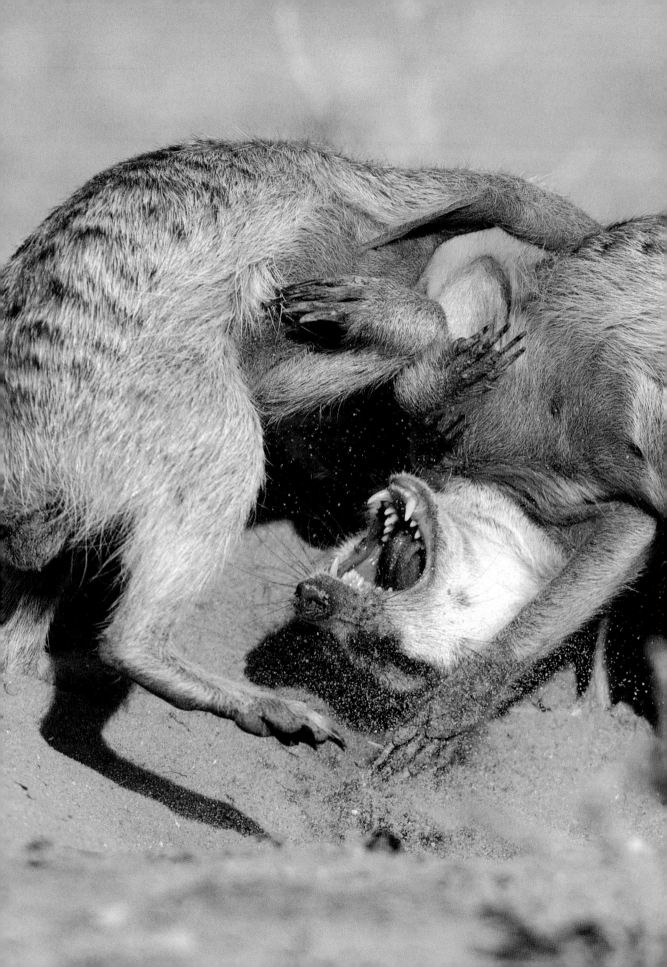

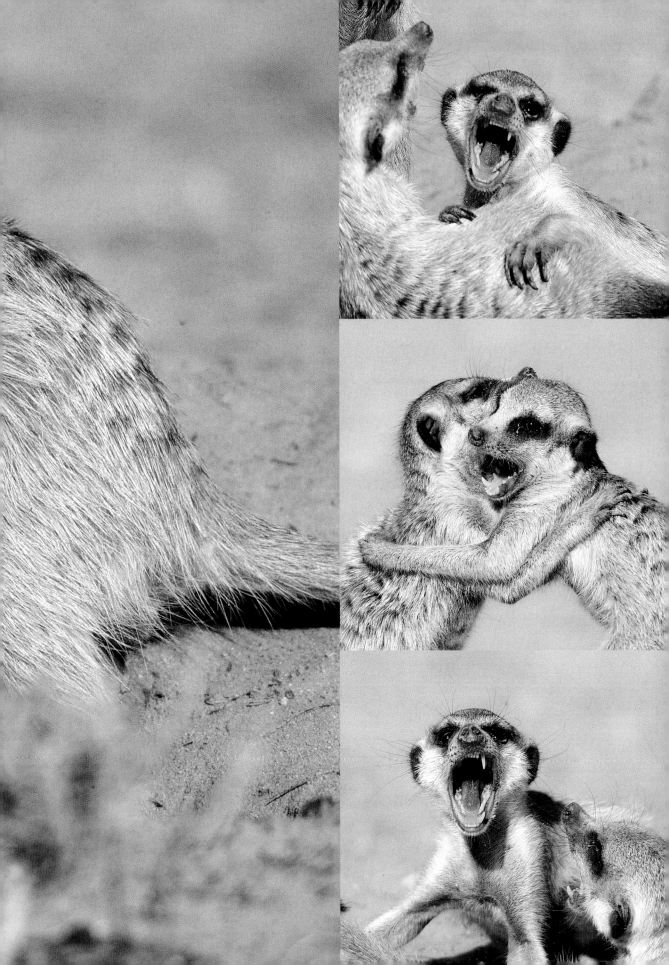

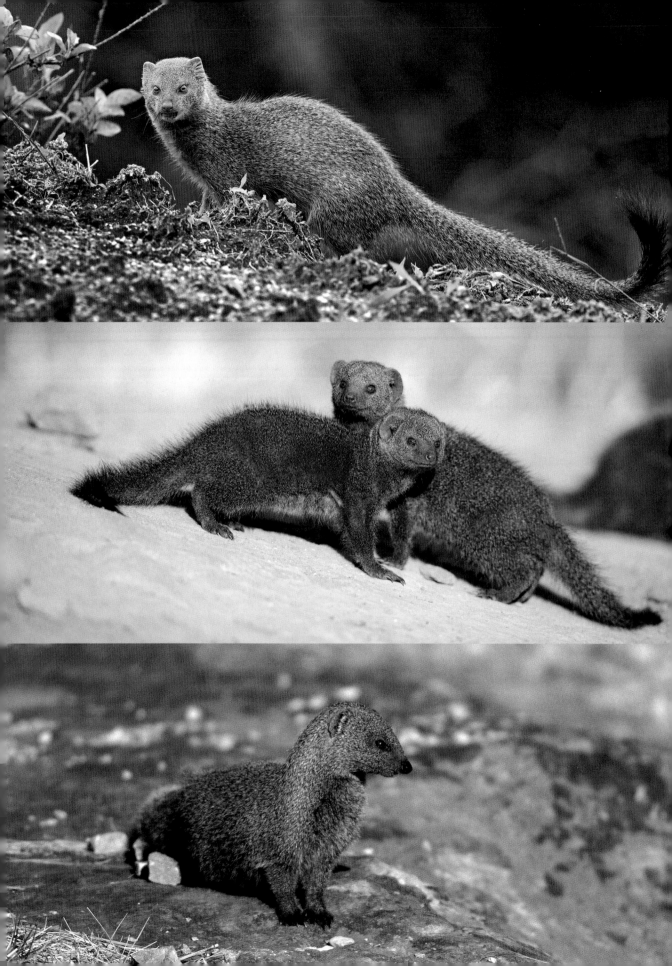

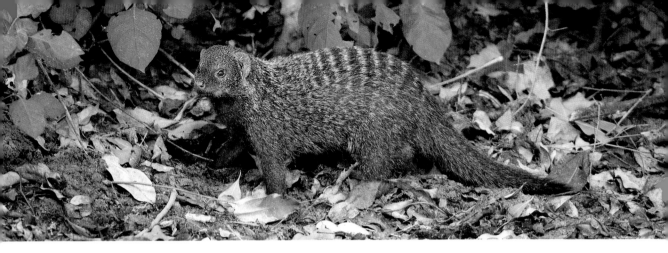

Slender Mongoose
(opposite top)
(Galerella sanguinea)

This mongoose is usually seen alone and is only noticed when alarmed or when crossing the road. It can easily be confused with the dwarf mongoose, but it is larger and the long tail is black-tufted. It is very common and widely distributed in woodlands and wooded savannah and feeds on small vertebrates and insects.

They show an unusual social organisation in that adult males usually live in coalitions of up to four males – very much like the coalitions of lion and cheetah males. They defend a collective territory that may include several females. When they forage, they do so alone.

Distribution: Although widespread in the northern parts of the sub-region, they are absent in the south where the small grey mongoose is found.

Dwarf Mongoose
(opposite middle)
(Helogale parvula)

Dwarf mongooses are some of the commonest carnivores in Africa. In the early morning, as they leave their den, they first socialise and sun themselves before they start foraging for the day. The dens are often in old termite mounds, hollow trees or crevices. They live in packs of up to nine adult individuals and many young.

Only the dominant individuals of the pack breed and the rest of the pack, who are mostly related, help to raise the young. Females without young are also able to produce milk to help with nursing, even though they have never been pregnant.

Distribution: They are widespread and common in the northern, eastern and north-eastern parts of the sub-region as far south as KwaZulu-Natal.

Banded Mongoose (above)
(Mungos mungo)

The first sighting of the banded mongoose is often one of disbelief – especially when they approach in a closed pack of fast moving, wriggling little brown banded bodies, heads low to the ground. They are widely distributed and quite common in the bushveld where they prey on invertebrates and occasionally also on larger vertebrates like rodents and snakes. They often pay visits to camps and lodges where they scavenge through the garbage.

Banded mongooses can intimidate predators the size of serval and jackal with mob attacks. They have strong social bonds, which they reinforce by social grooming and vocal signals. Scent marking is another ritual in marking their territories.

Distribution: They are widespread in the northern, north-eastern and eastern parts of the sub-region in wooded savannah.

Small and Large Grey Mongooses (opposite bottom)
(Galerella pulverulenta and Herpestes ichneumon)

The small grey mongoose is widespread but small, nondescript and solitary. It has a wide habitat tolerance, which includes forest, scrub, low and high rainfall areas, fynbos, riverine scrub and well-bushed hill and mountain slopes. It feeds mainly on small rodents and is an excellent pest controller.

The large grey mongoose is found throughout Africa in well-watered areas. It is also known as the Egyptian mongoose. It feeds on rodents, birds, amphibians, reptiles and numerous invertebrates. The grey colour is derived from annulated black and white hairs while the small grey mongoose is dark grizzled to almost brown-black.

Distribution: The small grey mongoose occurs in inland Namibia, down to the Western Cape and up to the Free State, Lesotho and into Mpumalanga. The large grey mongoose may overlap in the south eastern section but is generally not widely distributed in South Africa. It occurs in a narrow strip along the south eastern coastal regions and far north eastern regions of the sub-region.

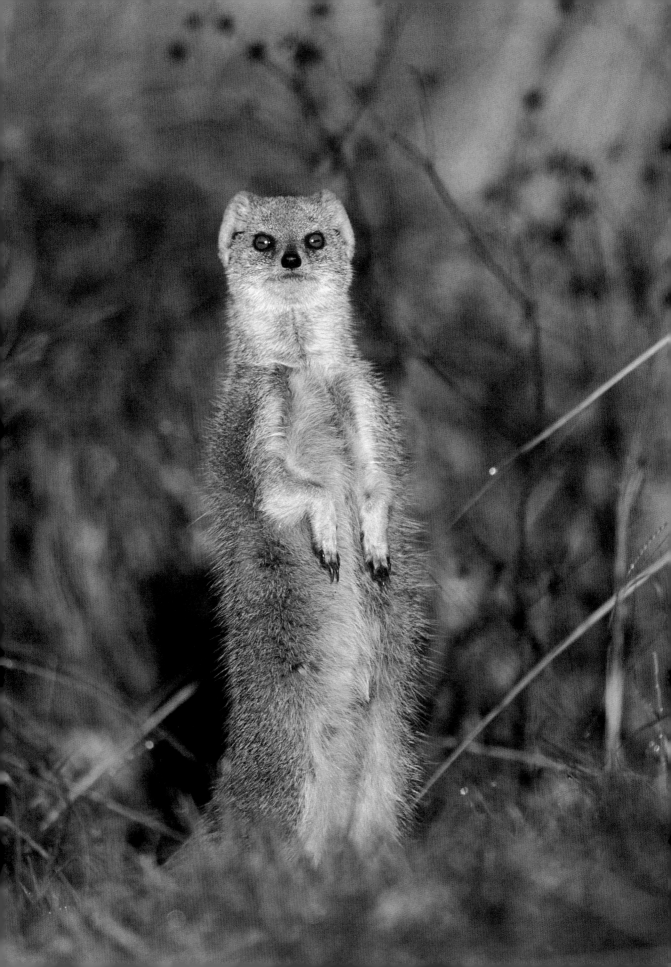

Yellow Mongoose (opposite)
(Canis mesomelas)

The yellow mongoose is a common sighting on game drives in the semi-arid parts of the subcontinent. It is widespread and prefers open, sandy substrate but its colour varies from south to north of the region. In the southern parts it is tawny yellow to reddish yellow with a white-tipped tail, whereas it gradually becomes greyer or even reddish towards the north without a white-tipped tail.

Living in colonies, it occupies warrens with up to 20 other individuals. Tunnels are interconnected underground and suricates and ground squirrels may share such warrens. Individuals defecate on middens close to their burrows and also perform territorial marking to warn intruders. It feeds mainly on insects but will occasionally take mice, scorpions and even birds.

Distribution: They are widespread in the drier parts of the sub-region.

White-tailed Mongoose
(below)
(Ichneumia albicauda)

This large mongoose is a typical eastern bushveld species and is mostly seen alone and at night. It prefers areas with good cover and close to water. The hair on the hindquarters is longer than the hair covering the front of the body. The bushy tail appears white with longer hair at the base, getting shorter towards the tip.

It is often seen in a vehicle's spotlight after eight at night with its white tail standing out, crossing the road or foraging in the undergrowth. When it is cornered or suspects danger, it freezes and lifts its tail and body hair to appear bigger. Although it can run fast over short distances, it depends on an evil-smelling secretion from scent glands as a deterrent. It feeds on insects, preferably termites but also takes frogs, mice, snakes and fruit.

Distribution: It is widespread in the better-watered northern, north-eastern and eastern parts of the sub-region.

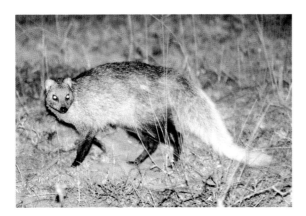

Water or Marsh Mongoose (below)
(Atilax paludinosus)

A marsh mongoose may be encountered early in the mornings or towards evening near streams and rivers and on the fringes of swamps, dams, tidal estuaries and wet vleis. The colour of the long, coarse hair varies from reddish brown to black, with the limbs being a shade darker than the body. The broad head and short muzzle are distinctive. It is usually solitary and shy, feeding on frogs and crabs but also occasionally fish and insects. It does not crunch the carapace of a crab as otters do, but breaks off the pincers, turns it over and eats the meat from the inside before discarding it.

It is a good swimmer, finding its prey mostly under water but also capable of catching insects in flight.

Distribution: The water mongoose is widespread in the eastern wetter parts. of the sub-region along rivers and in wetlands.

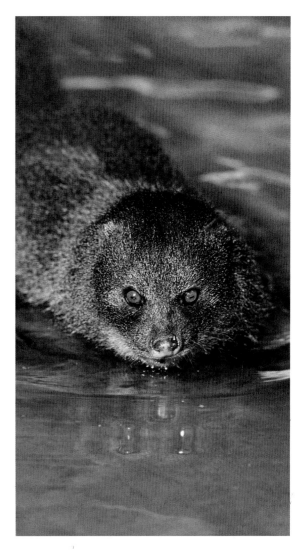

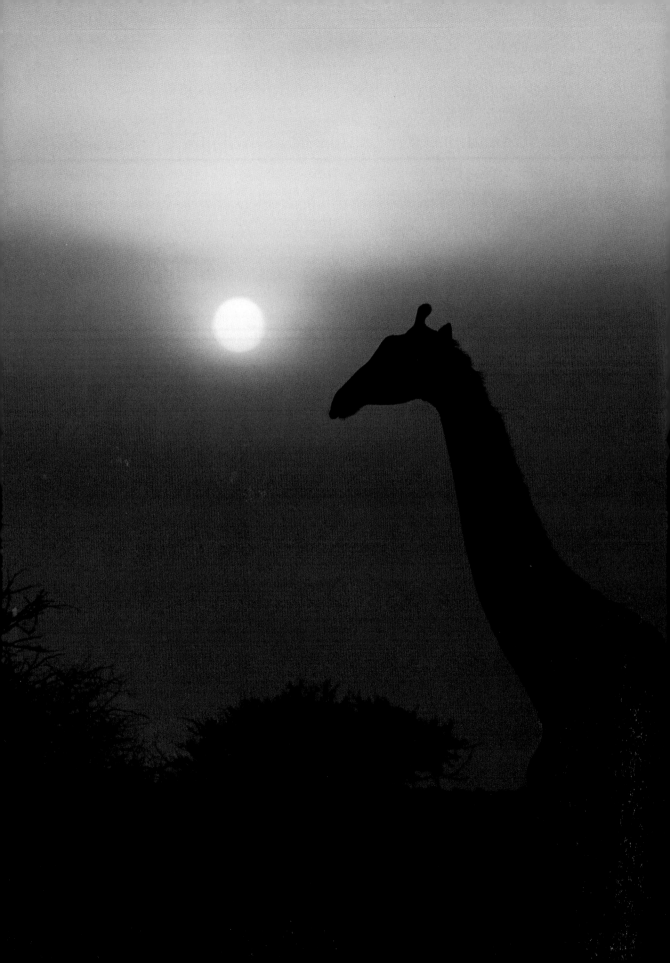

The Giant Herbivores

This chapter is an arbitrary collection of large animals, all of which are plant feeders. Green plants have the unique ability to manufacture carbohydrates from sunlight, water and oxygen. Plant feeders or herbivores utilise this food source directly by feeding on any part of the plant. Plant material is tough and fibrous, containing cellulose that herbivores must digest first before they can access the nutritious parts. A group of microbes are responsible for this action as mammals lack the digestive enzymes required to break down cellulose. In non-ruminants and the bulk feeders of the bush fermentation with the aid of microbes takes place in the hindgut. Unlike the ruminants, they ingest large quantities of low-nutrient food which passes through a longer intestine and is processed more slowly. The largest group, the ruminants, is adapted for foregut fermentation where the stomach has several chambers through which the food has to pass before it enters the rest of the gut.

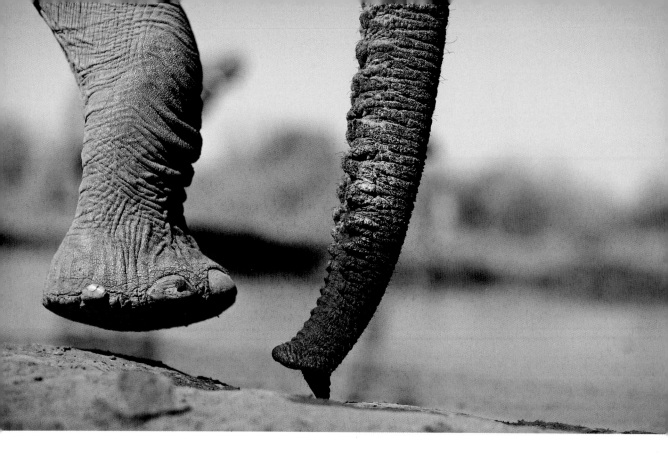

Only one species occurs in southern Africa – the African savannah elephant. The desert elephant of Kaokoland, the Addo elephant of the Eastern Cape, the elephant of the Knysna forests and the bushveld elephant of the lowveld all belong to the same species despite their different habitats.

African Savannah Elephant
(Loxodonta africana)

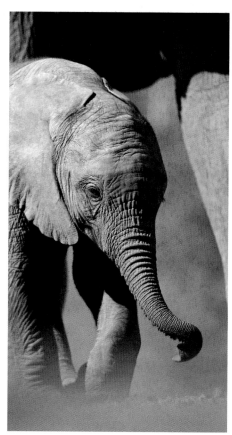

Although they are Earth's largest land animals, they blend perfectly into the bush and can easily be passed by unnoticed. The trunk is the muscular extension of the upper lip, containing the nostrils and two fingerlike projections. They are exclusively vegetarian, feeding on bark, roots, leaves, soft branches, grass and fruit. The tusks are used for stripping bark off trees, digging up bulbs or tubers and together with the trunk, for breaking branches.

Although tusks are a special feature, not all elephants have them. Their presence or absence is genetically determined, and where present, their size increases with age. When using their tusks, elephants will favour one side or the other, as with right- or left-handedness in humans. Elephants may try to scare off intruders by kicking up dust, flapping their ears, 'bush bashing', trumpeting and lifting the trunk – actions all intended to intimidate. Serious charges are silent, with ears pinned back and trunk lowered.

Distribution: African elephants are common and naturally occurring in the northern parts of the sub-region from east to west, along the eastern border of Botswana and adjacent Zimbabwe, the north-eastern parts of South Africa down to areas in KwaZulu-Natal and parts of Mozambique, as well as areas within the thickets of the Eastern Cape Province.

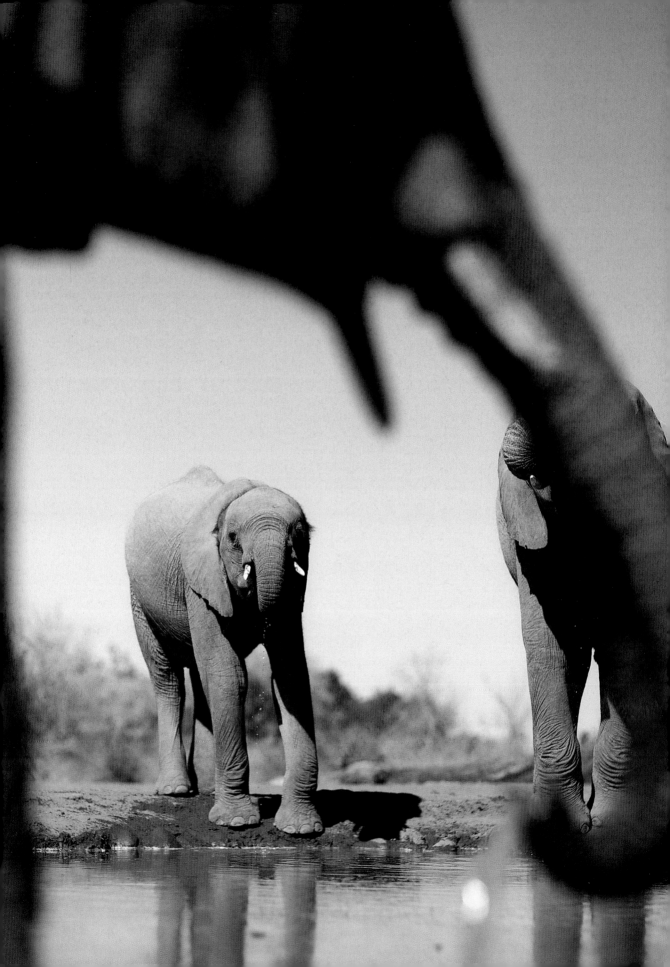

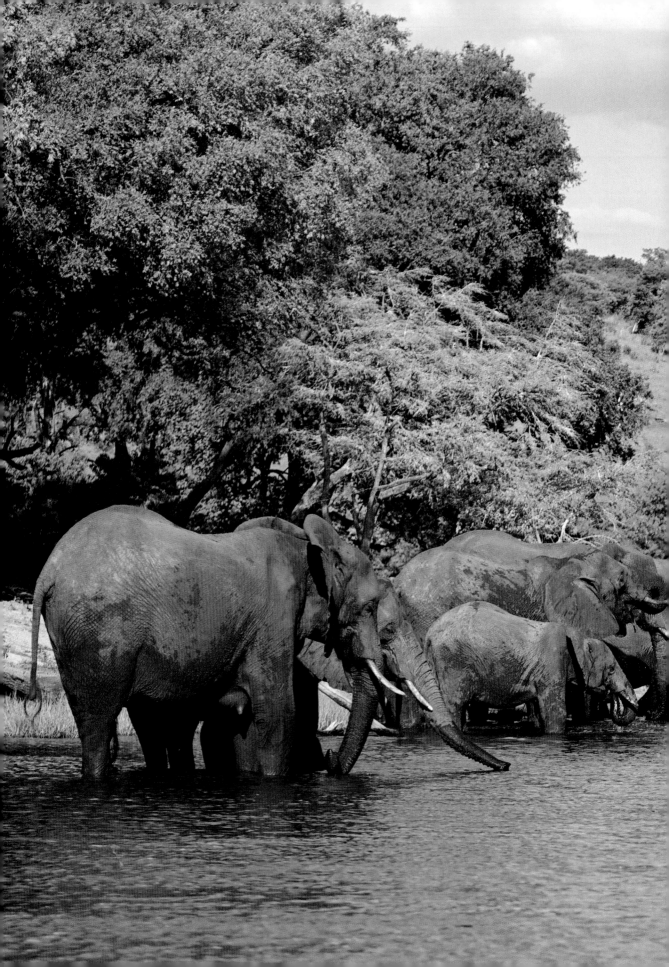

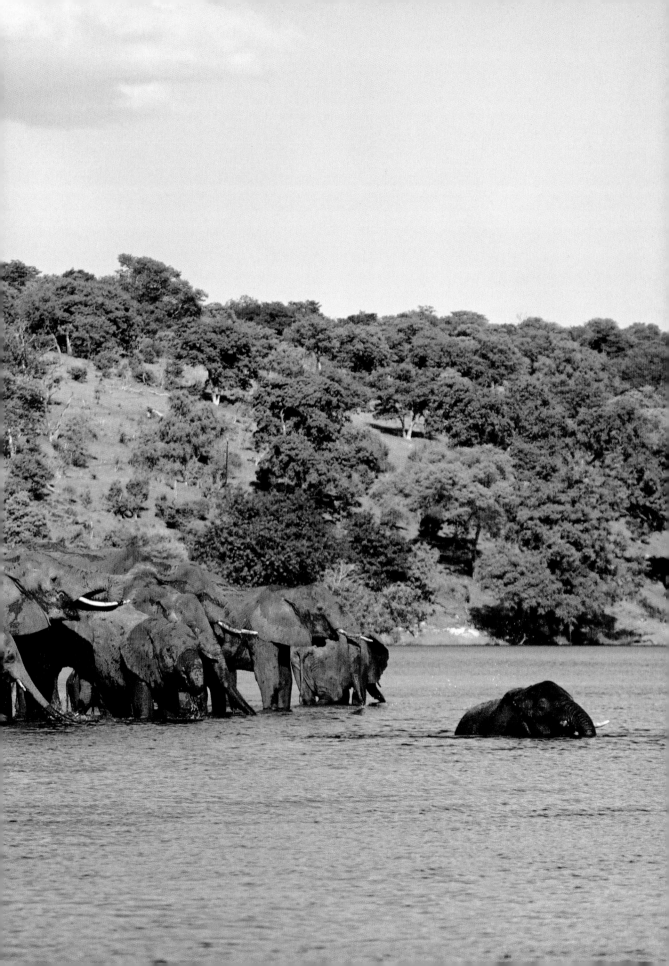

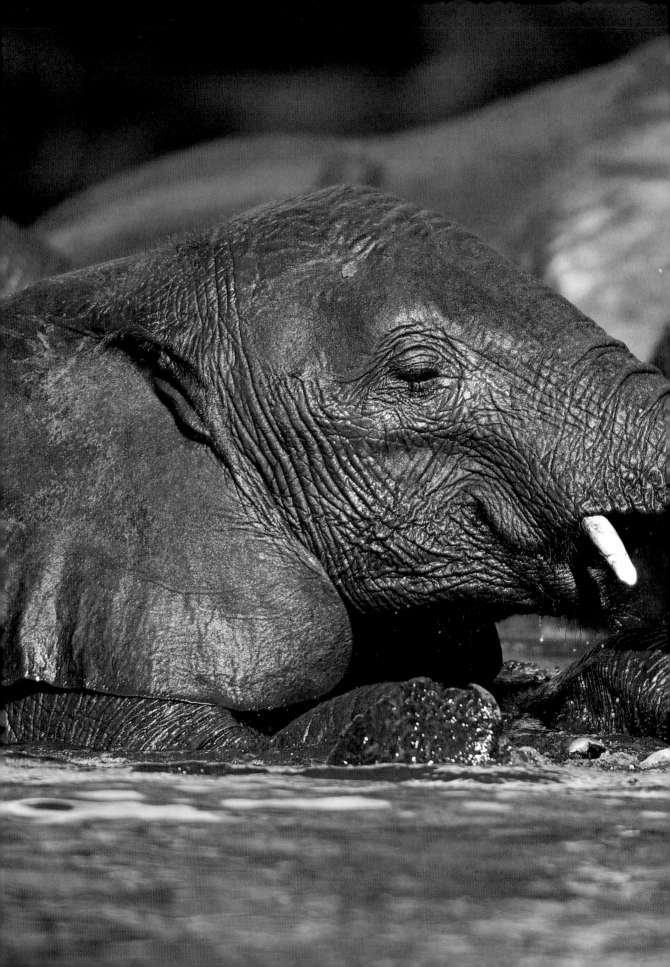

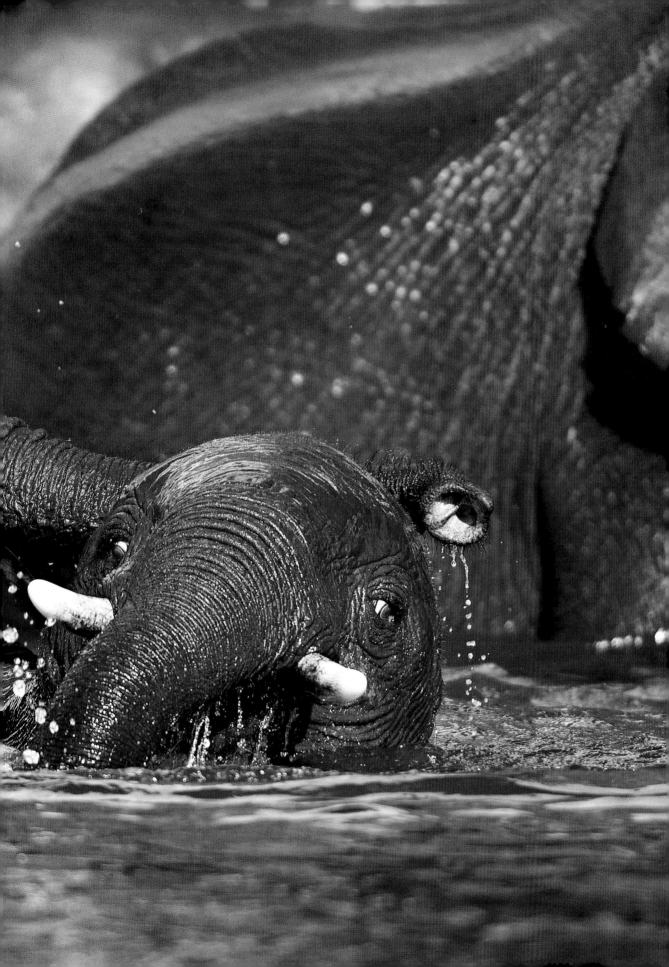

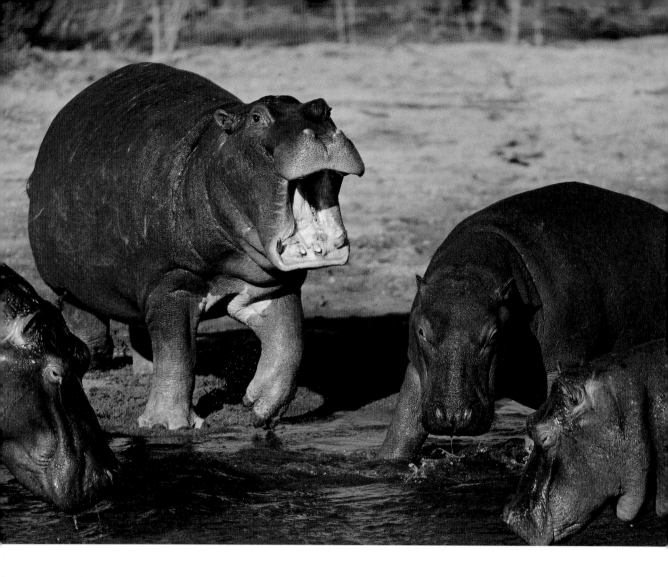

The hippopotamus has only one other relative, the dwarf hippopotamus that occurs only further north in Africa.

Hippopotamus
(Hippopotamus amphibius)

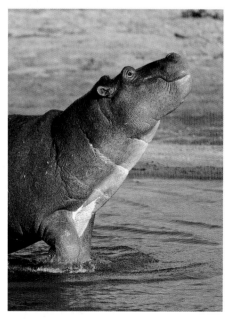

Look for hippos resting in water or basking on the bank close to their waterhole during the day. They usually have their preferred places. The water must be deep enough to cover their bodies and prevent them from overheating.

At night they are lone grazers, consuming up to 40kg per adult. Although hippos in Africa kill more people than lions or crocodiles do, they are only dangerous when they feel threatened or their space is invaded. Their agility and speed must never be underestimated – they can run faster than humans. A threat display of yawning, showing their long razor-sharp canines, usually discourages aggressors.

Distribution: Although patchy populations occur in Zimbabwe, hippos are fairly common along the Cunene, Okavango and Zambezi rivers. They are also widespread in Mozambique and well represented in the eastern parts of South Africa.

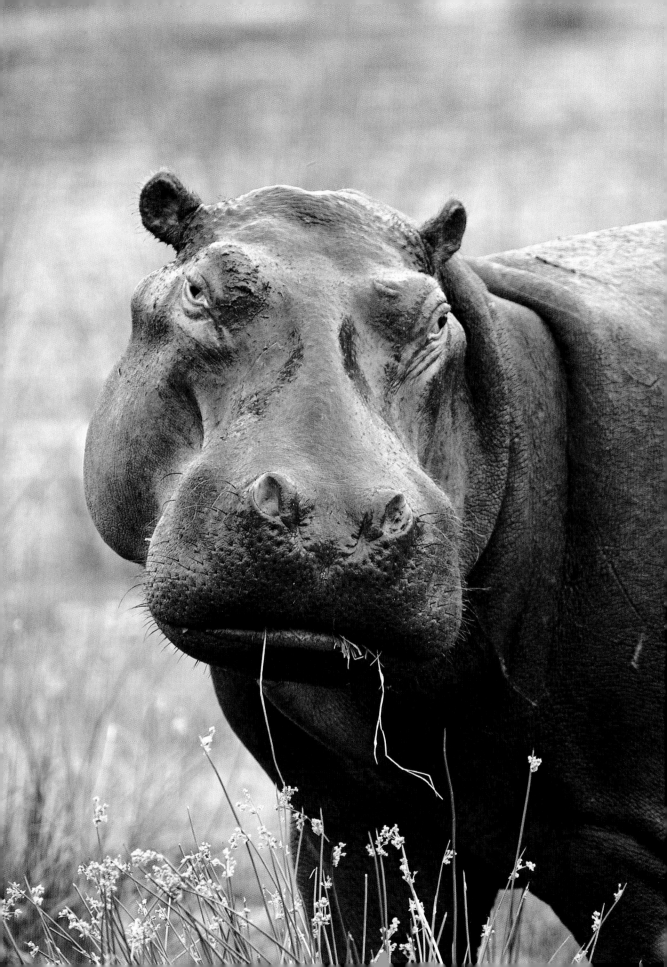

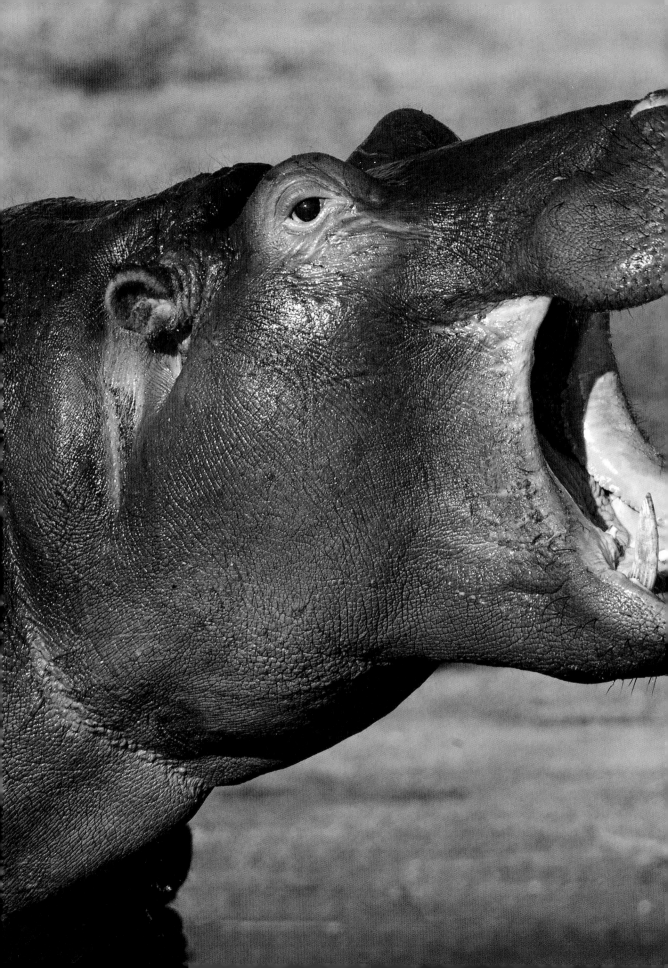

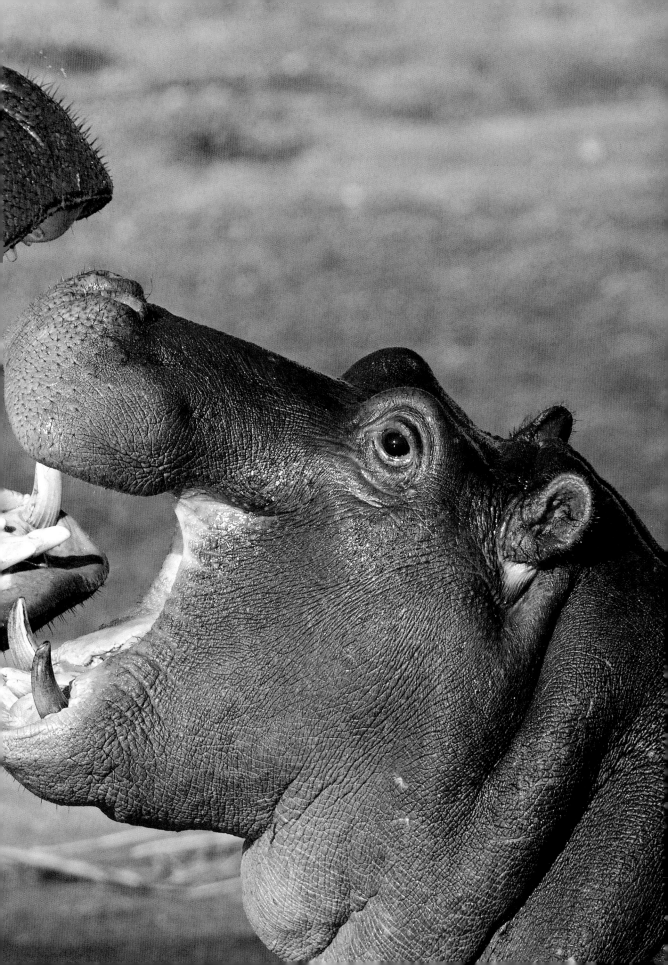

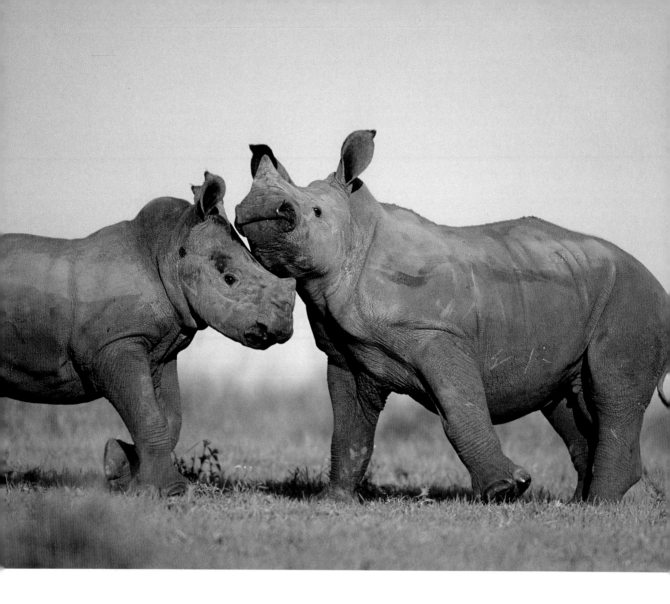

Rhinoceroses and zebras share at least one common characteristic – they are odd-toed and the main mass of the body is borne on the third digits of the feet – either three toes are in contact with the ground, as in the rhino, or a single toe, as in the zebra. The middle toe is larger than the others and the plane of symmetry of the foot passes through it. In some odd-toed animals only this one digit remains, but in most there are three digits on the hind foot and three or four on the forefoot. All are herbivores that rely on hindgut fermentation to break down the cellulose in the plant material. This process starts in the junction between the small and large intestine in the blind sac called the caecum where microbes start the fermentation that continues in the large intestine.

White Rhinoceros
(Ceratotherium simum)

Look for white rhinos in areas that include grassland with trees, water and mud wallows. They are the second heaviest of all land mammals and spend most of their time grazing.

There are several ways of distinguishing between the two kinds of rhino. The white rhino has a square upper lip for grazing; pointed, often tufted ears; a flattish back with a slight hump near the middle; an elongated head, which it often holds down; and when alarmed, it curls its tail and lifts it above its back. A white rhino calf will usually run ahead of the mother.

Distribution: Although formerly widespread throughout the savannah parts of the sub-region, numbers have dwindled almost to extinction. Saved by special conservation efforts, the species is now re-established in much of its former range. Poaching, however, still remains a severe threat.

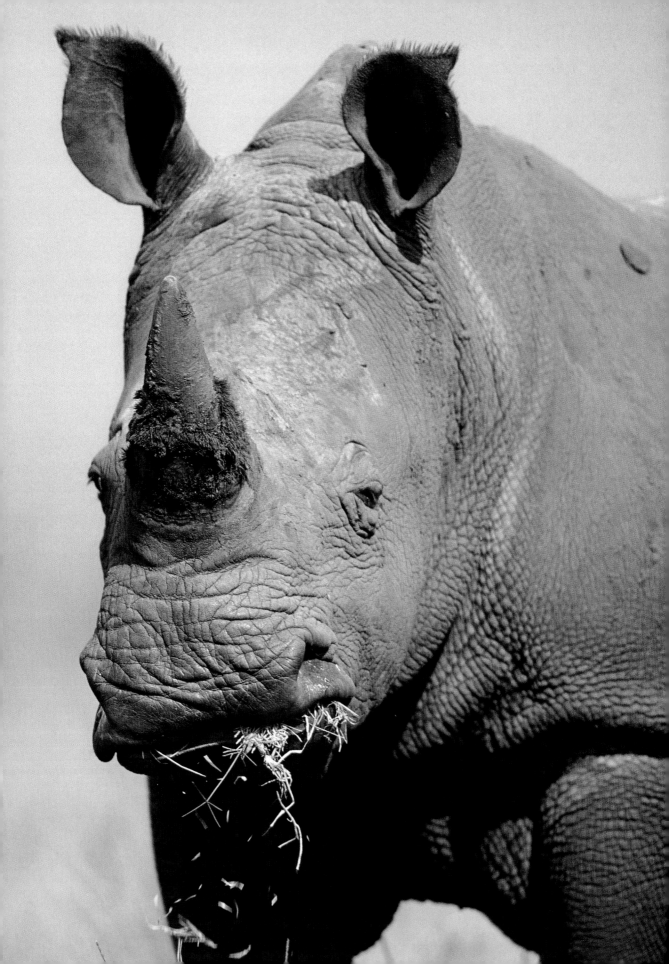

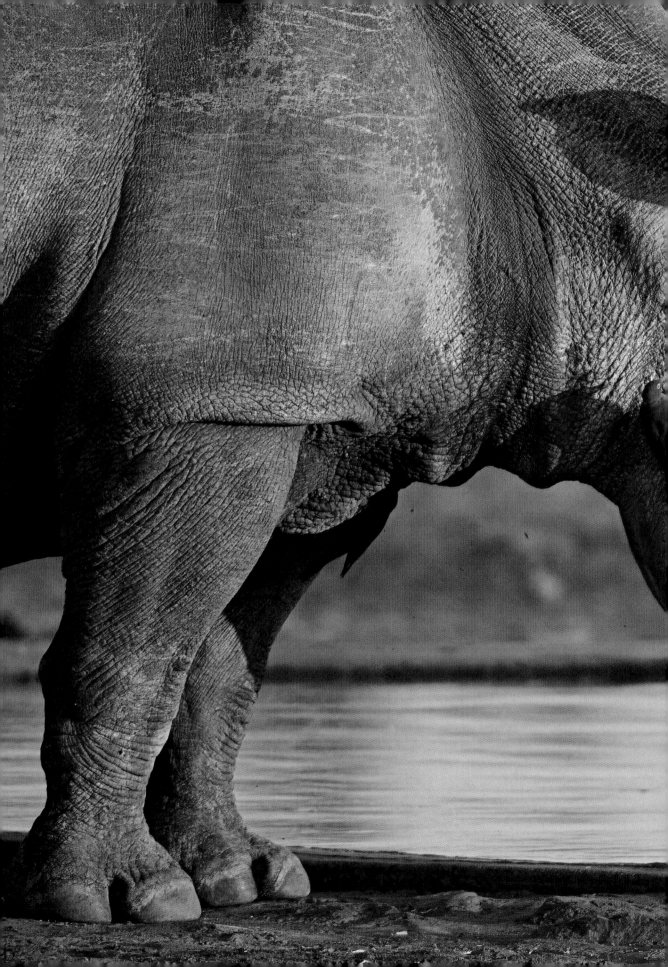

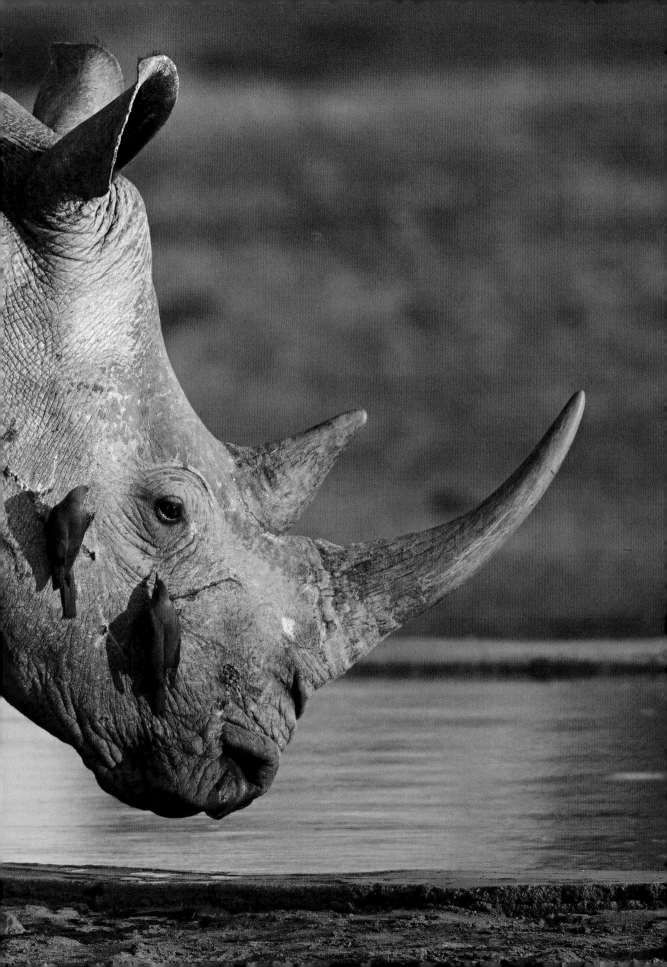

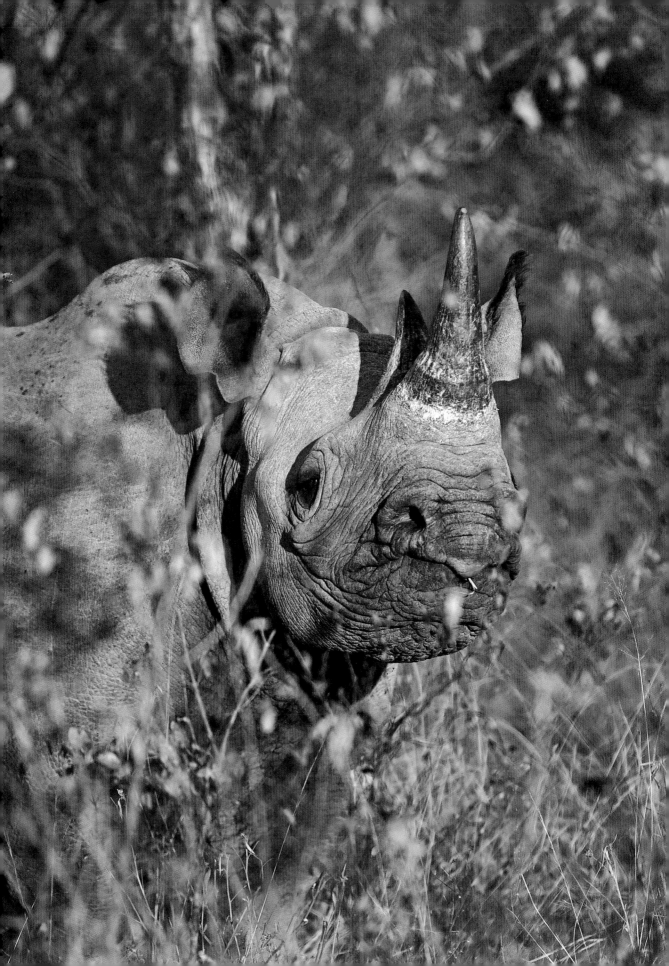

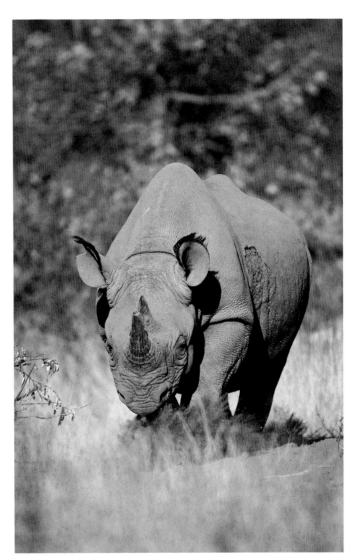

Black Rhinoceros
(Diceros bicornis)

The black rhino is likely to be found in dense bush or thickets, since it is a browser. It also requires access to water and mudwallowing, as well as mineral licks. Look out for black rhinos at waterholes. It differs from its close relative as it has a pointed, prehensile upper lip for browsing; rounded ears; a concave back; a rounded head, which it often holds up; and the calf usually runs behind the mother. The tail is held straight and vertical when the animal is alarmed. Lesions on the side of the body are a natural phenomenon and are caused by parasites.

Distribution: Black rhinos occur mainly in Namibia, Zimbabwe and northern to eastern South Africa. Only a few remain in Botswana and Mozambique. There are two subspecies in the sub-region – the larger, more arid-adapted subspecies found in semi-arid parts such as in Namibia and the most numerous subspecies of the eastern savannah. This is an endangered species severely threatened by poaching.

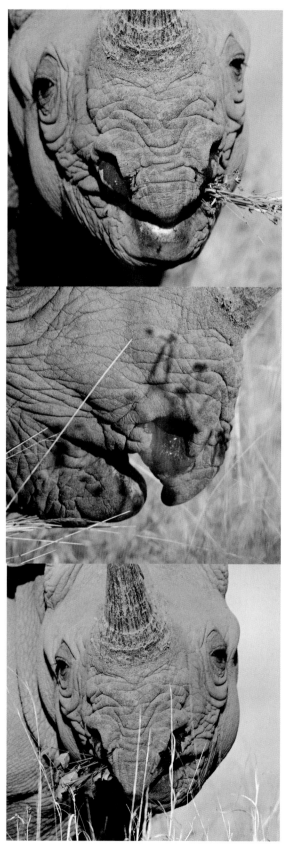

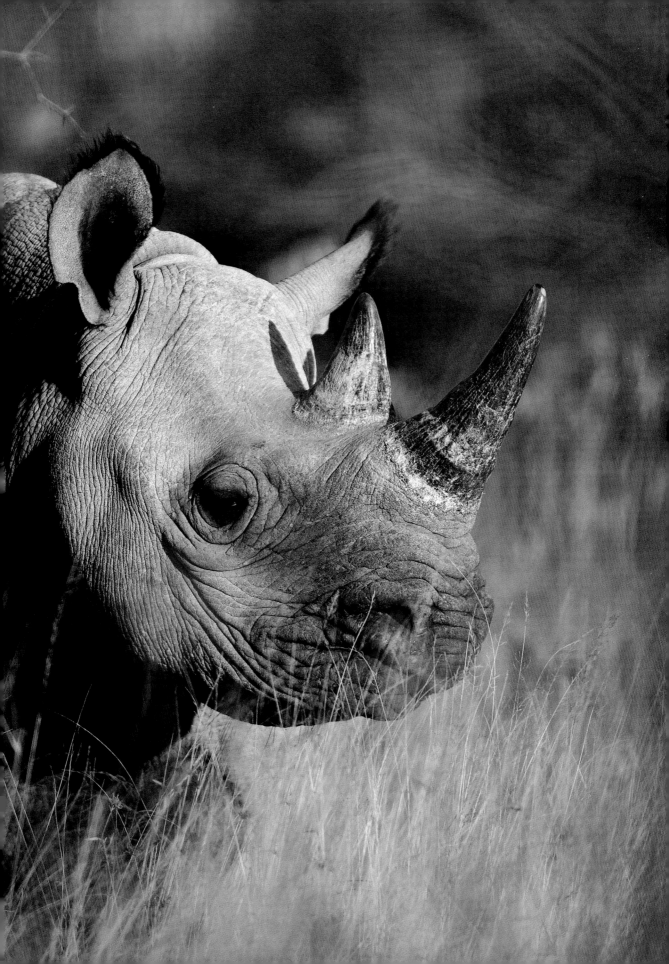

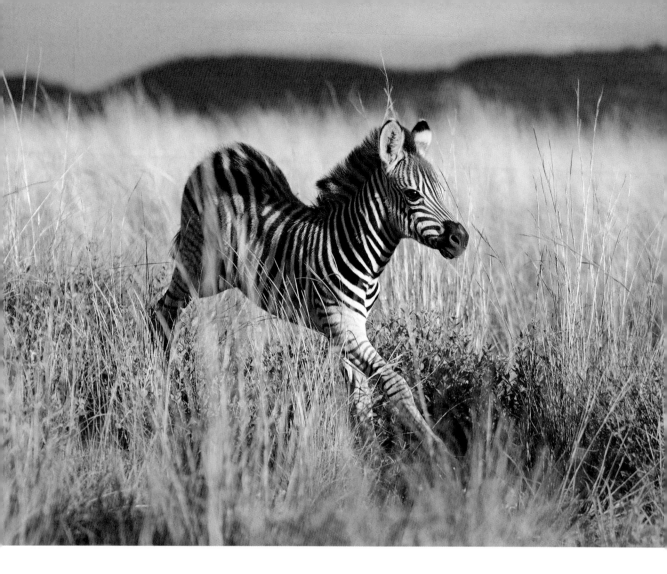

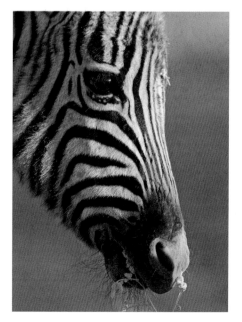

Plains Zebra
(Equus quagga)

Look for zebras on grasslands, plains and open or lightly wooded areas, close to water. The males and females look alike and are often found in large aggregations at water holes. Note that the lower legs and belly have no stripes and that shadow stripes occur between the black stripes. No two zebras have exactly the same stripe pattern.

Zebras often rest in pairs with their heads placed on the other's back, facing in opposite directions. This enables a pair to watch for danger in all directions and brush flies off each other's face.

Distribution: In Namibia and Botswana the plains zebras are confined to the north and north-eastern parts with populations occurring as far south as the Thuli Block and across the border into the western and central parts of Zimbabwe. In Mozambique they occur mostly towards the west of the country and are absent from the more heavily populated sections in the east and the extreme south. In South Africa and Swaziland they occur naturally in the greater Kruger area and south into Swaziland and beyond. Populations have been introduced into many private and other game reserves with suitable habitats.

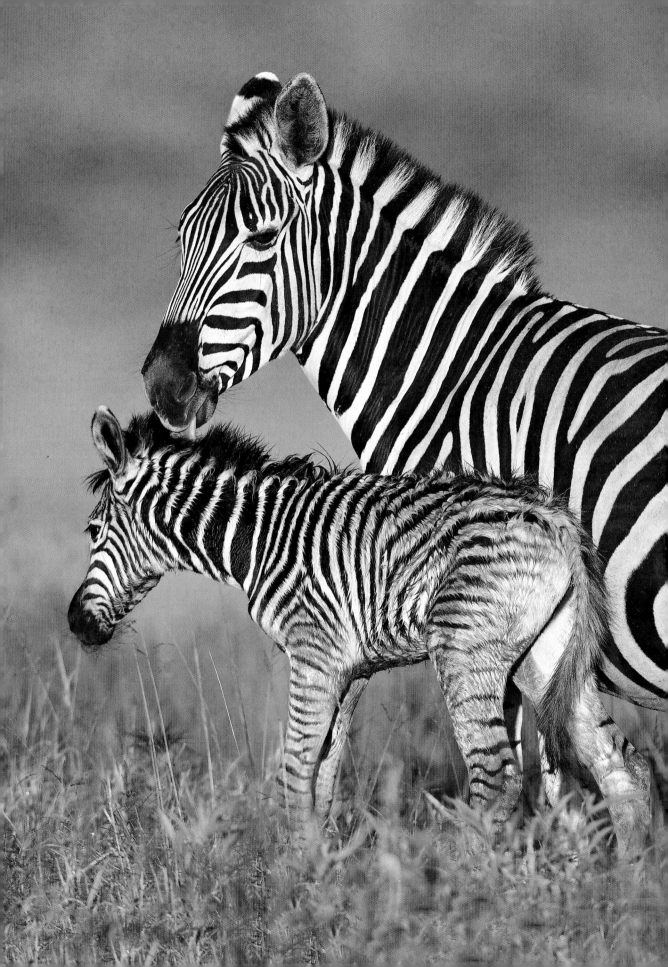

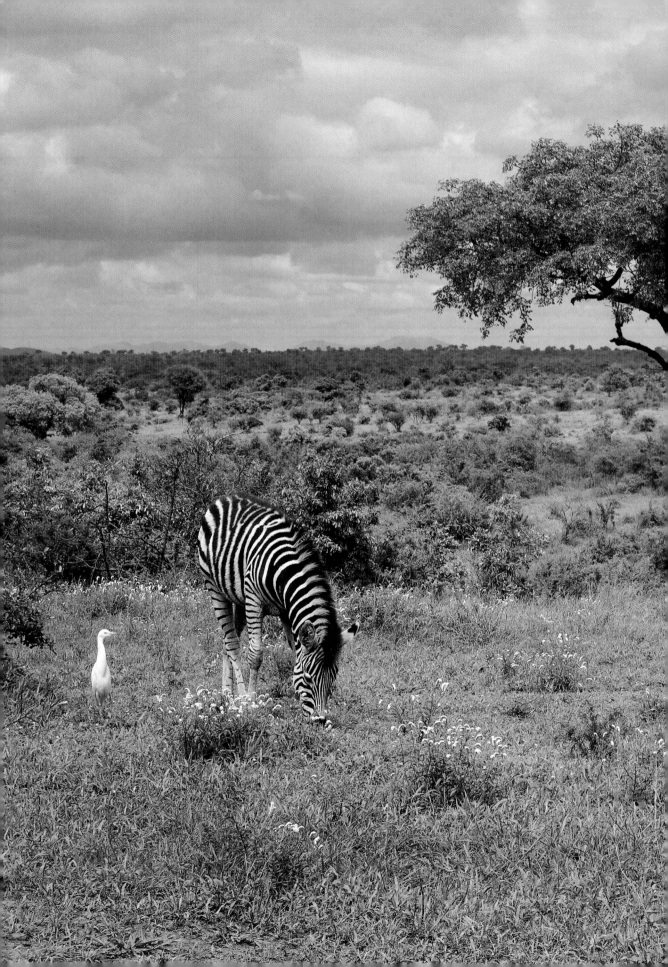

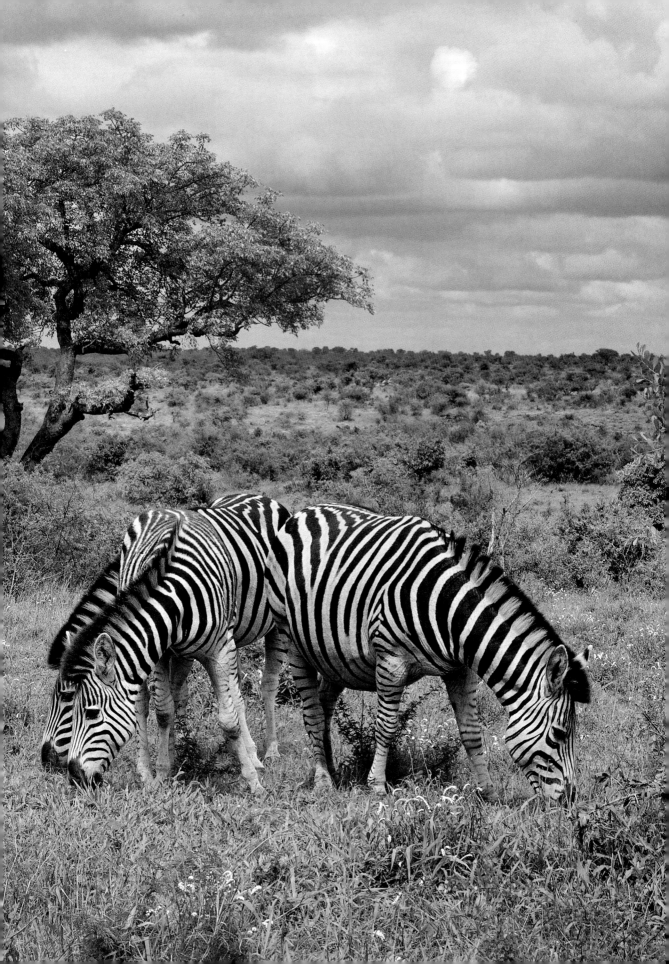

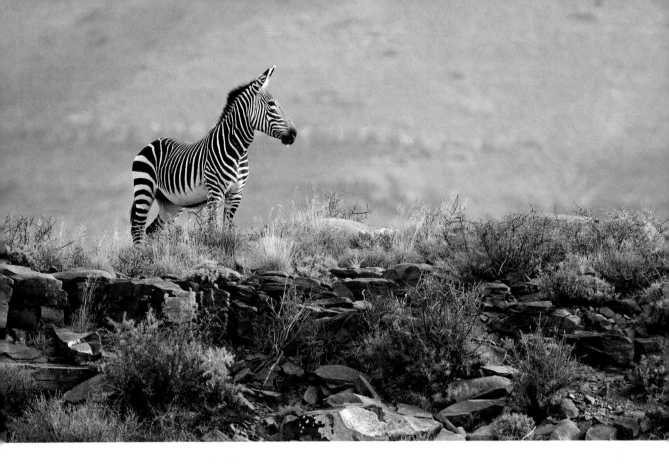

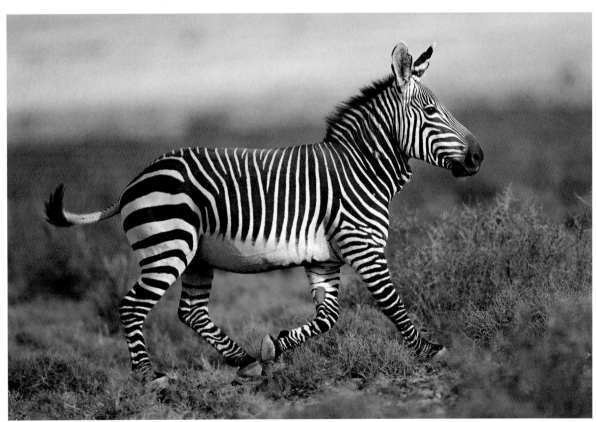

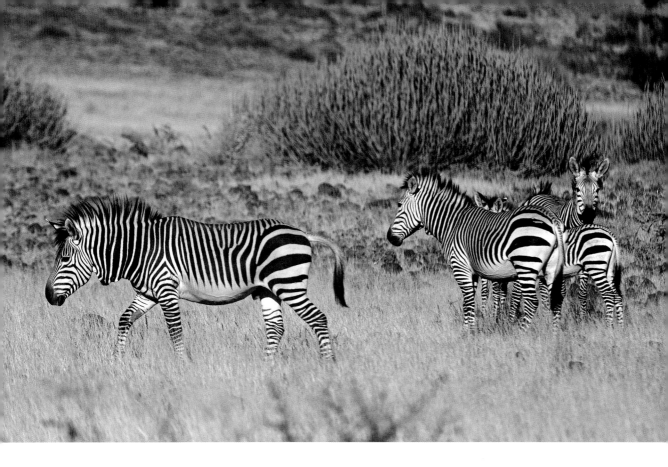

Cape Mountain Zebra
(opposite)
(Equus zebra zebra)

In the 1930s the mountain zebra was saved from extinction by the proclamation of the Mountain Zebra National Park near Cradock. The animal occurs at altitudes of about 2 000m and needs grass for grazing, a plentiful water supply and nearby kloofs and ridges for shelter.

The mountain zebra is similar to the plains zebra, but the black stripes on the rump are much broader than on the rest of the body. The first three are without a shadow stripe. The legs are striped to just above the hooves and the stripes stop at the lower parts of the flanks. The underparts of the body are white with a black longitudinal stripe on the middle of the belly and chest. It has a distinguishing gridiron pattern just above the base of the tail. The muzzle is black and just behind it, on the top and sides, the hair is suffused with orange. The ears are rounded and have black margins and white tips and it has a dewlap below the head.

Distribution: In years gone by, the Cape mountain zebra was widely distributed in the mountain ranges of the Eastern and Western Cape. Numbers dwindled to near-extinction, but due to conservation efforts, they are presently flourishing in the Mountain Zebra National Park and have been re-established in other parts of their former range.

Hartmann's Mountain Zebra (above)
(Equus zebra hartmannae)

This zebra occurs in Namibia in the transitional zone between the mountainous inland plateau and the Namib Desert. The more nomadic Hartmann's mountain zebra also prefers mountain habitats with enough grass for grazing, access to water and nearby kloofs and ridges for shelter. When food diminishes in the winter months, it moves to the flat valleys.

The Hartmann's zebra is very similar to the Cape mountain zebra but is slightly larger and has dark and light stripes of more or less equal width on the rump. Similar to the Cape mountain zebra, a black longitudinal stripe on the middle of the belly and chest as well as a dewlap, is present.

Distribution: Closely related to the mountain zebra, this subspecies occurs in patchy distributions from the northern sector south of the Cunene River down to the extreme southern part of Namibia.

Subspecies are not usually given different colloquial names but in the case of the two mountain zebra subspecies, this has been done to differentiate between the two. The ranges of the two subspecies overlap in places and hybridisation remains a threat, since they belong to the same species and interbreed easily.

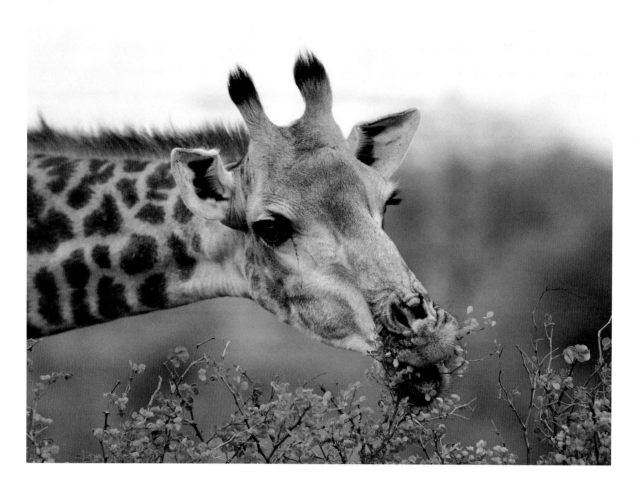

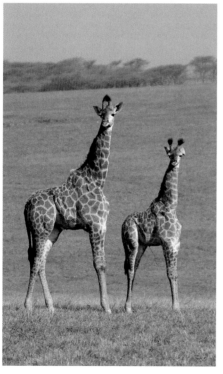

Ruminants are a large group of mammals that feed on plant materials rich in cellulose and rely on foregut fermentation to aid in the digestion of cellulose. There are two main lineages: the giraffes and the bovids (buffalo and all antelopes). All ruminants are two-toed mammals.

Giraffe

(Giraffa camelopardalis)

Look for giraffes where there are food trees for them to browse. They are visible from afar since they are the tallest mammals and the largest ruminants. They have extremely long tongues (45cm) and can reach foliage that is beyond the reach of other browsers. Despite its great length, the giraffe's neck has only seven vertebrae like all other mammals.

Long ago, people thought a giraffe was a cross between a camel, because of the way it walked, and a leopard, because of its markings. This led to the word *camelopardalis*. The Arabs called it Zarafa and the Ethiopians Zurafa. Eventually, taxonomists named it *Giraffa camelopardalis*.

Distribution: At present they inhabit areas in northern Namibia, northern and central Botswana, north and north western parts of Zimbabwe but are absent to the east and in the Zambezi Valley. They occur in the Gaza area of Mozambique and greater Kruger area in South Africa. They have been introduced widely to various parks in KwaZulu-Natal and other game reserves with suitable habitat, including the Kgalagadi Transfrontier Park.

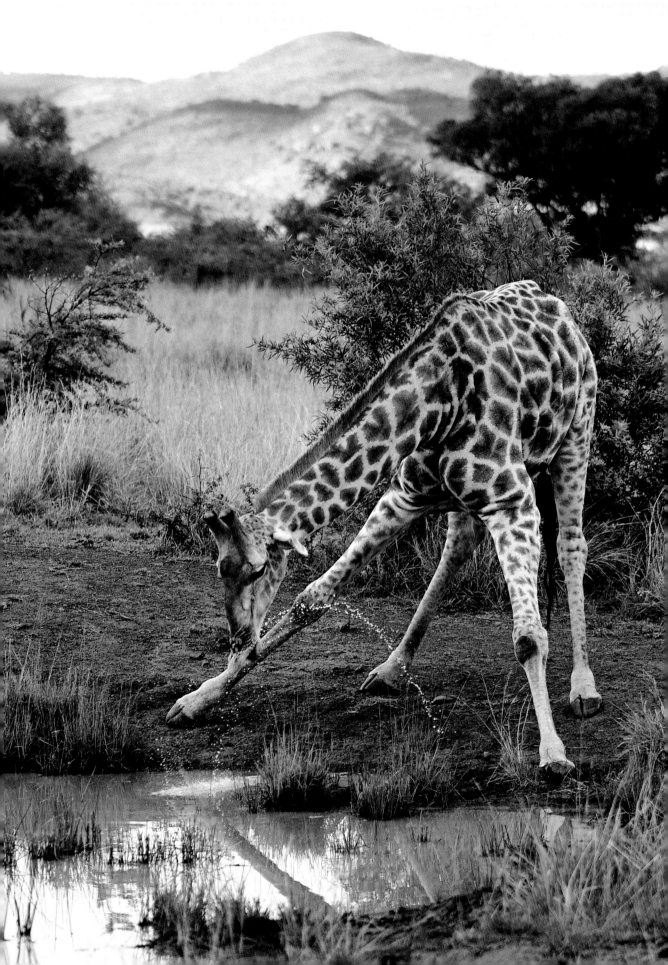

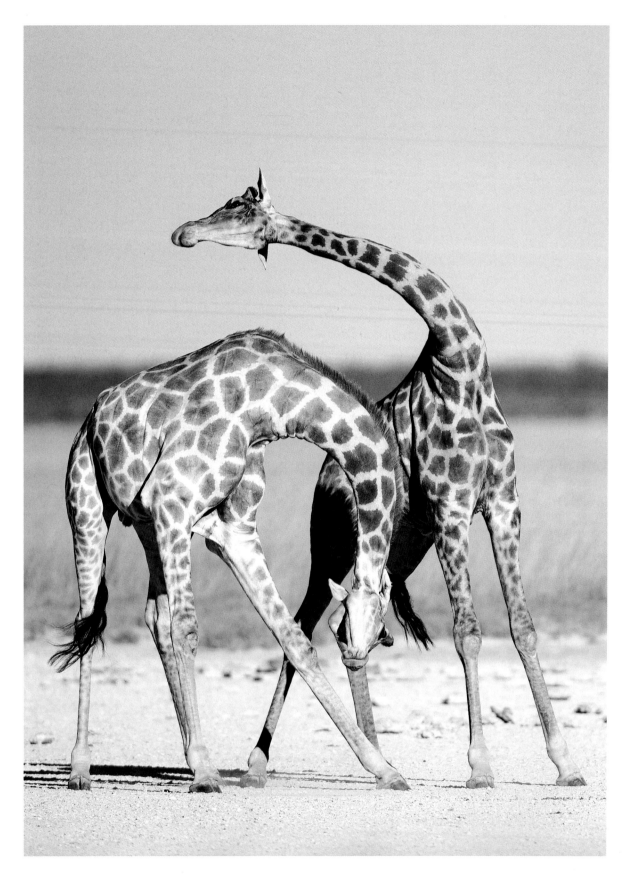

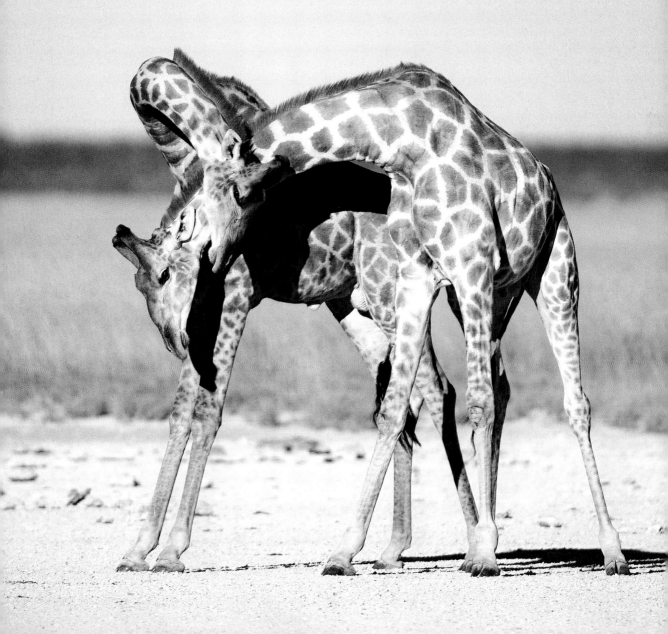

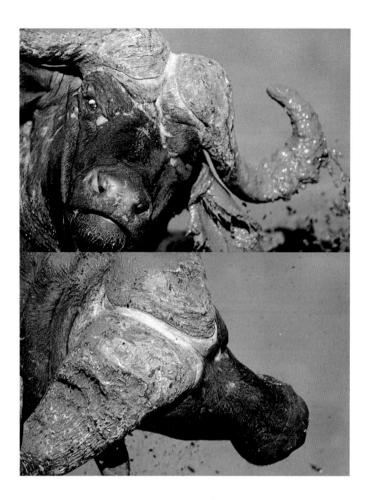

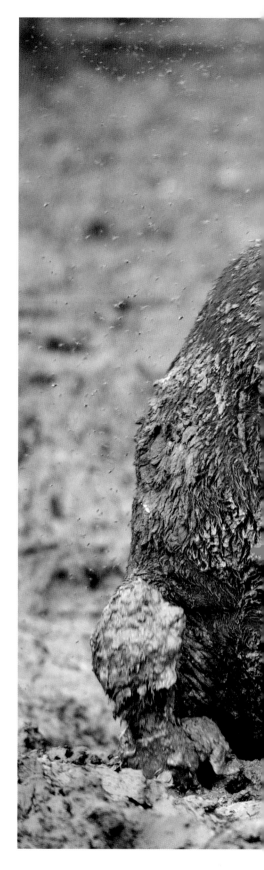

Buffalo and all antelopes are grouped together as bovids. Cloven-hoofed ruminants, they have another characteristic in common – all have unbranched bony horns (at least in the males), which are permanently covered by a sheath of keratin. The keratin sheath makes them hollow-horned.

African Buffalo
(Syncerus caffer)

Buffaloes are often encountered on their way to water after the night feed. They require large space, are bulk grazers and they feed on a variety of grasses of various lengths. They prefer open areas, are nomadic and need water every day.

The buffalo lifestyle requires vigilance of all individuals. Females need horns to defend themselves and their offspring against predators, or at least to deter them. These animals are quick-tempered and will not hesitate to use their massive horns to ram and gore if they perceive any threat.

Distribution: Their current range is fragmented and they are mostly confined to large protected areas within the savannah. Drought, disease, habitat destruction and hunting are factors influencing buffalo distribution. Only a small percentage of the entire buffalo population is disease free. Efforts are being made to reintroduce disease-free buffalo to safe disease-free former ranges.

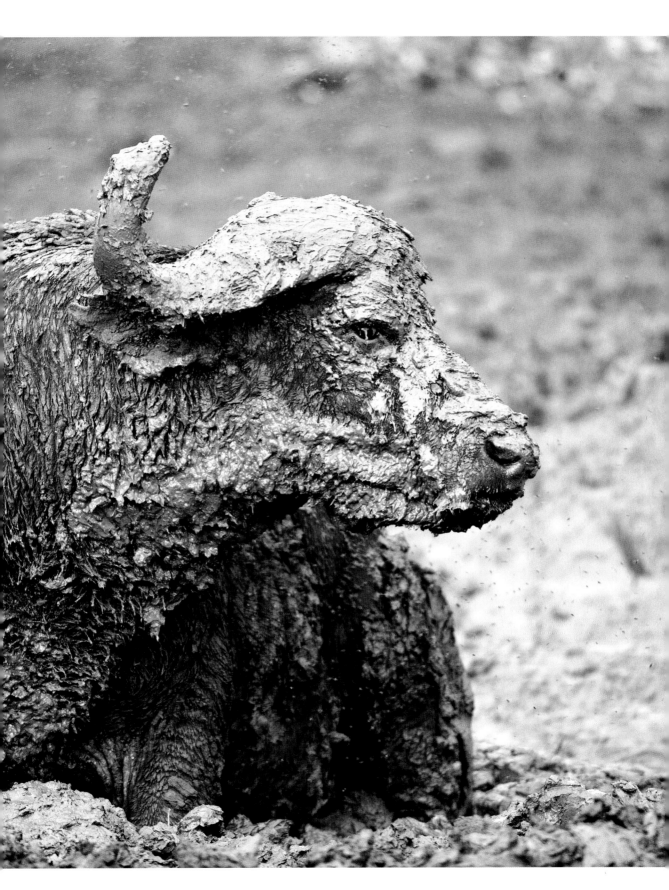

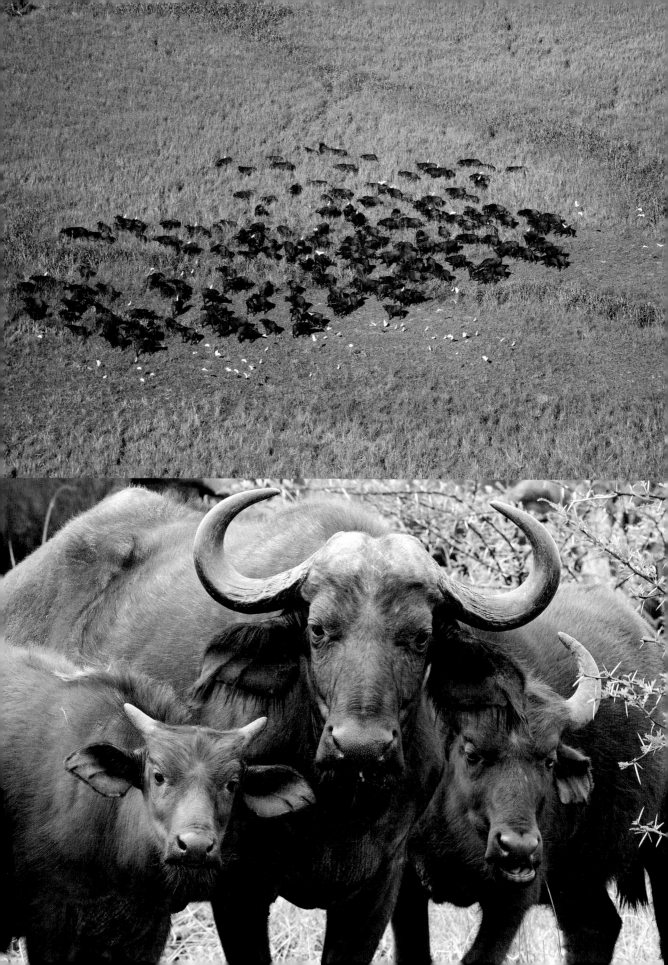

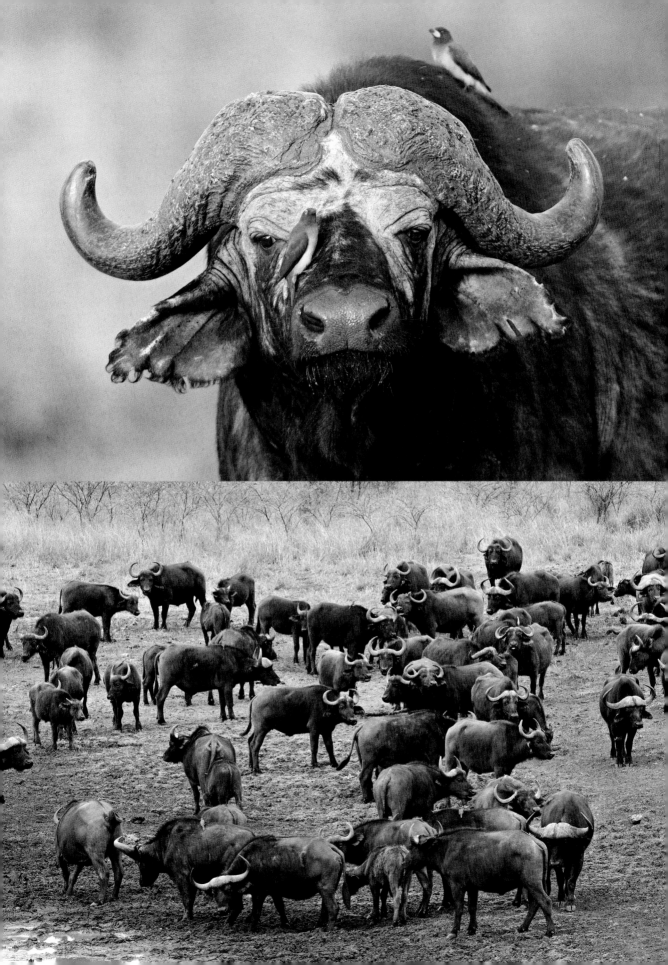

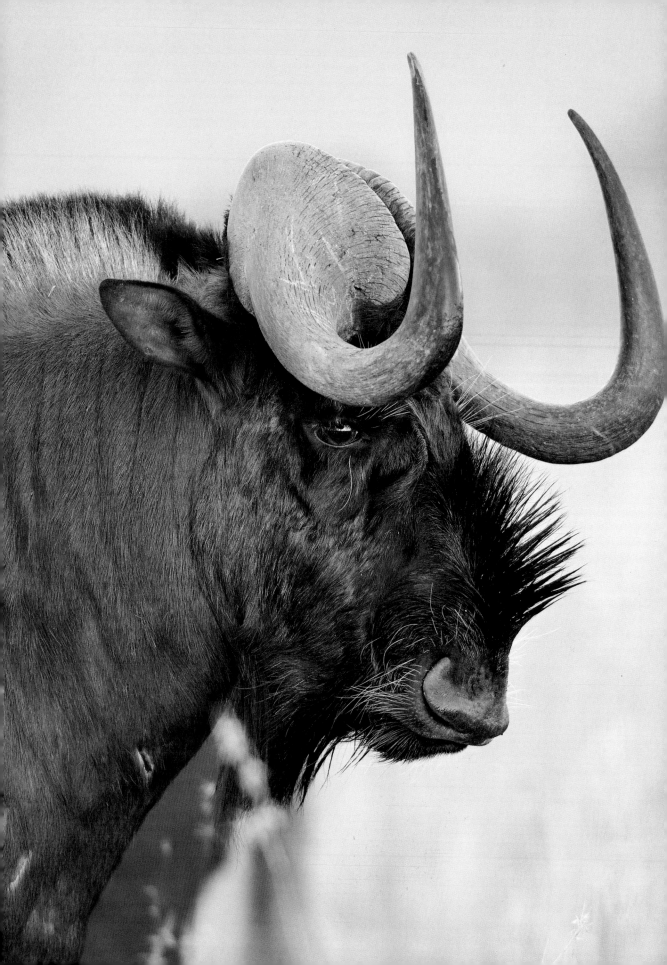

The Antelopes

Antelopes are abundant in Africa and occur in a wide range of habitats. Being bovids, they are even-toed hoofed ruminants with bony horns. In addition, they are an important link in the food chain since killers and scavengers rely on them as a source of food. Although they vary in body shape/type, mass and size, they all have to avoid predators. Keen senses are important. In all the antelopes, the eyes are placed at the sides of their heads giving them a wide radius of vision as opposed to the binocular vision of their enemies. In addition, they have horizontally elongated pupils to increase their field of vision. An acute sense of smell and hearing helps them to detect danger, especially at night. But senses also assist in effective communication amongst members of the same species, warning each other of imminent danger.

The earthen coat colours help in various ways with camouflage – many have darker upper and lighter to white underparts. Since most predators are colour-blind, antelope easily blend into the background.

Many antelope are fast runners, some have an amazing leaping ability and others can clear obstacles of 2.3 metres or more.

Although all males have horns, they are rarely used to defend themselves against predators, and are more often used in ritual horn-clashing combats when males fight for dominance and access to females.

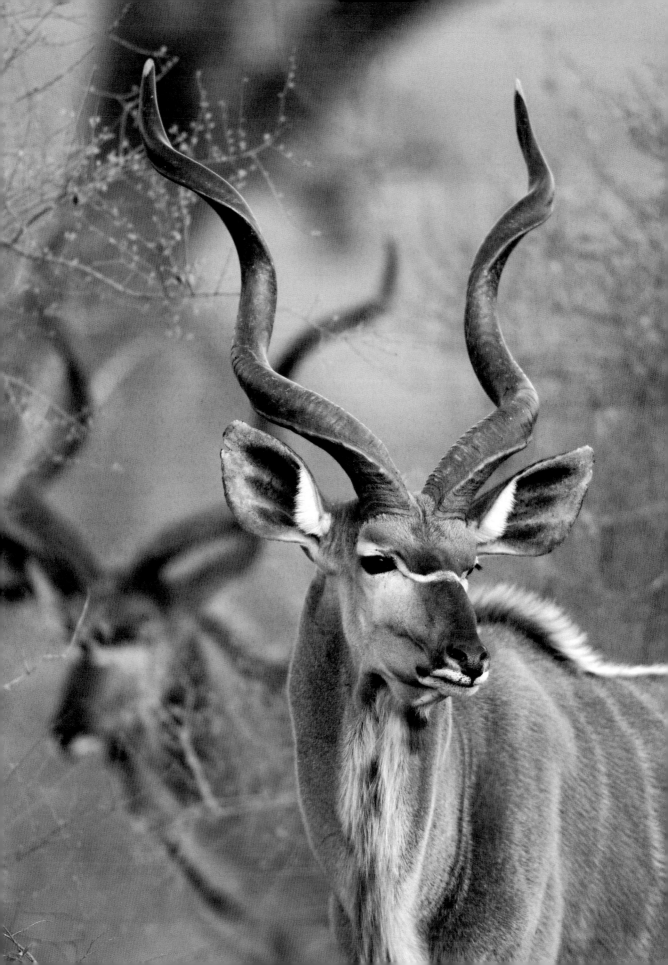

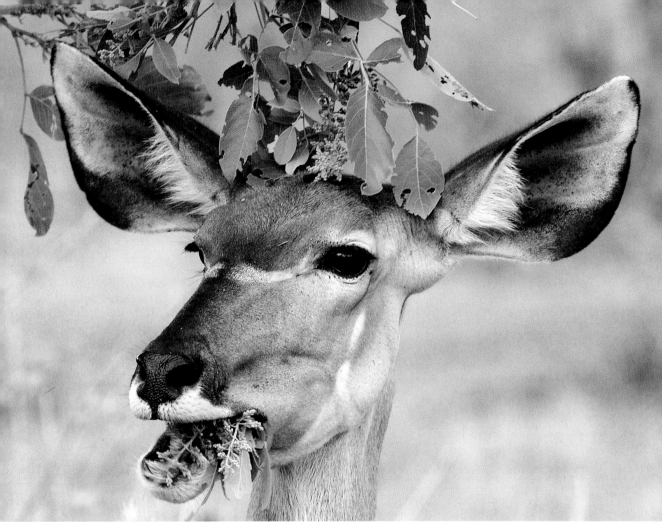

Female

Sitatunga, kudu, nyala, bushbuck and eland all belong to the group of spiral-horned antelopes. They are medium to large animals with white faces and body spots or stripes. The males are larger than the females and have twisted horns (some females may develop horns too).

Greater Kudu
(Tragelaphus strepsiceros)

Kudus are found in places where there is dense cover, such as scrubby woodland. They prefer rocky, broken terrain. They are browsers and are well concealed by their colouring. The males of this second-tallest of antelope have the most spectacular horns, while the smaller females are hornless. They display the huge cupped ears of the species to best advantage.

Despite being long and twisted, the horns never get in the way when the antelope flees from predators – it simply lifts its chin so that the horns lie flat at shoulder level. They are high jumpers, clearing fences up to 2.5m high.

Male

Distribution: The greater kudu is common throughout the savannah or bush-veld areas and has even extended its range westwards into parts of the Karoo. It is absent from desert and forest.

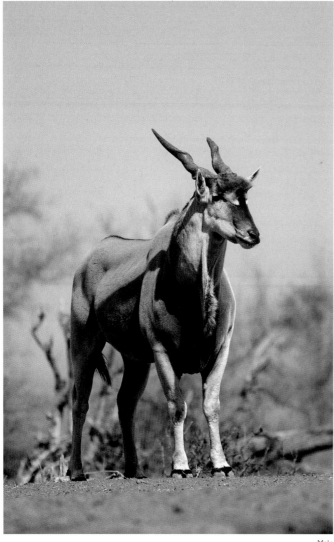

Male

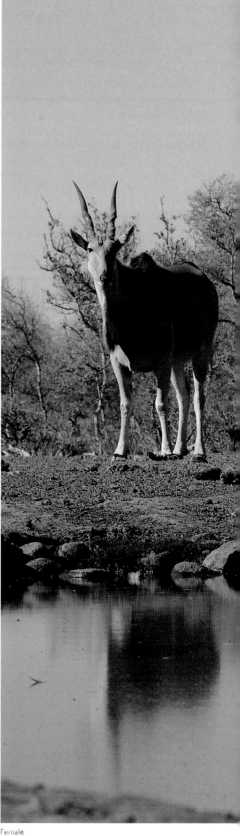

Female

Eland

(Tragelaphus oryx)

It is difficult to predict where this antelope will be found since it is so nomadic. It is one of the most adaptable of all antelope and is the largest one in Africa, weighing up to a tonne or more. The characteristic dewlap is enormous and bearded in the males.

It has a cloven hoof, which is well adapted for covering long distances. Due to the animal's springy gait, massive weight, and the hoof design, the hoof splays out when walking and snaps shut when the foot is lifted.

Distribution: Initially abundant and widespread, eland now only occur in northeastern Namibia, Botswana (but absent in Okavango Delta), north-western and southeastern Zimbabwe, southern Mozambique and parts of northeastern South Africa with populations in the Drakensberg and the Kgalagadi TFP. They have lately been reintroduced into several conservation areas within their former range.

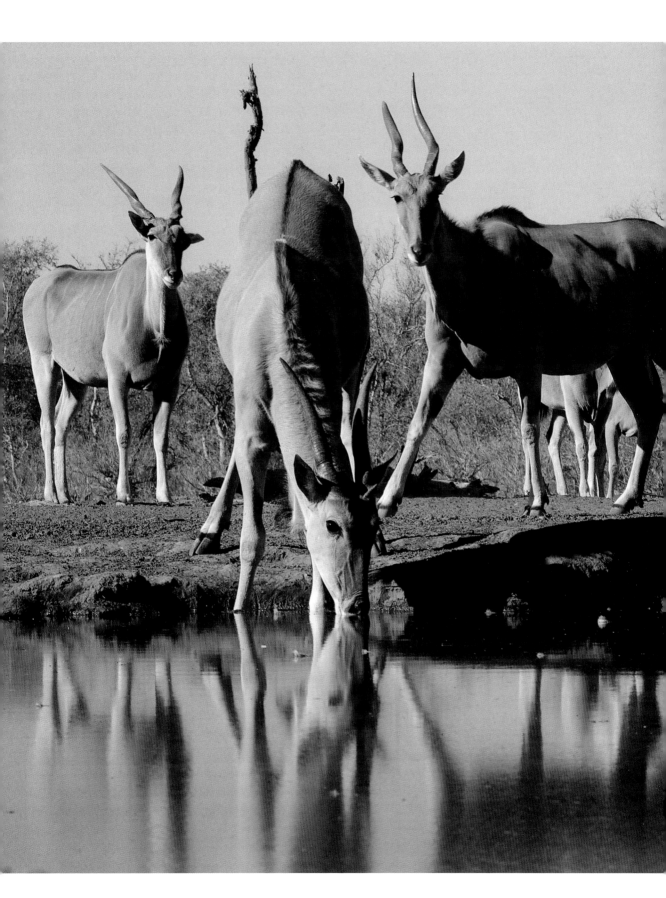

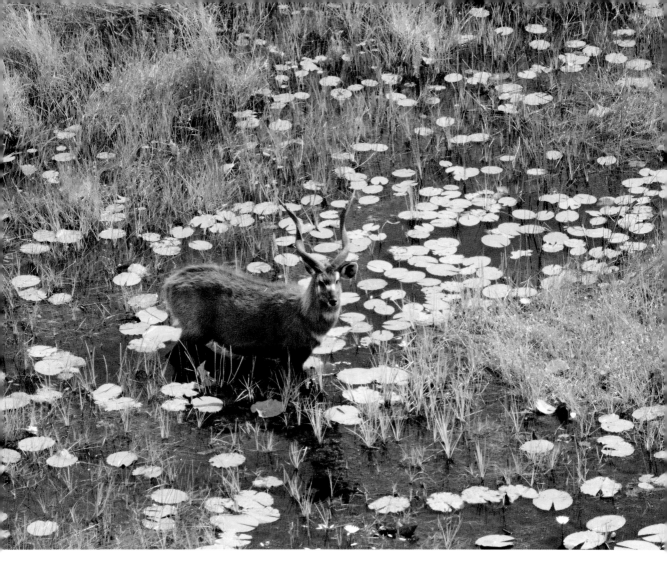

Sitatunga (above)
(Tragelaphus spekii)

Closely related to the bushbuck and the nyala, this species is closely associated with a semi-aquatic habitat. It differs from its relatives in that the hind quarters are higher than the shoulders, its coat has long shaggy hair and the hooves are extremely long and slender, splaying widely to allow walking in mud and on mats of floating vegetation. The southern race, which has very few white markings, is greyish-brown in colour and occurs in the Okavango swamps and along the Chobe River. It favours dense reedbeds and well vegetated aquatic environments. Males are larger than females and only males carry the shallow spiralled and keeled horns. While the rams are solitary, the females are often encountered in groups.

Distribution: The sitatunga is restricted to the swamps in the Caprivi, Chobe, Zambezi River and the Okavango Delta.

Nyala (opposite)
(Tragelaphus angasii)

Nyalas are common only in the Zululand bushveld and the north-eastern parts of southern Africa. You will find this close relative of the bushbuck in thickets and dense woodland, generally near water. It browses on leaves, feeds on pods, fruits, herbs and also on fresh green grass.

The colour of the male coat differs considerably from that of the female and becomes darker as it matures. The dominance display of a male is spectacular – it struts with mane erect and neck arched, and presents its flank to the rival, making itself appear bigger. The tail is raised over the rump and the white hairs fan out; the head is lowered and the horns point outward.

Distribution: Nyalas occur in hot, low-lying areas of the subregion; Zimbabwe in the north and south, including the Thuli Block; in several parts of Mozambique; South Africa in the northeastern parts of Limpopo and Mpumalanga and northern KwaZulu-Natal; and in the eastern parts of Swaziland.

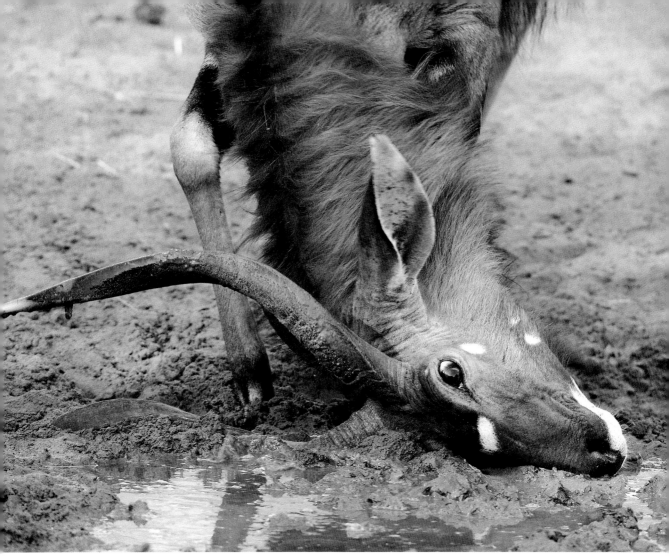
Male

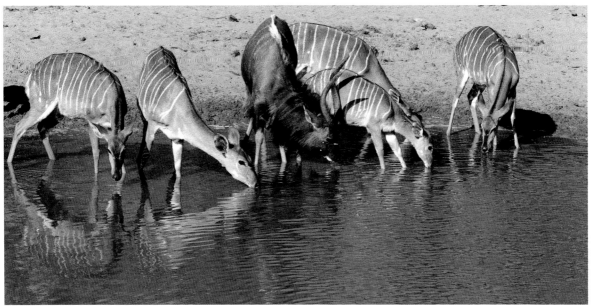
Females and male

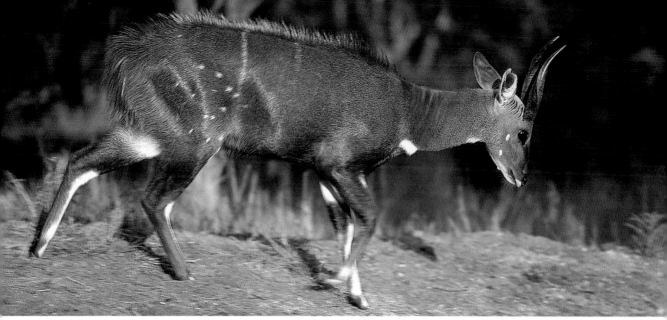

Bushbuck
(Tragelaphus scriptus)

Look for the bushbuck along forest edges and densely vegetated places near water. Along the Zambezi and Chobe rivers, bushbuck are redder in colour with more prominent white markings than elsewhere. They are browsers but also feed on seeds, fruits, flowers and tender green grass.

This solitary antelope is neither territorial, nor does it defend its home range. The stripes and spots on its coat help with camouflage, blending it in perfectly with the dappled shade of its surroundings. Cornered bushbuck males can be extremely dangerous, using their sharp horns and hooves to good effect. An enraged bushbuck can even scare off leopard.

Distribution: Bushbuck are widespread in the sub-region where rainfall is high and riverine bush or forest well developed. They are also found in Namibia along the Cunene River and in the Caprivi; Botswana in the Okavango Delta, Chobe and the Zambezi River; widespread along rivers in Zimbabwe and Mozambique; throughout Swaziland; and in South Africa along the Limpopo and other rivers in the north, the greater Kruger and down along the east coast towards the southern tip.

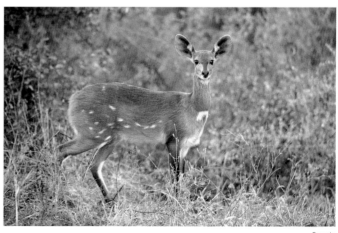

Male

Female

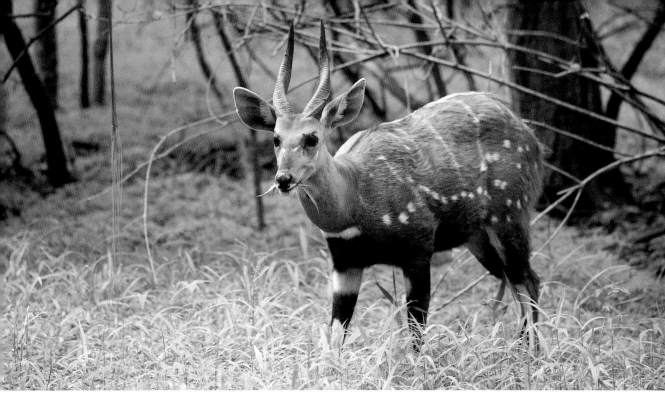

Chobe Bushbuck male

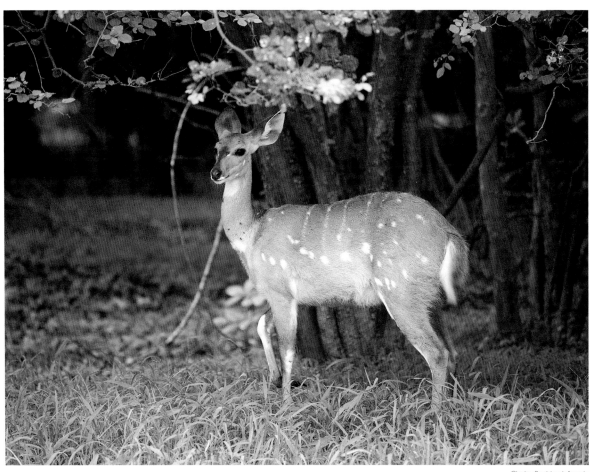

Chobe Bushbuck female

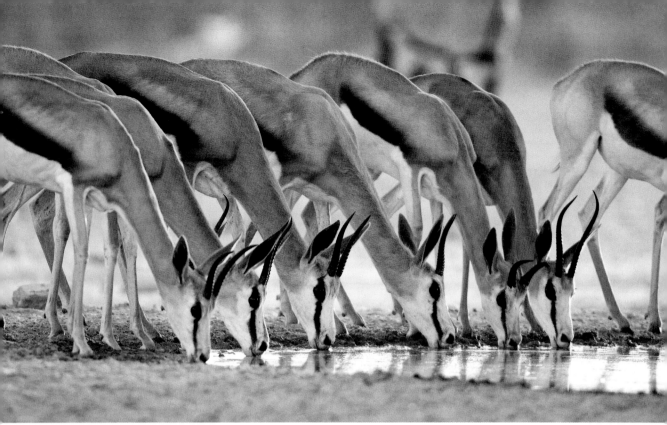

Females

The springbok is the only representative of the gazelles in the sub-region. Both sexes have horns, but while the males have medium to long-ridged horns, those of the females are shorter and thinner. The most distinguishing feature is the skin fold on the back containing a crest of white hairs. Note the contrast between the colourful bright upper coat and the pure white underparts. The visual difference in the coat colour aids in camouflage and this colour is not the result of different colour pigments, but can rather be attributed to different quantities and translucencies of the same colour pigment. Contrasts in the brightness of the colour pigments in the hairs tend to be confusing for a colour-blind predator.

Springbok
(Antidorcas marsupialis)

Springbok are a species occurring in arid areas and open grassland. Although they normally live in small herds, thousands often congregate in areas like the Kalahari as they migrate to find better grazing. Territorial males migrate less and tend to remain in their particular territories.

Lambing coincides with summer and rainfall patterns when food is readily available. The name springbok is derived from their habit of stotting or "pronking" (jumping with stiff legs and opening the crest on the back exposing the long dorsal fan of white hair). This is one of the most beautiful animal sights of the arid regions in southern Africa.

Distribution: Springbok are not only common in the sub-region but also endemic. They occur in the arid western zone from the far northwestern parts of Namibia, through central and southern Botswana, and the western parts of South Africa. They are not restricted to conservation areas but also roam freely and often appear on farmlands.

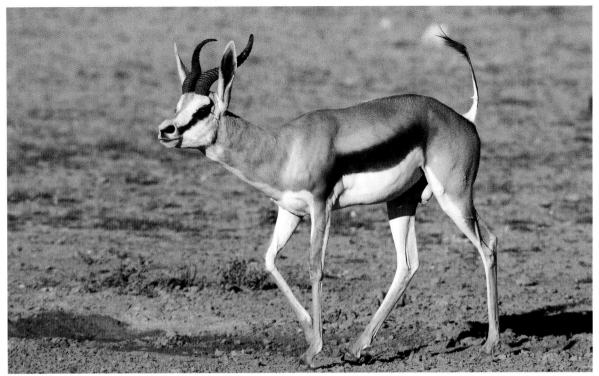

Male

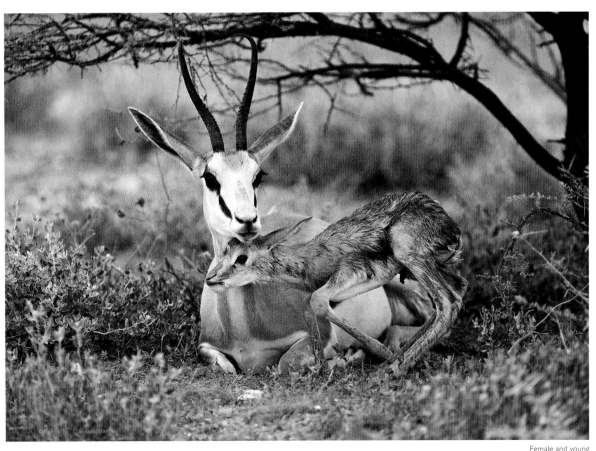

Female and young

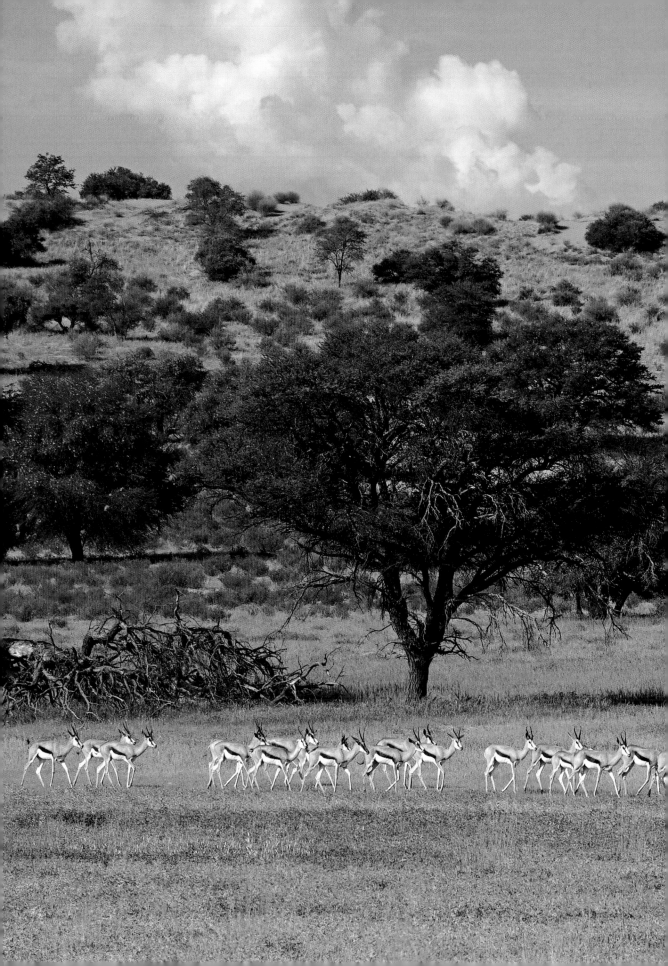

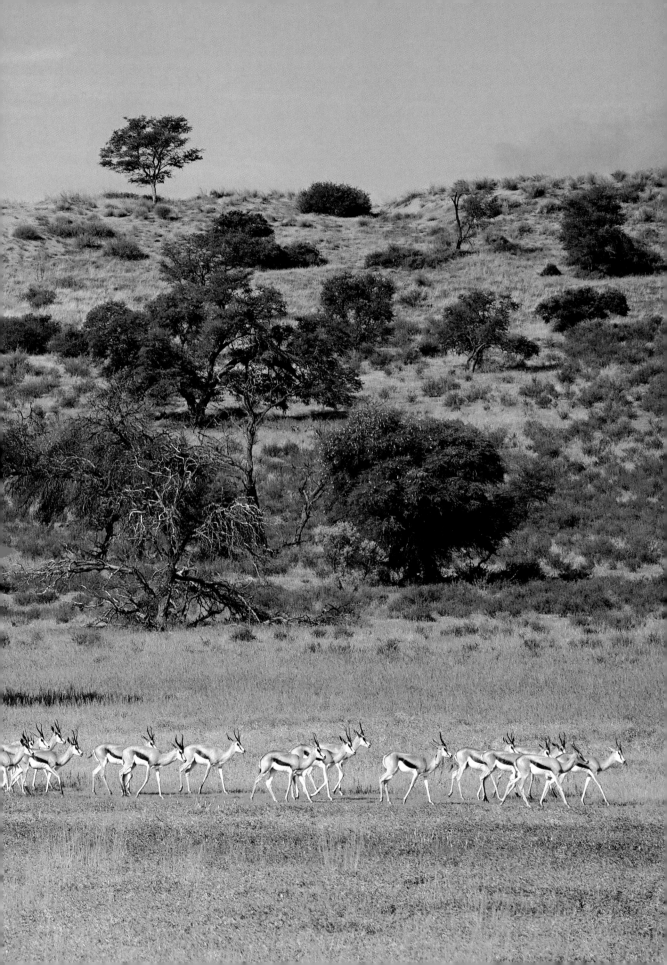

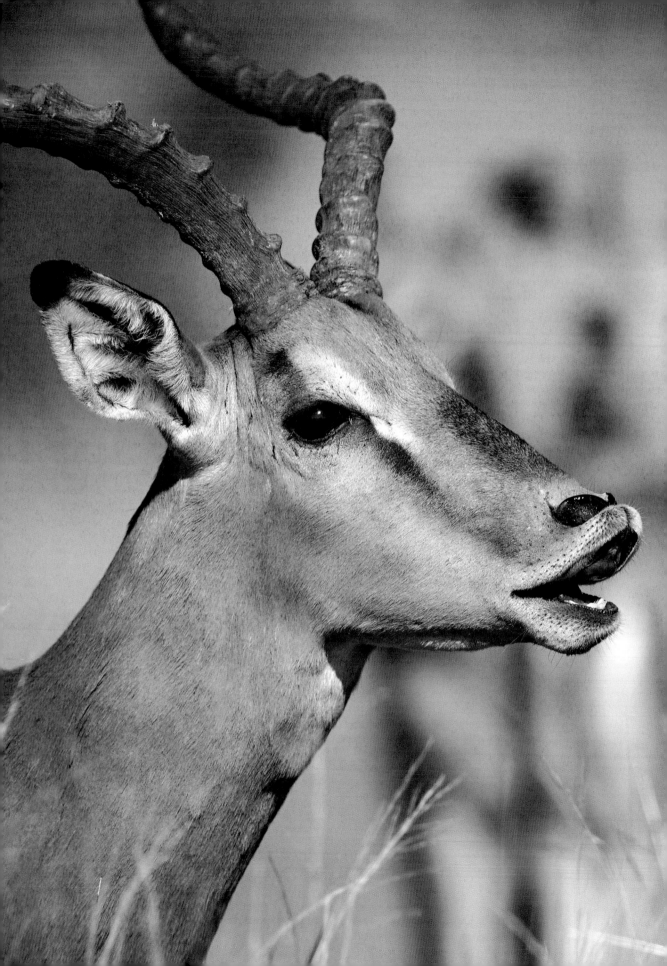

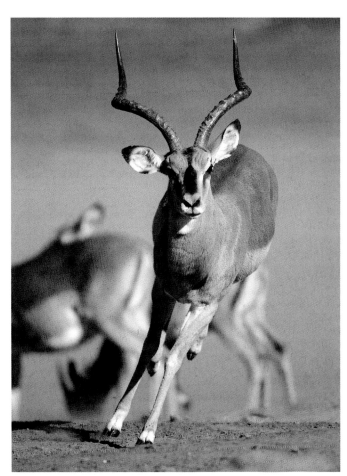

Black-faced Impala male

The impala antelope has no close relatives. One sub-species, the black-faced impala (*Aepycerus melampus petersi*), occurs in the northern parts of Namibia and is restricted to Etosha, a few game farms and the Kaokoveld. The most conspicuous difference is that the black-faced impala has a dark blaze on top of the muzzle that extends from the nostrils to the top of the head.

Impala
(*Aepyceros melampus*)

Impalas are abundant and by far the commonest animals in bushveld reserves. They are grazers and/or browsers, depending on the habitat, but they prefer open woodland.

The black tufts on the rear feet above the hooves are scent glands. Adult males also have scent glands on the face. The dominant males often use these glands to mark their territories and advertise their presence by rubbing scent on to the trunks of trees and other vegetation. During the rutting season there is much roaring and aggression amongst the males as they fight for dominance.

Distribution: The impala is widespread within woodland savannah in the eastern part of the sub-region. The black-faced impala, on the other hand, has an extremely narrow distribution in the north-western part of Namibia.

121

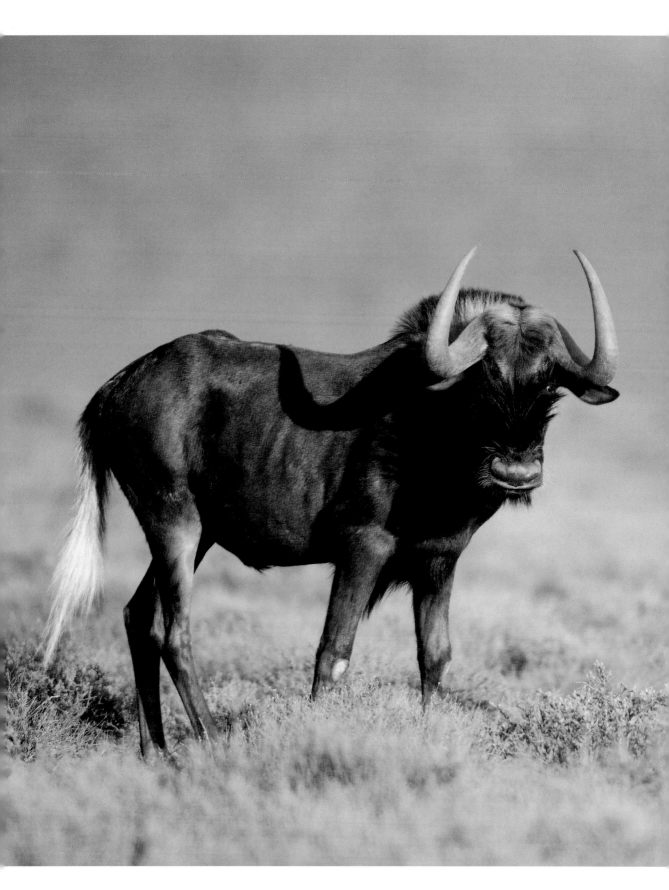

Blue and black wildebeest, red hartebeest, tsessebe, bontebok and blesbok are closely related and belong to the same group. Members of this group are medium to large in size and both sexes have horns. In the wildebeest species the horns are smooth and initially curve downwards, while in the red hartebeest, tsessebe, bontebok and blesbok species the horns are ridged at the base and twisted without a downward curve. All members have long faces with well-developed facial glands called pre-orbital glands. Foot glands only occur on the front feet and the females have only one pair of nipples (milk glands). Some members of this group have the habit of 'mud-packing', where the animal digs its horns into muddy patches while on its knees.

Black Wildebeest

(Canis mesomelas)

Black wildebeest almost reached the point of extinction due to loss of habitat as a result of agriculture. They are endemic to the open plains of the central plateau of South Africa where they once occurred in very large numbers.

Black wildebeest are not actually black but dark brown. Note the whitish tail, the distinct beard of long hair, the patch of long hair between the front legs and the strongly curved horns. Territorial males engage in several activities to demonstrate dominance and mark their territories. Their stiff-legged cantering and running while swishing their tails has earned them the name 'clowns of the Free State'.

Distribution: This is a typical grassland species that occurs in karroid vegetation (vegetation typical of the Karoo) in the Northern Cape, Karoo, Free State, Northern Province and below the mountains of KwaZulu-Natal and Lesotho. Reintroductions to game farms and reserves have contributed to a wider distribution.

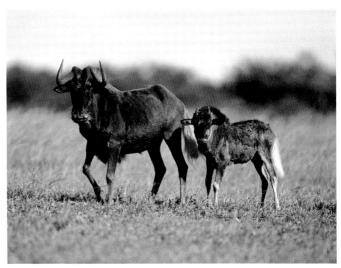

Male Female and young

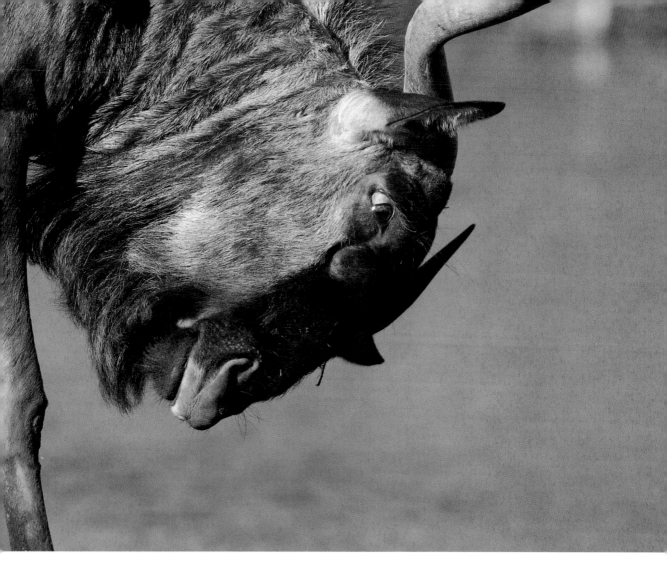

Blue Wildebeest
(Connochaetes taurinus)

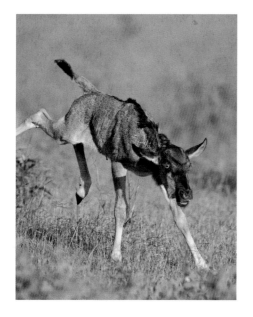

You will find these animals in small or large herds on short-grass plains and acacia savannah. The blue wildebeests, with their blunt muzzles and wide row of incisors, prefer short grasses. Unfortunately, they cannot reach these unless they are exposed and therefore they are often seen following zebras who graze the medium-height grasses, so exposing the short grasses below.

Scent-marking is important for territorial species such as wildebeest. The pre-orbital gland is situated between the eye and the nose. They rub this gland against twigs, stems, grass stalks or trees to communicate by scent with other members of the species.

Distribution: Although not endangered, the blue wildebeest are mostly restricted to conservation areas. They occur in northern Namibia, throughout Botswana and Zimbabwe, most of Mozambique and the northern sections of South Africa. There are isolated populations in KwaZulu-Natal and Swaziland; others have been relocated to various other smaller game reserves and conservation areas.

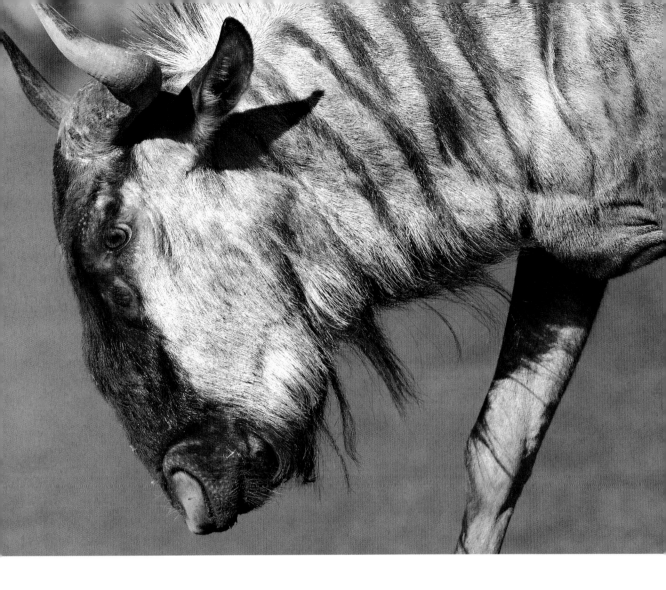

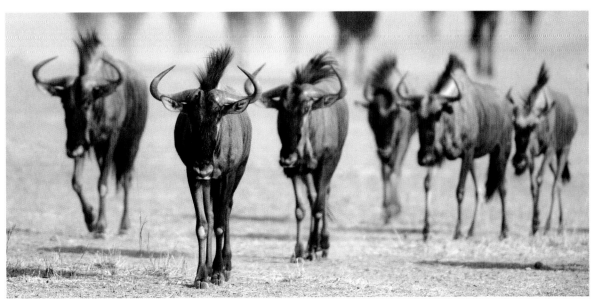

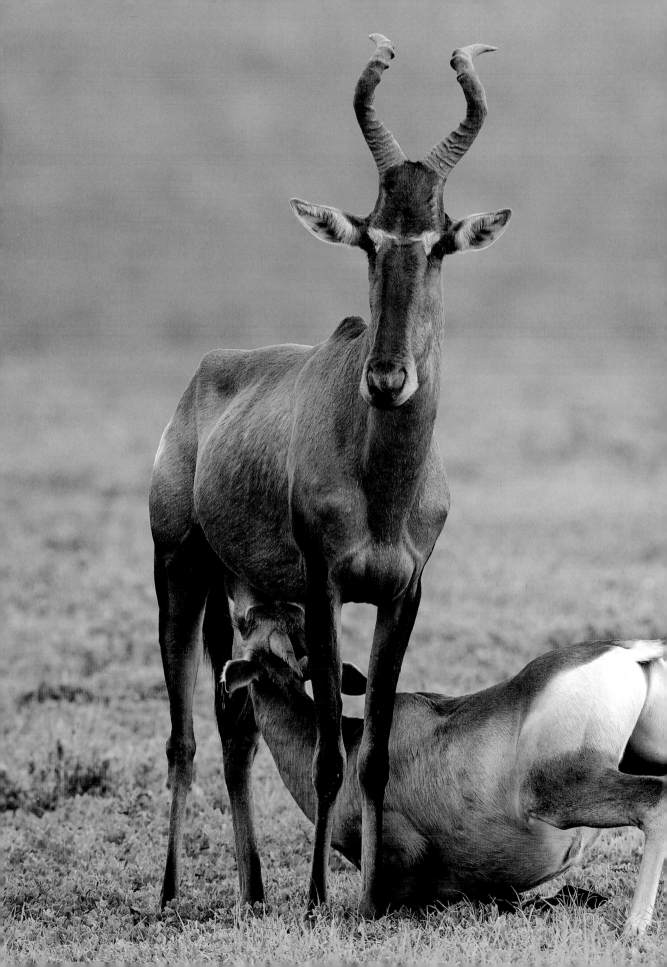

Red Hartebeest
(Alcelaphus buselaphus)

Red hartebeest occur mainly in semi-arid regions with open grasslands. These antelope used to be abundant and widespread, even in the rest of Africa, but severe hunting has resulted in dwindling numbers. They have since been reintroduced to many areas where they had become extinct.

The coat of the red hartebeest has high reflective properties enabling it to overcome the difficult conditions of arid regions. They live in small herds but sometimes gather in huge herds numbering thousands, depending on the climate. The territorial bull is very visible, often advertising himself on prominent mounds. During rut, vicious fighting may take place; during this time too the bulls are particularly handsome with their shiny coats and proud posture.

Distribution: The red hartebeest uses to be widespread but now occurs mainly in northern Namibia, southern Botswana and northwestern South Africa.

Another hartebeest species, the Lichtenstein's hartebeest (below), is present in very small populations and is rare in the sub-region.

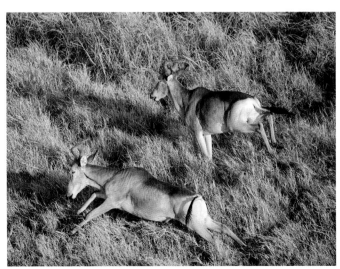

Lichtenstein's Hartebeest

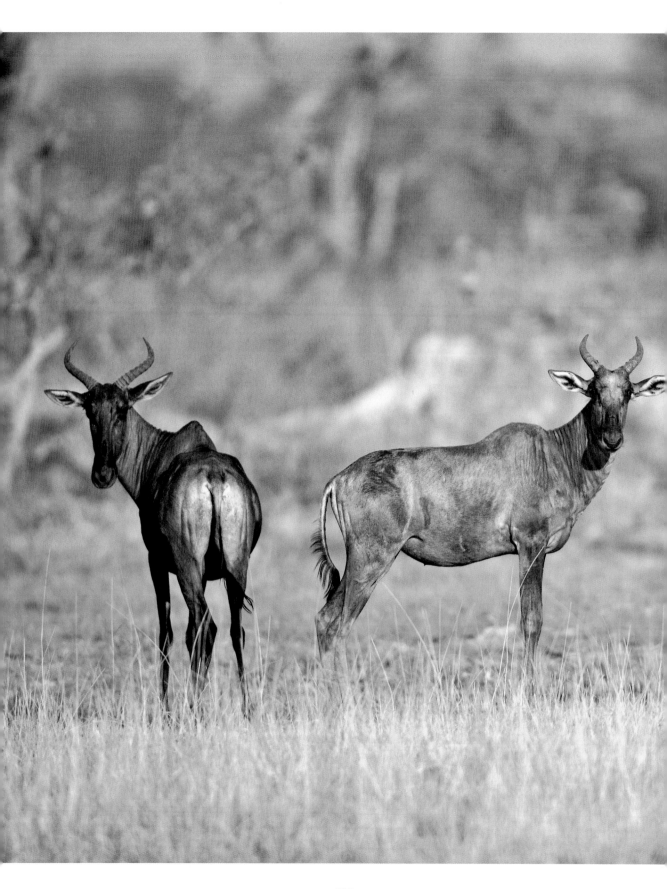

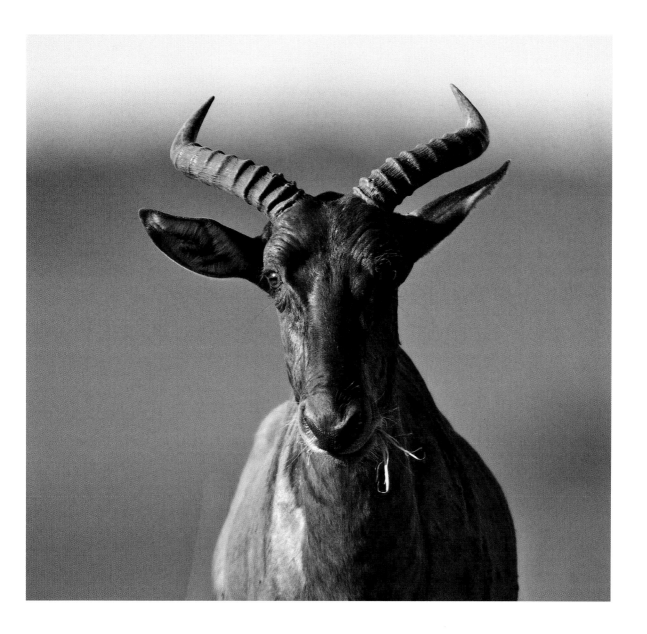

Tsessebe

(Damaliscus lunatus)

This antelope only occurs in the far north-east of South Africa, and in Botswana and Zimbabwe where there are medium-length grasslands and transitional zones between woodland and grassland. It selects only the greenest, most tender growth, avoiding mature stems and dry grass.

Its lean body is built for speed and thus the tsessebe is considered the fastest antelope in southern Africa. Its habit of 'mud-packing', where it digs its horns into muddy patches while it is on its knees, possibly serves to make the horns look more formidable when caked with mud. Both sexes will do this.

Distribution: A typical southern African species, the Tsessebe inhabits the northern parts of the sub-region with the highest densities in northern Botswana and southwestern Zimbabwe. This species avoids arid places.

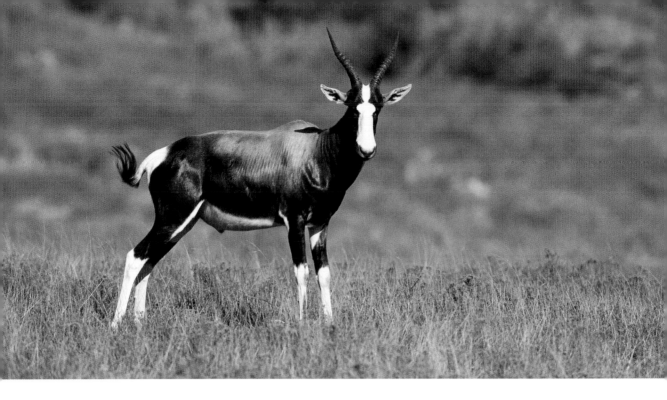

Bontebok (above)
(Damaliscus pygargus pygargus)

The bontebok prefers renosterveld within the fynbos biome and needs regular access to water and small trees for cover. It is almost exclusively a grazing species and prefers short grass.

The name refers to the multi-coloured coat, which is rich dark brown. It differs from the closely related blesbok in that the coat is darker on the sides of the head, the flanks and upper parts of the limbs. The patch on the buttocks is pure white and it extends to the base of the tail. The limbs are also almost entirely white from the knee downwards. The bontebok is the least common antelope in the sub-region.

Distribution: The bontebok is endemic to the sub-region and has a restricted distribution in the Western Cape.

Blesbok (opposite)
(Damaliscus pygargus phillipsi)

Valued for meat and hides, blesbok were severely hunted in the nineteenth century. Although numbers were substantially reduced because of this, these animals are now plentiful in grassland game reserves and on highveld farms. The blesbok is a special antelope, one of South Africa's endemic species that occurs nowhere else in Africa or the world.

Blesbok are easily recognised by the white face blaze and belly. During hot weather they have the habit of standing with their necks drooping, faces close to the ground while making nodding movements with their heads. Once they are lying down, they are difficult to see in long grass.

Distribution: Blesbok were historically widespread. They are now restricted to areas in central South Africa. Reintroductions to game farms and reserves have contributed to a wider distribution.

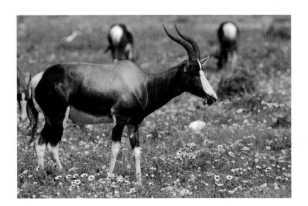

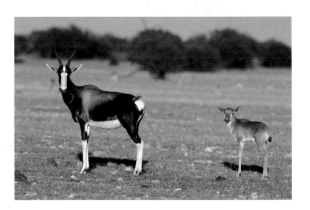

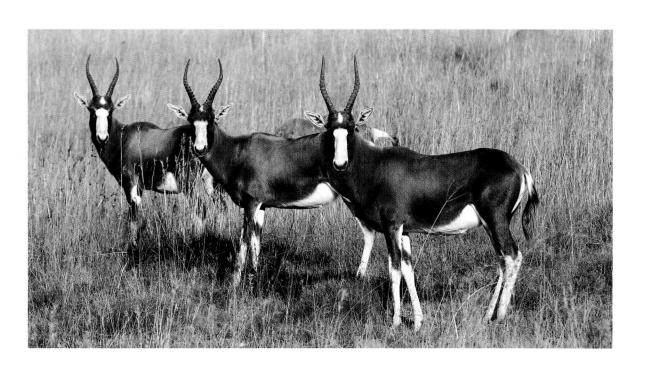

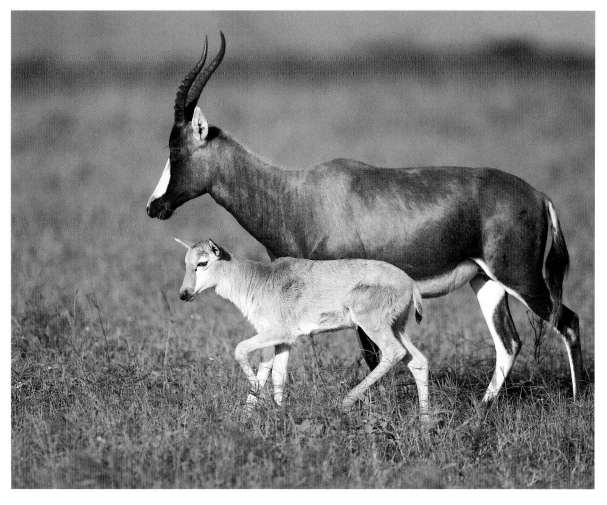

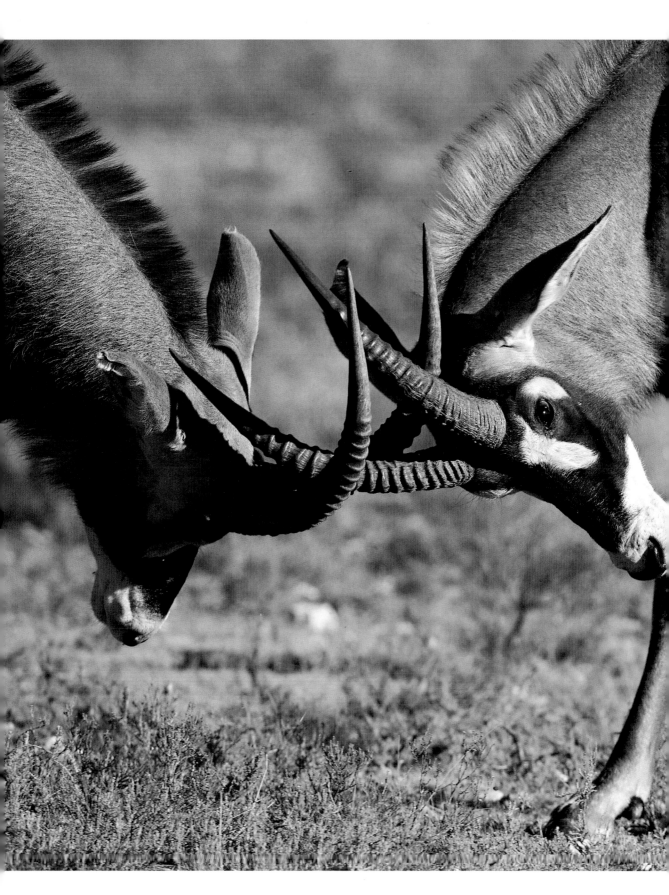

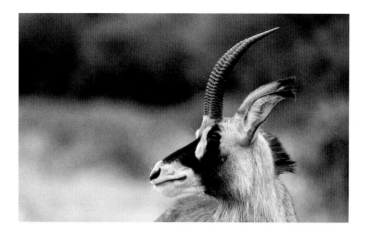

Large and barrel-shaped, the roan, sable and gemsbok are called 'horse antelope'. They have several features in common including their exclusively patterned African faces. They often occur in areas where the vegetation is of a poor quality. Horns are present in both sexes and are long and ridged. Besides the glands in all their feet, there are no other external glands except for the two pairs of milk glands.

Roan Antelope (opposite and above)
(Hippotragus equinus)

Although the roan antelope is widespread, it is not often seen. As a grazer and browser, it tolerates taller grass, unlike its close relative the sable. It prefers wetter parts with broad-leafed deciduous woodland and floodplains. It is sensitive to habitat change and very specific about its requirements, which results in a discontinuous occurrence in southern Africa.

The head, with extraordinarily large ears, has black and white markings that resemble a mask. Their hearing is very acute and any noise makes them extremely skittish. The roan is the second heaviest antelope after the eland.

Distribution: The roan antelope formerly occurred in all savannah areas of Africa, but their numbers have dwindled and in the sub-region only isolated pockets are left in the northern woodland savannah.

Sable Antelope (following page)
(Hippotragus niger)

Finding sable is always a special sighting. It prefers savannah woodland with grassland and widely spaced, broad-leafed, deciduous, fire-resistant trees. It occurs in the northern parts of southern Africa. A grazer and browser, it needs water at least every other day.

Sable antelopes are regarded as one of the most handsome antelope with the longest horns of all the species, except the kudu. Most predators are extremely wary of the long, impressive backward-curving horns.

When threatened it backs into bushes, drops to its knees and scythes the air from side to side with its horns to deter predators.

Distribution: Its historic range has been reduced but it is still quite common in northwestern Zimbabwe, northeastern Botswana, the Caprivi and greater Kruger.

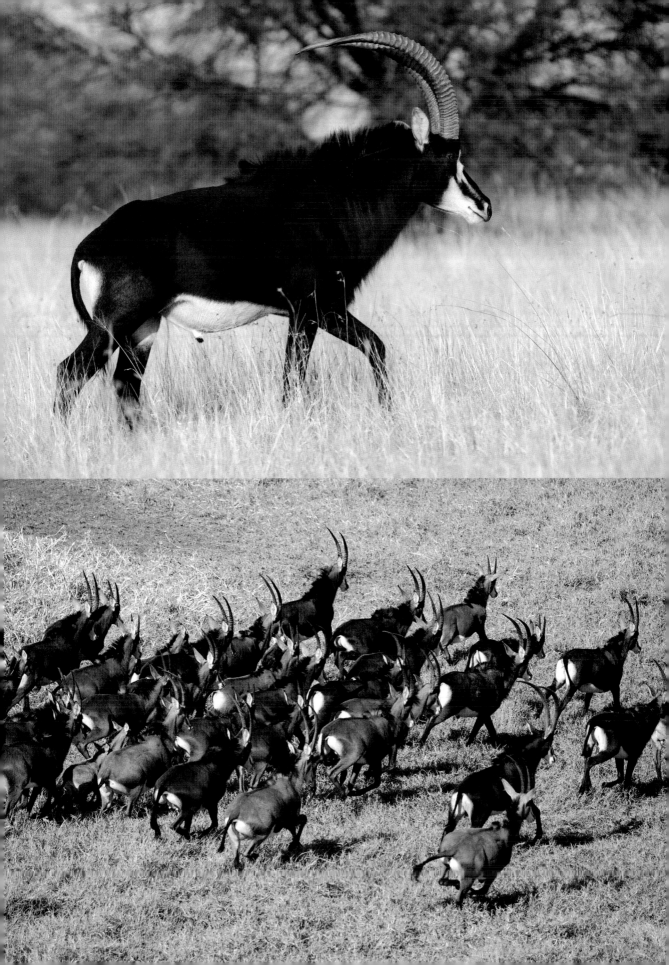

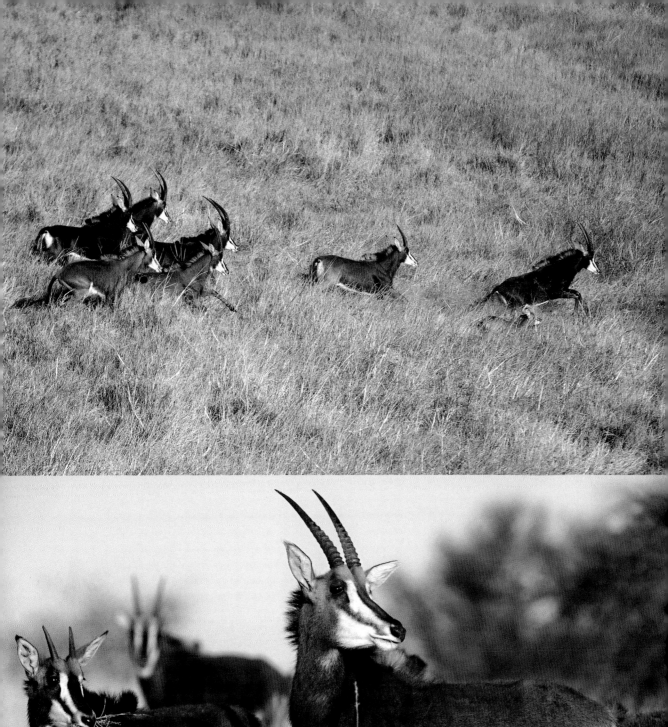
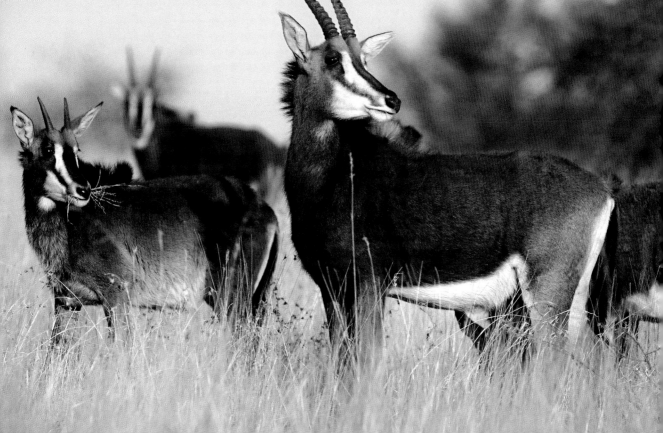

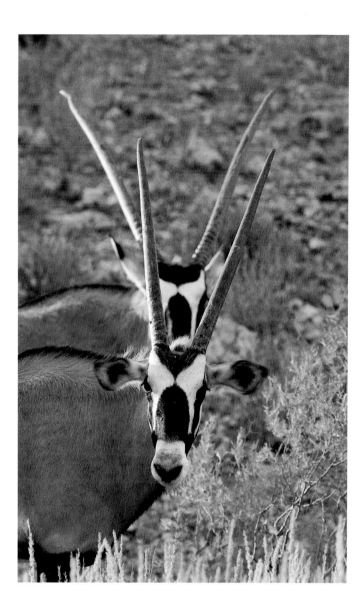

Oryx/Gemsbok
(Oryx gazella)

Gemsbok have a wide distribution in southern Africa but are confined to the more arid semi-desert areas. These powerfully built antelope with their magnificent V-shaped straight horns are particularly common in the dry western parts of the country where they can be seen in small herds. They sometimes gather in large numbers where rain has fallen.

Gemsbok are particularly well adapted to desert-like conditions. Their resourcefulness in obtaining moisture from plant material allows them to survive in some of the hottest places. When they drink it is often more a case of obtaining necessary minerals. A gemsbok, furthermore, has a special blood-cooling system in its head, which protects its brain from overheating.

Distribution: Relatively common in the sub-region, the gemsbok occurs throughout Namibia, the semi-arid parts of Botswana and South Africa.

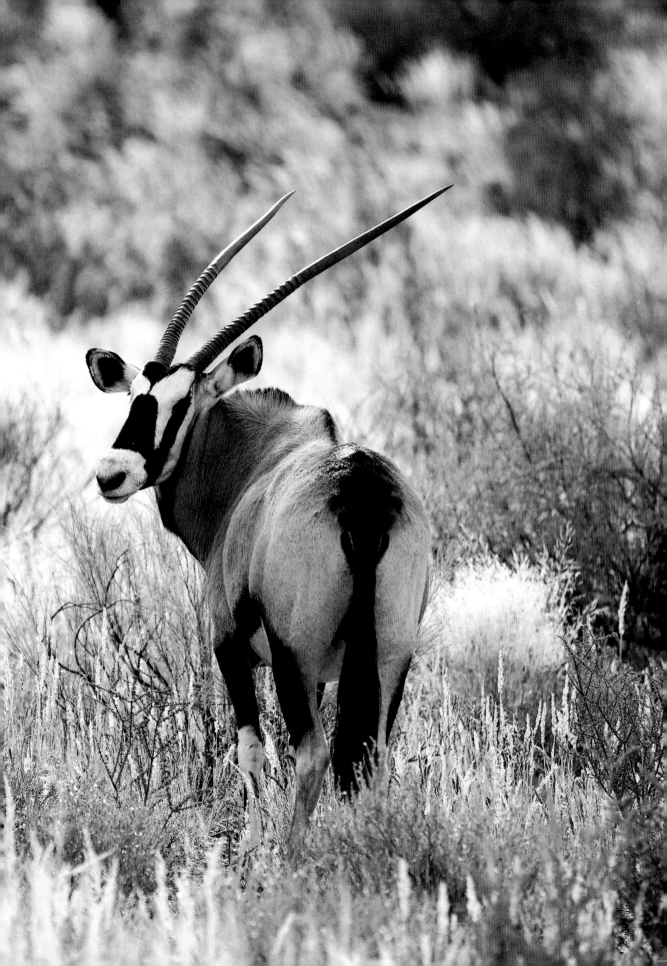

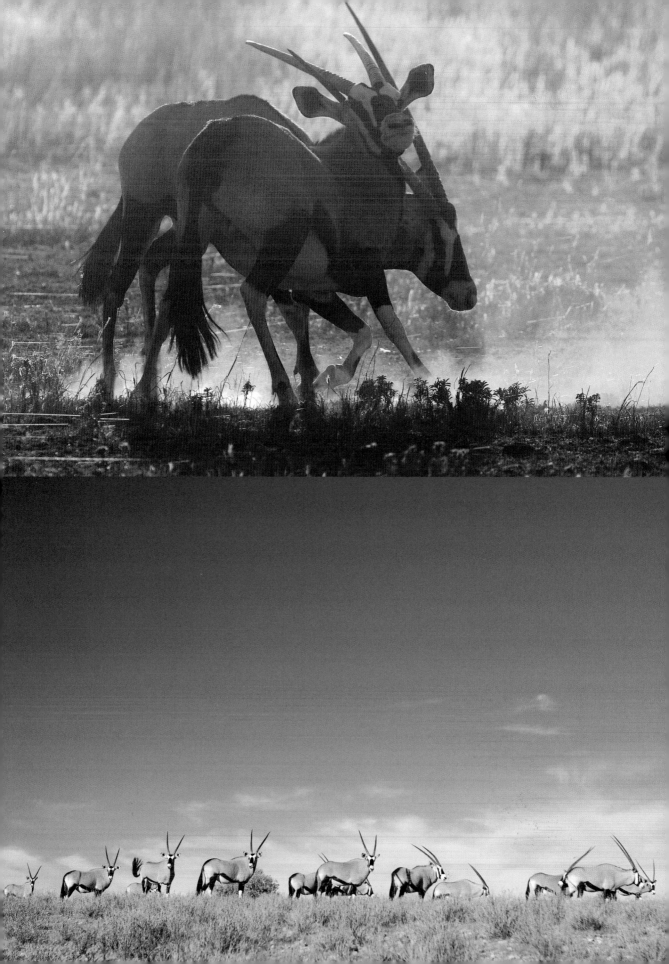

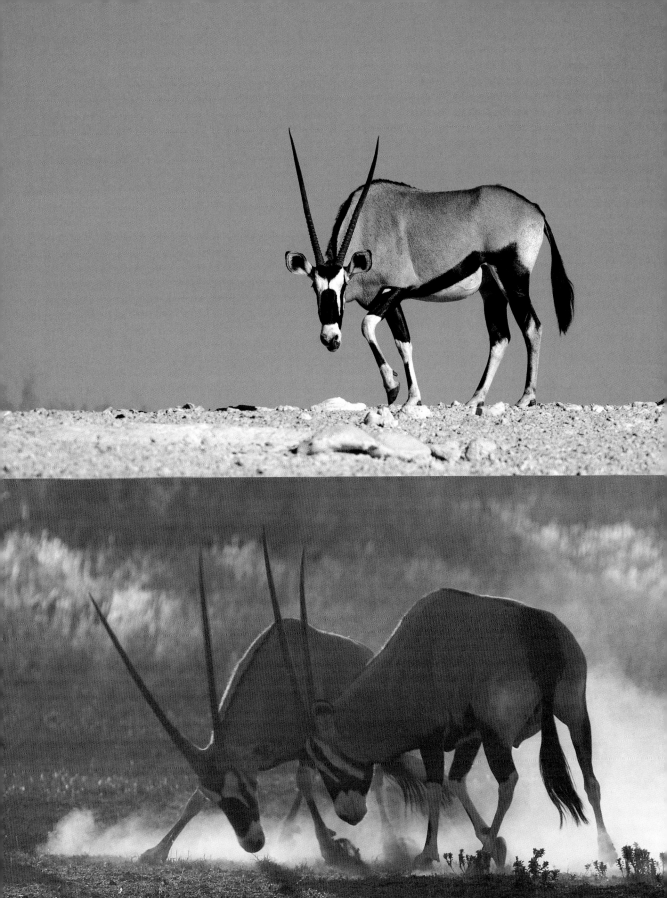

The waterbuck, lechwe and puku are closely related, the waterbuck being the largest of the three species. All the males are larger than the females and have forward-curving ridged horns while the females are hornless. They all seem to have a poor sense of smell, and are all principally wetland grazers, but the waterbuck often roams further away from those areas.

Waterbuck
(Kobus ellipsiprymnus)

Look for waterbuck in grassland at the edges of savannah woodland, close to wetlands and water. It is a grazer of medium and short grasses and browses on foliage when green grass is not available.

The white ring around the rump probably serves as a following mechanism – each animal follows the signal of the animal in front and in turn serves as a following beacon for the one behind. Abundant sweat glands secrete a musky substance which taints the flesh and gives it an unpleasant flavour, effectively deterring animal predators and human hunters.

Distribution: Waterbuck keep close to water, favouring floodplains, vleis and grassy areas along rivers and streams. They also occur in the Oka-vango Delta, near the Chobe and Zambezi rivers and the Mozambican floodplains, along the Limpopo River into the greater Kruger, and down to KwaZulu-Natal.

Male

140

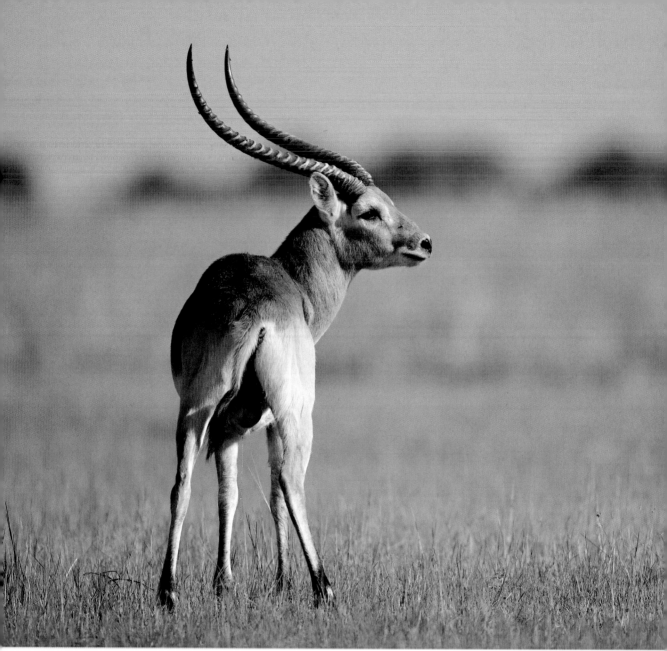

Male

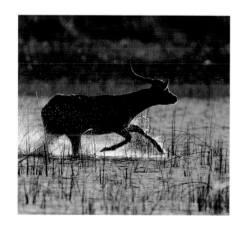

Red Lechwe
(Kobus leche)

Lechwes have very specialised habitat requirements and are always found in the vicinity of water, where they utilise the inundated floodplains and the fringes of dry land. They are often seen grazing on the semi-aquatic grasses where they can readily take to water to escape predators.

It is a beautiful sight to see a herd of running lechwe fleeing through the shallow water with long graceful leaps. Rams are often involved in elaborate displays, lifting their heads proudly to show off their impressive lyre-shaped horns. Vicious fighting may ensue in cases of trespassing.

Distribution: Lechwes are confined to wetlands in the Caprivi, Chobe and Okavango.

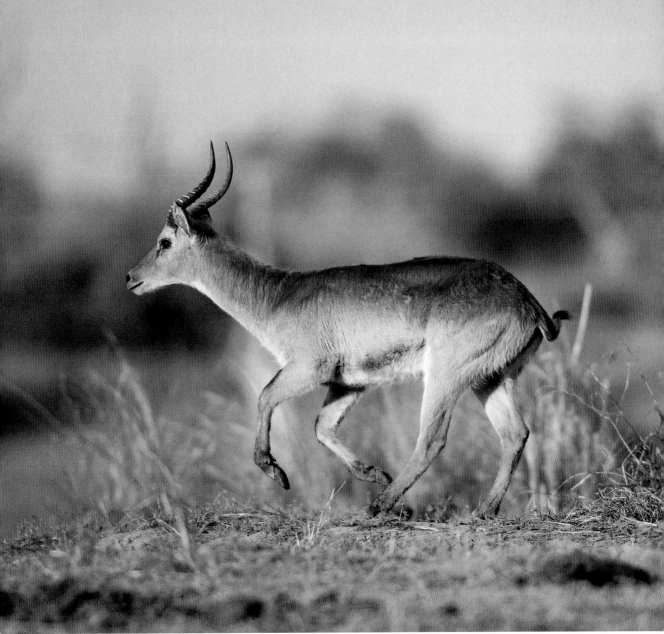

Puku

(Kobus vandonii)

Puku occur widely higher up in Central Africa, but down south they are only found in the Chobe National Park. They favour riverine areas, where they graze on open flat land between the water and the adjacent woodland. Good sightings are fairly regular, but they do not occur in large numbers in this area.

Puku are shy and can best be seen in the early morning and late afternoon when game viewing from a boat on the river. The dominant males occupy territories which they maintain for periods ranging from a few days to months. Females and their offspring occur in small herds.

Distribution: In the sub-region they are found only in the Chobe area.

Female

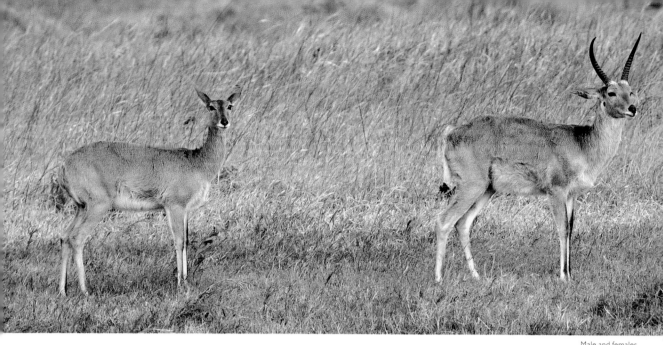

Male and females

The southern and mountain reedbuck are related but the grey rhebuck is only distantly related to the reedbuck species. All three species are medium-sized antelopes. Reedbuck males have forward-curving heavily-ridged horns while the females are hornless. The rhebuck males also have horns but they are short, straight and ridged. Rhebuck can be distinguished from other similar species by their long ears and woolly coats.

Southern Reedbuck (above and left)
(Redunca arundinum)

Reedbuck can be found where there are stands of high grass or reedbeds near water. They depend on the existence of wetlands, vleis and seasonally moist grasslands.

Reedbuck have a distinctive voice. When disturbed they give a characteristic piercing whistle and run in a distinctive rocking canter, displaying their white tail, and whistling at every bound. The clicking sound is caused by the forced expulsion of breath through the nostrils, varying in pitch and tone. In distress, they make a long-drawn plaintive cry, but when suddenly frightened they make a soft hissing sound.

Distribution: Although not uncommon in the northern and eastern parts of the sub-region, they are restricted by suitable habitat.

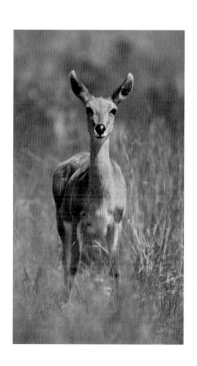

Mountain Reedbuck (opposite)
(Redunca fulvorufula)

Mountain reedbuck are common and occur on stony and grass-covered hills and mountain slopes, even up to high altitudes. They take cover near bushes or scattered trees and rocks, preferring the lower slopes and avoiding bleak open conditions. When disturbed, one gives a shrill whistle to warn the rest and they usually run uphill, negotiating rocky and broken country with great ease, holding their fluffy white tails over their backs. This small antelope is often confused with the grey rhebuck but it can be distinguished by the males' curved horns.

Distribution: The mountain reedbuck occurs mainly within South Africa with a relic population in Botswana. They inhabit the mountain slopes of the Drakensberg and various other stony slopes of hills and mountains in the south east.

144

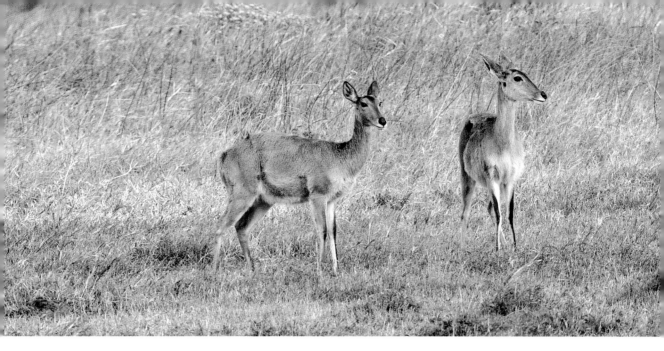

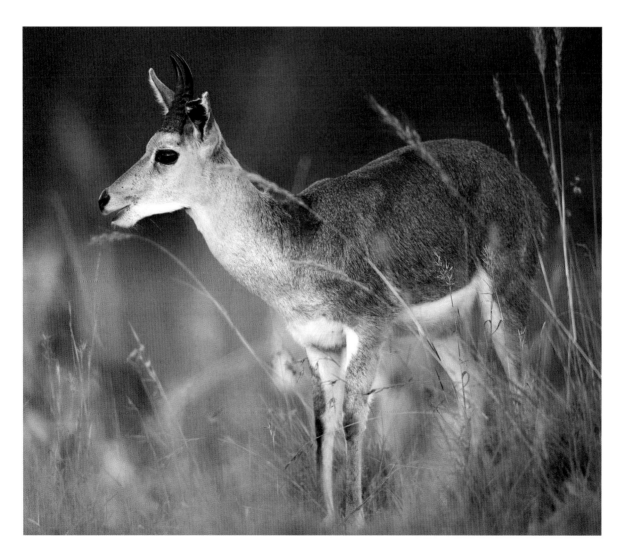

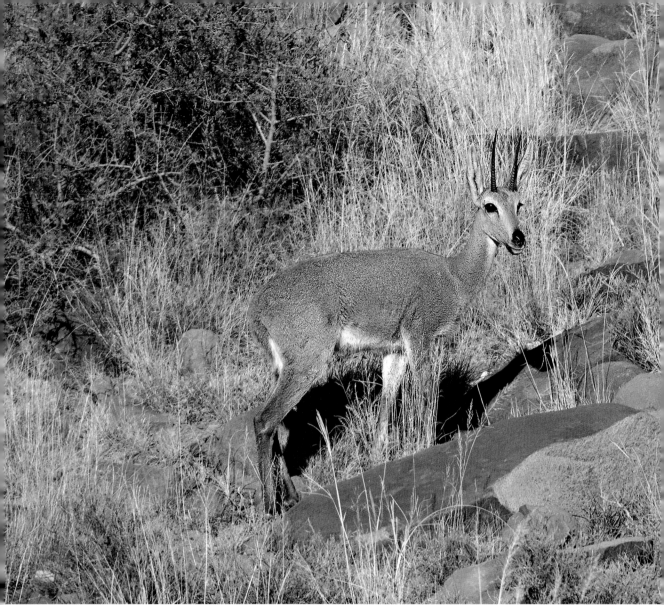

Male

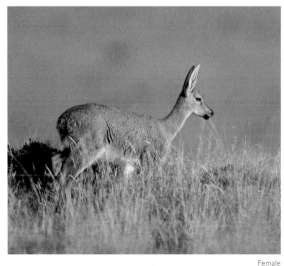

Female

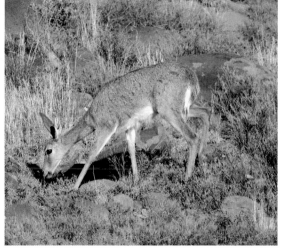

Female

Grey Rhebuck
(Pelea capensis)

The grey rhebuck favours grassy slopes of rocky hills and mountainous areas. Predominantly a browser, it feeds on the many herbs found in grassland. When disturbed it runs away in a characteristic rocking-horse motion with its short bushy tail resembling a powder puff, held erect. It has the habit of running for a short distance and then stopping to look back.

The grey rhebuck has extremely long ears and almost straight horns. Its woolly coat makes it well suited to withstand the extremes in temperatures at high altitudes. It is one of the antelope endemic to South Africa.

Distribution: The grey rhebuck is found only in South Africa on mountain slopes and rocky hills from the southwestern Cape to Mpumalanga and Limpopo.

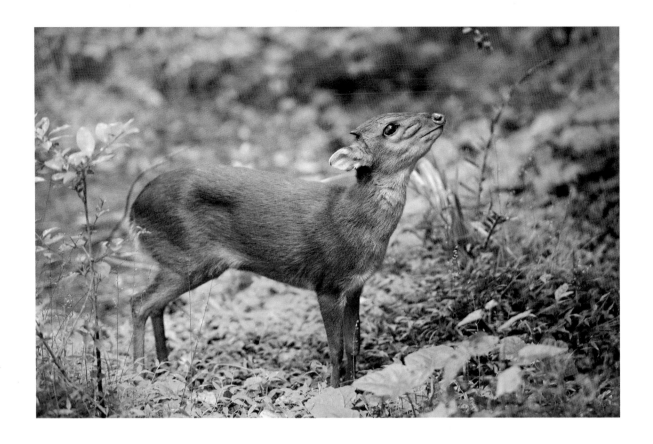

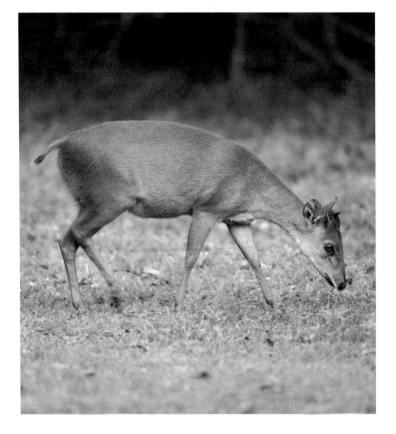

Although many more species of duiker occur further north in Africa, southern Africa has only three species of these small antelope. Their horns are all short and simple, present in both sexes except for the common duiker where only the males have horns. An outstanding characteristic is the tuft of hair on top of the head between the horns. The blue and red duiker are forest species while the common duiker is found in savannah woodland and grassland.

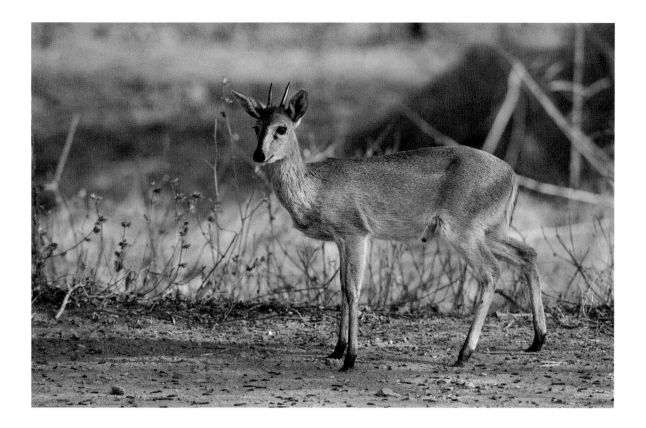

Blue Duiker (opposite top)
(Sylvicapra grimmia)

This is the smallest antelope in South Africa with the male weighing a mere 4kg and the female slightly larger at 4.7kg. Cryptically coloured, the blue-grey coat has a touch of rufous, while the belly and underside of the tail is white. Both sexes have short sharp horns, often concealed by a tuft of hair. They live exclusively in evergreen forests.

Distribution: Although widely distributed further north in Africa, the blue duiker is rare in the sub-region and located only in discontinuous patches along the south coast of KwaZulu-Natal down to the forested areas in the Cape Province. It is also found in the extreme northeastern parts of Zimbabwe and in Mozambican forests.

Common/Grey Duiker
(above)
(Sylvicapra grimmia)

Look for duikers in areas with ample shrubs and other plants growing under trees. This is one of the commonest small antelope in the bushveld and the last to be eliminated by settlements. Its diet is varied but it eats mainly herbs, fruits, seeds and cultivated crops.

They are secretive and, if disturbed, will steal away with head lowered and tail up. When they suddenly decide to flee, they seem to dash between hiding places, almost diving into thickets. 'Duiker' is the Afrikaans word for diver. Both sexes have a characteristic spiky tuft of hair between the ears.

Distribution: The grey duiker is widespread throughout the sub-region where the habitat is suitable.

Red Duiker (opposite bottom)
(Cephalophus natalensis)

You will find this tiny, beautiful antelope in thickly-wooded areas near water in the eastern areas of southern Africa in Mozambique, Swaziland and KwaZulu-Natal. The best place to see it is along sub-tropical forested areas in Zululand where it browses primarily on fallen leaves, flowers and fruit, as well as the fine stems of shrubs.

Although solitary, individuals do occasionally meet. They then may greet each other by rubbing the scent glands in front of their eyes together.

They also mark their home ranges by frequently rubbing their scent glands on branches, twigs and tree trunks.

Distribution: The red duiker only inhabits the eastern and northeastern parts of the sub-region from Mozambique down to KwaZulu-Natal. However, there is an isolated population in the Soutpansberg too.

The Suni has no relatives in the sub-region.

Suni/Livingstone's Antelope (right)

(Neotragus moschatus)

This is a rare antelope found only in the far northern parts of the Limpopo Province, Mozambique, and in the scarce sand forests of Maputaland.

It prefers dry woodland with dense undergrowth. Suni are shy and wary, feeding on herbs, low shrubs, fruit and mushrooms.

This is a small antelope – only the blue duiker is smaller. They use their well-developed pre-orbital glands for marking their territories, and they also use communal middens. They have the largest pre-orbital scent glands, relative to size, of all antelope. To see a suni on a game drive is indeed a special sighting.

Distribution: Independent of surface water, the Suni occurs in dry sand forest (woodland on drainage lines) in the extreme eastern inland part of the sub-region up to the northern reaches of KwaZulu-Natal.

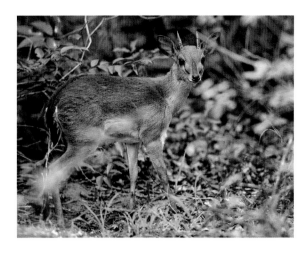

The steenbok are related to the two species of grysbok; Oribi are related to the Damara dik-dik. In all these dwarf antelope, the pre-orbital glands are exceptionally well developed and situated in depressions below the eyes. Both males and females are horned, have face and foot glands, and all have a well-marked face pattern. They are all solitary, usually mate for life and have strong pair bonds. They defend their territory and often carry out actions involving dung on boundary middens to mark their territories and maintain their pair bonds.

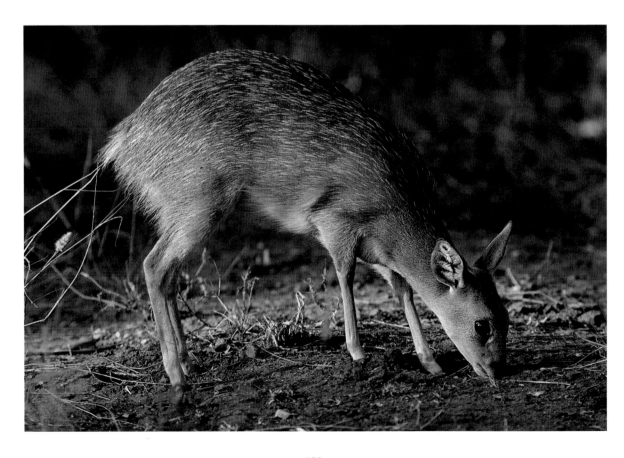

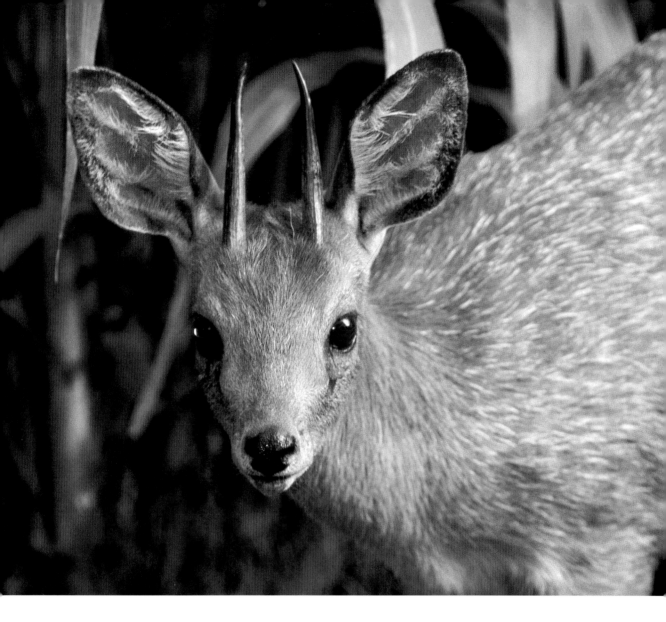

Sharpe's Grysbok (opposite)
(Raphicerus sharpei)

This small antelope is only found in the north-eastern savannah regions of southern Africa, in areas with low shrubs and grass. It is nocturnal, shy and secretive. It is easily overlooked and very rare. Look for it in rocky, hilly areas of mopane veld where there are no dense stands of grass.

The coat is rich reddish-brown and suffused with long greyish hairs, which distinguishes it clearly from the steenbok. They are not only prey to the larger diurnal and nocturnal predators such as lions and leopards but are also preyed upon by pythons and large raptors.

Distribution: Sharpe's grysbok is found in tropical parts of the sub-region – Mozambique; central, northern and eastern Zimbabwe; South Africa on the drier northern aspects of the Soutpansberg; and the Kruger National Park.

Cape Grysbok (above)
(Raphicerus melanotis)

The Cape grysbok with its large ears that are buffy-white on the inside and greyish on the outside is an antelope endemic to the Cape region. Look for it along lower levels of hills, amongst scrub bush, in kloofs and coastal forests, or even in dry succulent veld where there is enough cover.

This very small antelope is taller at the hindquarters than the forequarters. Both males and females have pre-orbital glands that secrete a black substance with which they mark their territories. They first do a lot of smelling around before applying their glands to tufts of grasses or branches and releasing the secretion.

Distribution: The Cape grysbok occurs only in the southwestern and southern parts of the Western Cape.

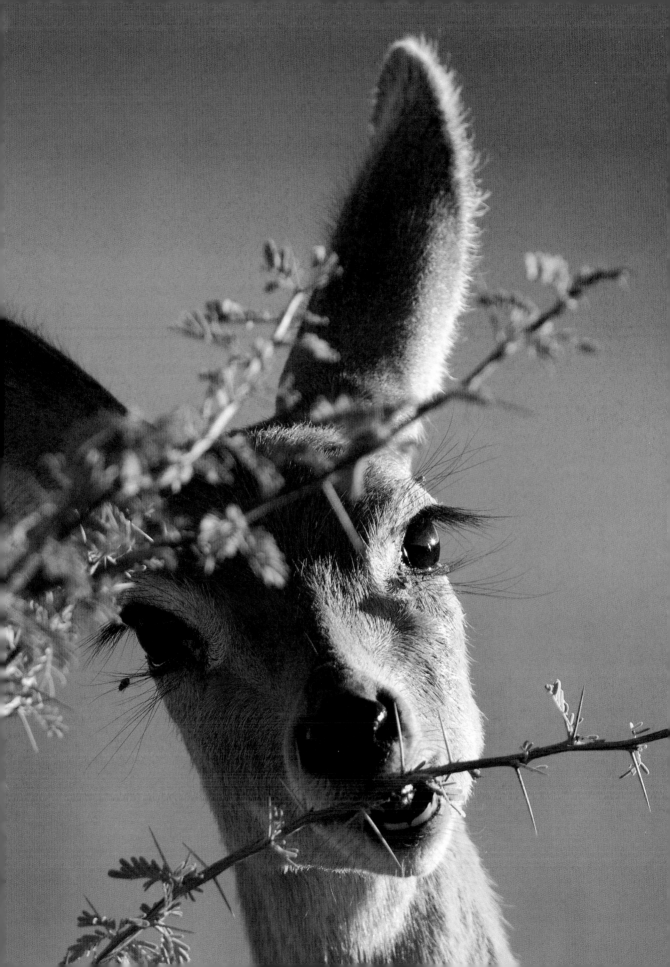

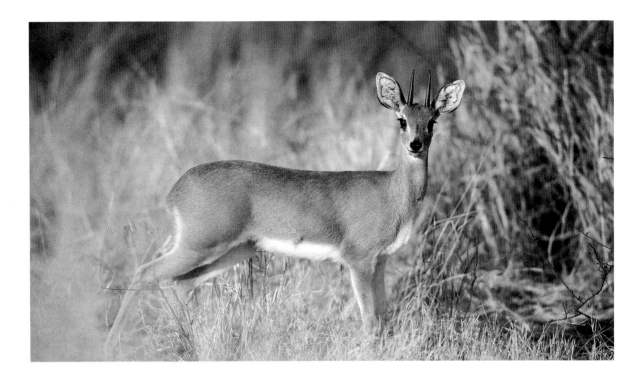

Steenbok/Steinbuck

(opposite and above)

(Raphicerus campestris)

This tiny antelope is common in the open dry bushveld. It is not dependent on water sources, since it obtains sufficient moisture from its diet of foliage, seedpods and seeds, berries and tender green grass. Sexes are alike, except for the horns.

Both sexes are territorial and will defend their areas against others. They use dung middens.

When about to urinate or defecate, the antelope prepares a slight depression with its front hooves in which it leaves a deposit before covering it up. When they sense danger, they hide in the grass by lying flat to escape detection, not moving unless they are flushed out.

Distribution: The steenbok is widespread throughout the sub-region.

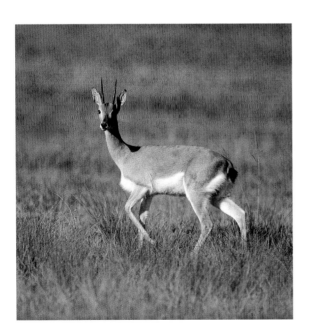

Oribi (left)

(Ourebia ourebi)

The oribi is one of the most threatened antelope in the grass lands. It is a highly selective grazer, requiring a combination of high-quality short grass for food and long grass for rosting and hiding its young. It selects only certain kinds of grass and eats only specific parts of those grasses. Oribi are not dependent on water but they do need a high moisture content in the grass they feed on.

The oribi is the fastest of the smaller antelope and when disturbed, it runs away in a typical rocking-horse fashion. They occur either in pairs or in groups of three or four, i.e. a male with two females, one of which may be a female offspring. The male maintains a territory with pre-orbital markings and dunging ceremonies.

Distribution: The oribi's distribution is patchy and discontinuous over the eastern parts of the sub-region up to the Caprivi and Chobe areas, where it is rare. The species is considered rare and vulnerable.

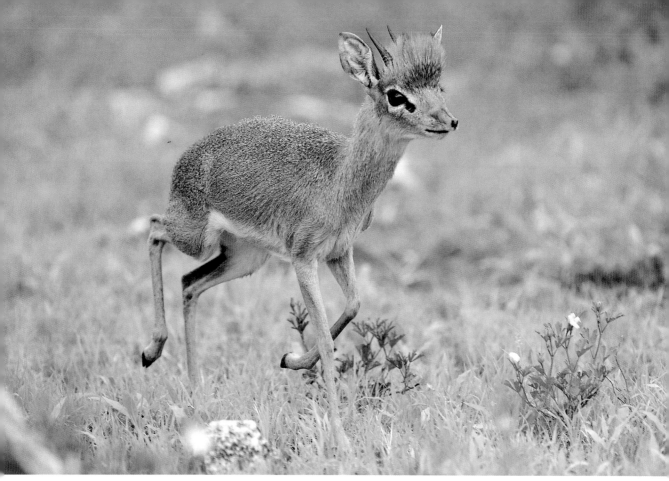

Male

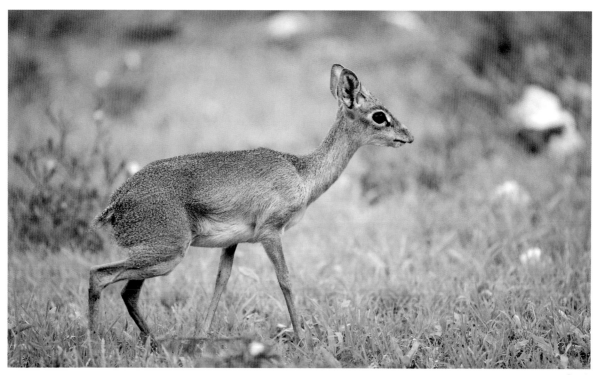

Female

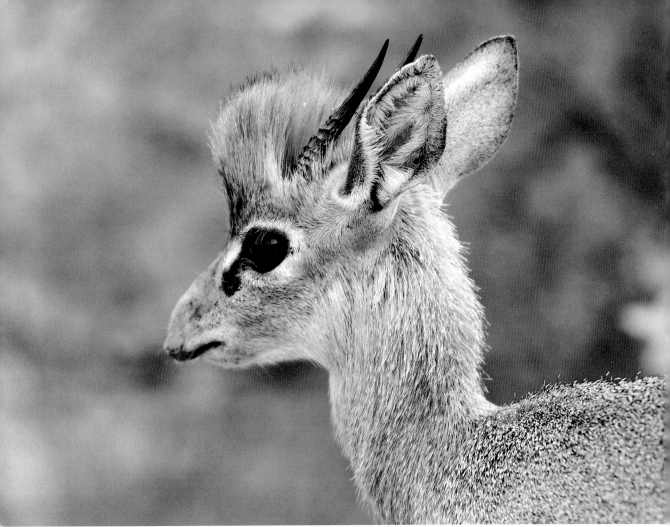

Damara Dik-dik
(Madoqua damarensis)

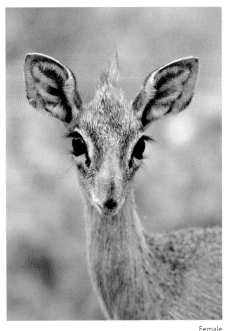

Dik-diks prefer open shrub or woodland thicket with hard ground and can even be found in very arid regions. With their elongated proboscis-like snouts, dik-diks feed on tender, nutrient-rich parts of plants and can stand on their long hind legs to reach the tender parts higher up on shrubs. They are very rare and can be seen in the eastern parts of Etosha National Park.

Dik-diks mate for life and scent-mark their territories with secretions from their pre-orbital glands and by defecating and urinating rituals. The dik-dik female also has a territory, which is very rare among antelope. Life-long pair bonds are formed. During courtship, which takes place only once a year in mid-summer, the male approaches the female in a stiff-legged walk with his nose pointed forward and the crest on his forehead fully erect. A single lamb is born during the rainy season and stays hidden for the first three weeks. A most striking feature is the elongated, mobile nose which it uses to make a variety of sounds including the characteristic zik-zik from which it derives its name.

Distribution: In the sub-region, the dik-dik only occurs in the far northwestern parts of Namibia.

Female

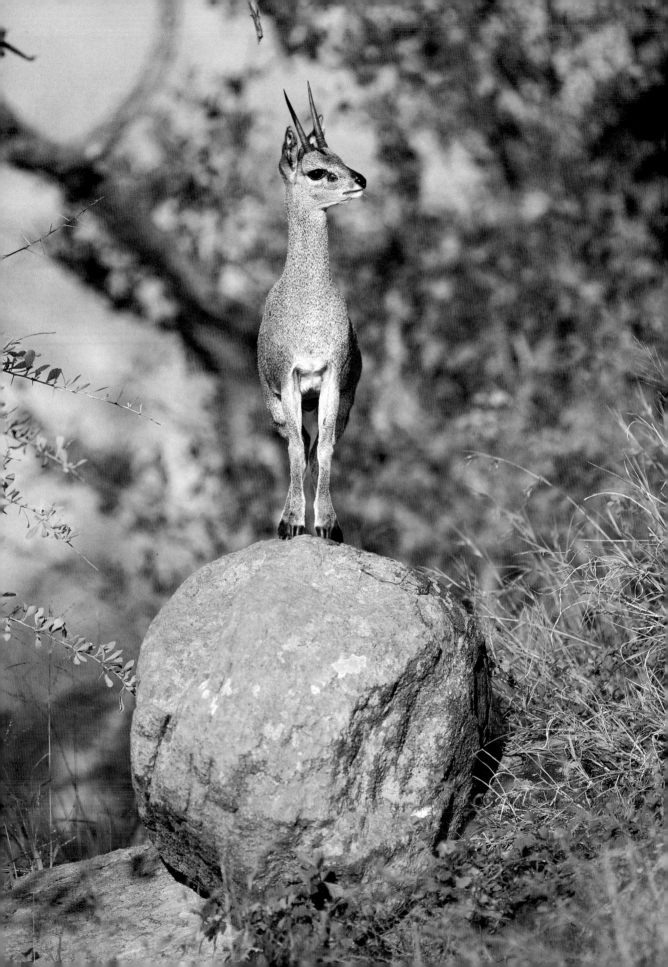

The klipspringer has no other relatives in the sub-region. In Afrikaans the word 'klipspringer' means rock jumper, since they occur on mountainous escarpments with rocky plateaux and outcrops.

Klipspringer
(Oreotragus oreotragus)

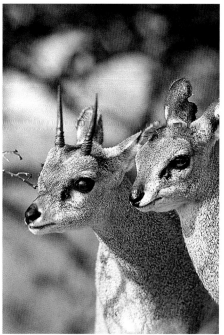

This sure-footed antelope lives on rocky outcrops and in mountainous areas (kopjes), and is independent of drinking-water sources. A browser, it feeds on leaves, shoots, berries, pods, flowers and succulents.

When you see one, look for its mate for it will almost certainly be close by. They form lifelong pair-bonds. The specialised hooves have flat tips, which enable it to bound up and down steep slopes. It can jump from rock to rock, landing on all fours on a small space. The hairs are hollow, flattened and spiny, springy in texture and adhere loosely to the skin. In bygone days, klipspringer hair was sought after for saddle stuffing because of these unique features.

Distribution: Due to its specialised habitat requirements the klipspringer has a patchy and discontinuous distribution. It is common on mountains of the Western Cape, the lower regions of the Orange River, up into Namibia and through to Angola. On the eastern side of the sub-region its distribution is patchy but widespread in Zimbabwe and the western parts of Mozambique.

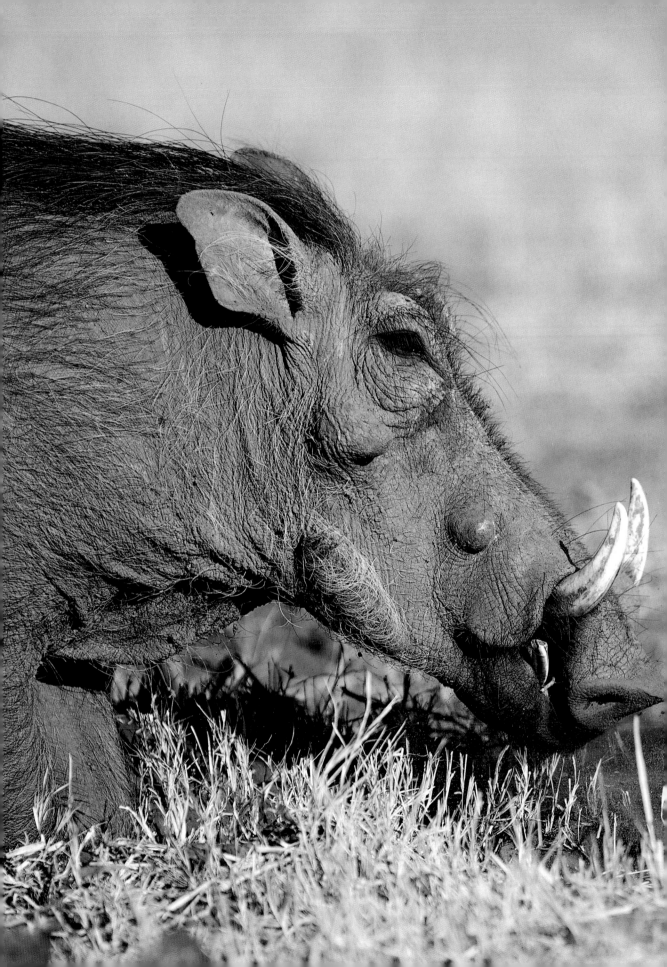

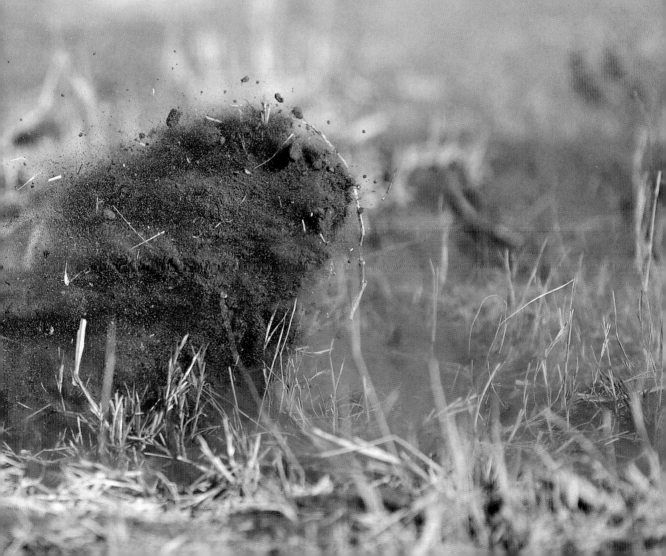

Other Mammals

This final chapter includes the rest of the mammal groups and species that have not featured so far. They are not arranged in any specific order but related species are kept together. The pigs are a little out of place here, since they are cloven-hoofed, and taxonomically belong to the group of hoofed animals in the second chapter. The pangolin, hedgehog and aardvark are single species without close relatives; the rodents are a huge group, but only a few interesting and representative species have been selected for inclusion; the hares, hyraxes, elephant shrews and primates make up the rest.

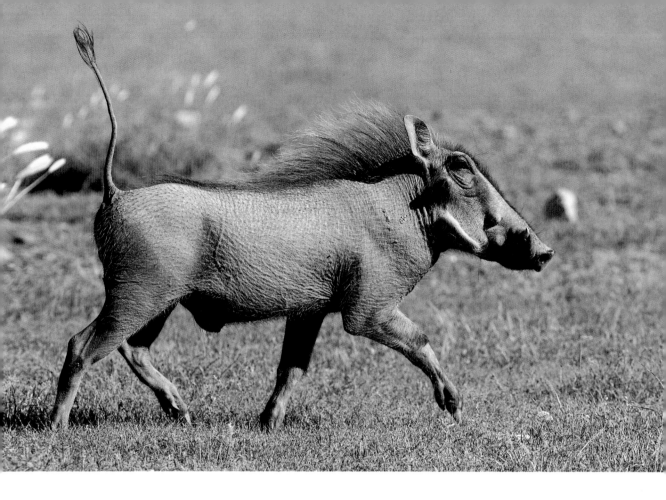

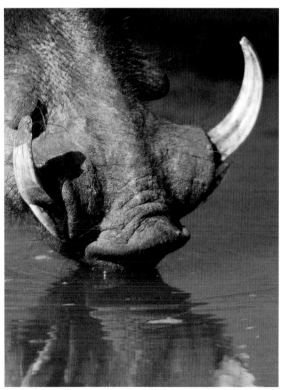

The bushpig and common warthog are the only two pig species in the sub-region. Both have similar four-digit front and hind feet. The two central digits bear the weight of the animal and have well-developed flattened hooves, while the outer digits do not reach the ground and have claw-like hooves.

Common Warthog
(Phacochoerus africanus)

Look for warthogs on floodplains, open areas, dry pans and around waterholes. They avoid dense cover and favour open short grassland with edible grasses, rhizomes, bulbs and tubers. Warthogs often drop down on the knees of their forelegs to dig more effectively, using their snouts. They do not depend on water sources, but nevertheless drink fairly regularly and enjoy mud-wallowing.

The warthog's foremost enemies are the lion and leopard. They defend themselves with their long canines called tushes. The lower ones are razor sharp and slightly curved but shorter than the upper ones, against which they are honed when the animal eats.

Distribution: The warthog occurs in the northern, northeastern and eastern parts of the sub-region. Isolated populations can be found in the southern parts.

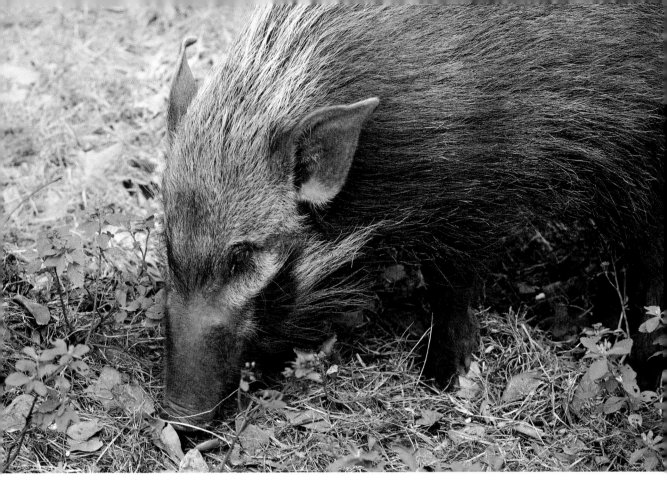

Bushpig
(Potamochoerus larvatus)

Look out for bushpigs in riverine vegetation where there are dense thickets or tall grass for cover. They are shy and highly nocturnal animals, seldom seen during the day. They eat virtually anything from plant matter, insects and worms, and occasionally even feed on carrion.

Bushpigs do not drop to their knees when rooting plants as warthogs do, nor do they have warts. Unlike warthogs, they run with their tails down and their tushes (tusks) are inconspicuous. Like warthogs, they enjoy mud-wallowing, probably to get rid of insects and for temperature control. They are aggressive and dangerous and their sharp tusks can inflict serious wounds.

Bushpigs are social animals and live in groups consisting of one dominant pair, subordinate sows and juveniles. Many farmers consider bushpigs as a major pest because they have a predilection for agricultural crops and can survive close to human settlements. Timber plantations and stands of invasive weeds often provide suitable cover where they can rest during the day. At night they use well-used paths to get to their feeding grounds.

Distribution: Bushpigs occur in forests, thickets, riparian underbush, reed beds and tall grass in the northern, eastern and southern coastal sectors of the sub-region.

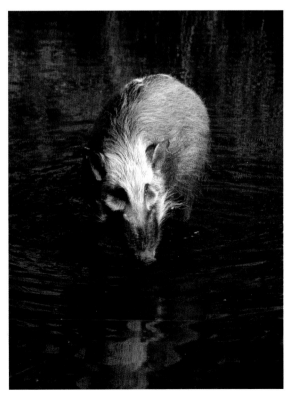

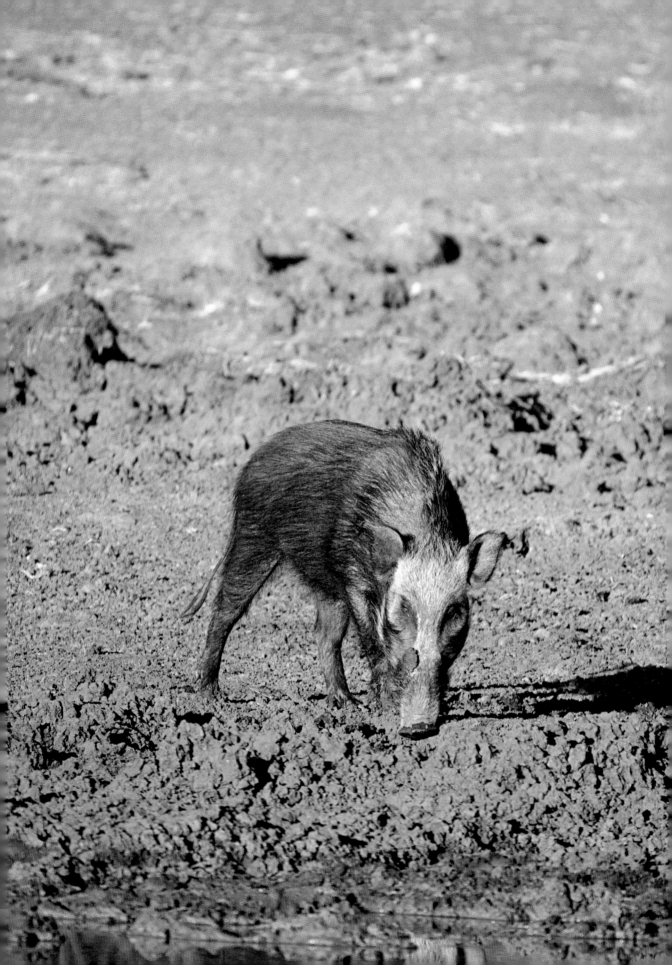

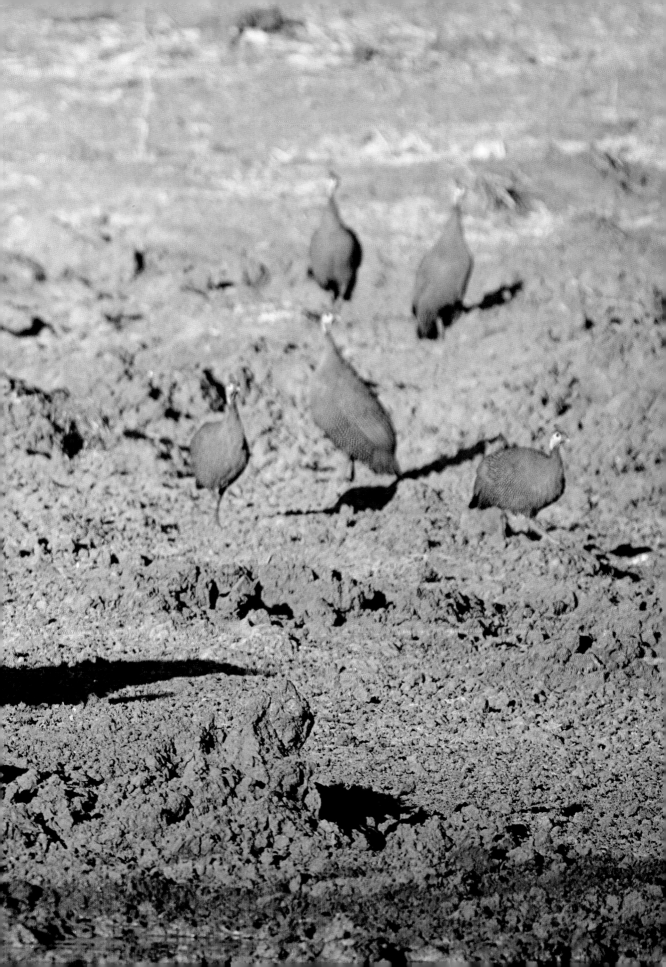

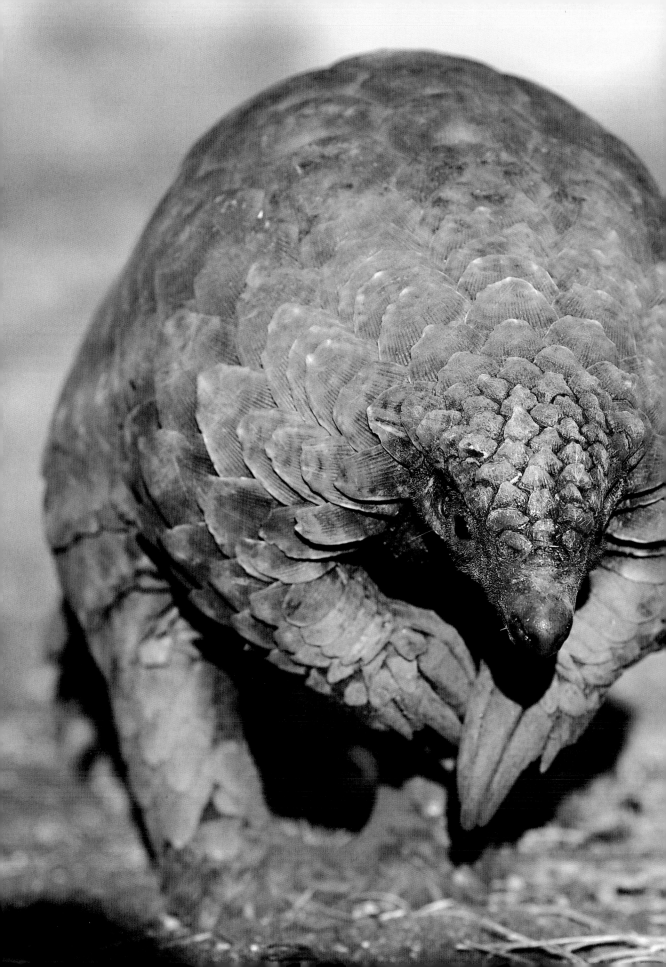

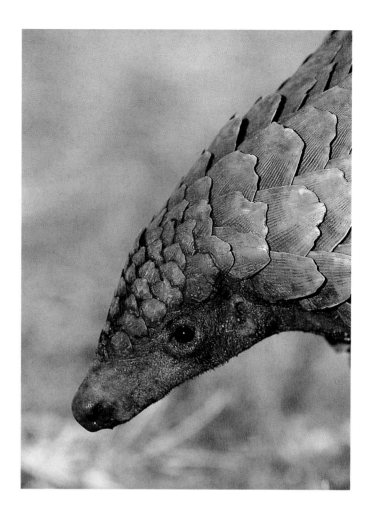

The pangolin has no other relatives in the sub-region. They are rare and secretive. Their survival is threatened by those who believe that pangolins have a medicinal value – they are often collected and killed for this reason.

Ground Pangolin
(Manis temminckii)

Look for pangolins on floodplain grasslands and rocky slopes where the soil is sandy. They feed mainly on ants and termites, using the claws on their forefeet to open underground food sources so they can lick up ants and termites with their long sticky tongue. Pangolins have no teeth and the food is ground up in the muscular part of the stomach, aided by grit. Pangolins are armoured with heavy yellow-brown scales. They walk on their hind legs with the tail off the ground, forelegs and head just above the ground. They defend themselves simply by rolling into a ball when threatened and are thus seldom preyed upon.

Distribution: The pangolin occurs widely but sparsely in Namibia (except in the south and in the coastal desert), Botswana, Zimbabwe, Mozambique and in the Northern Cape, North West Province, Limpopo, Mpumalanga, the central and southern parts of the Free State and northeastern KwaZulu-Natal in South Africa.

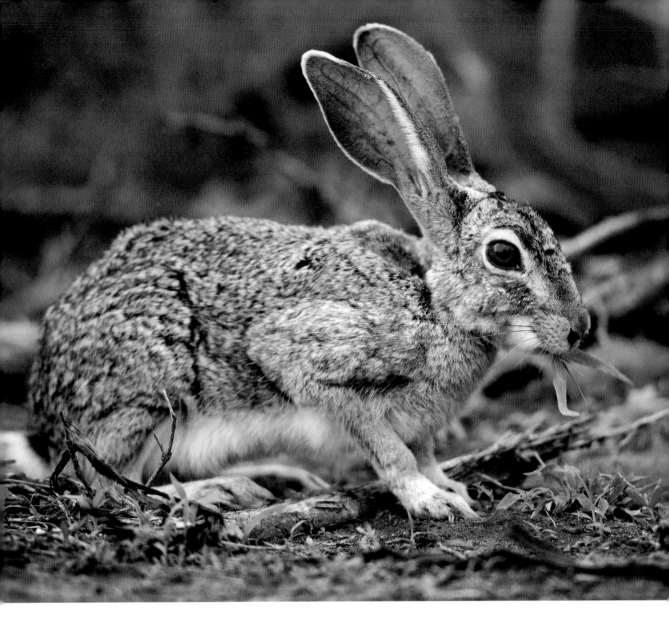

Apart from the confusion between the terms hare and rabbit, there is also confusion over fossil evidence of relationships with other groups. It was formerly believed that hares and rabbits were closely related to rodents, but new evidence indicates a closer relationship with the primates.

Many people confuse hares and rabbits. While both groups have longer hind legs than forelegs, this is less marked in rabbits. Hares live in open spaces and escape from predators by running, with frequent changes of direction. Rabbits, on the other hand, seek cover rather than run when they feel threatened. Rabbits keep their young in short fur-lined burrows since they require care and nursing after birth. The young of hares are born at a much more advanced stage of development and can soon fend for themselves.

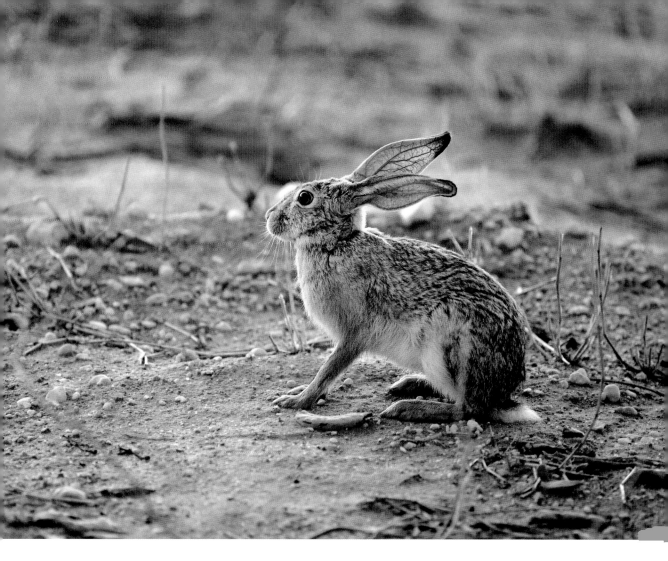

Scrub Hare (opposite)
(Lepus saxatilis)

The scrub hare is often seen on night drives or sunning itself during early mornings. It favours densely wooded areas with shrub cover and grazes on leaves, stems and green grass rhizomes.

The huge ears help with thermo-regulation. They are richly supplied with blood and help to dissipate heat when it is hot by exposing a large surface area to a cooling breeze. When it is cold, the hare sunbathes in the mornings to warm the blood. Its white belly and larger size distinguish it from the very similar Cape hare.

Distribution: The scrub hare is very common and widespread throughout the sub-region. It is only absent in the far western parts of the Northern Cape and Namibia.

Other species that are seldom seen on game drives and not featured here are: Smith's Rock Rabbit, Natal Red Rock Rabbit, Jameson's Red Rock Rabbit and Riverine Rabbit.

Cape Hare (above)
(Lepus capensis)

The Cape hare is very similar to the scrub hare, but it is much smaller and lighter in build. Although it has a wide distribution in the west and southwest of the sub-region, it also has a localised distribution in the north and east. It prefers more open country than the scrub hare – open grassland or grassland with light scrub cover.

The scrub hare, on the other hand, prefers a habitat that offers a substantial tall grass cover with woodland bushes and shrubs.

The variation in colour of the Cape hare makes it very difficult to identify on the basis of colour from the greyish, black-speckled fur of the scrub hare. In most Cape hares, there is, however, a narrow indistinct ochre-yellow margin between the white of the underparts and the darker speckled upper parts of the body.

Distribution: The Cape hare is widely distributed in the western and southwestern parts of the sub-region.

Rodents are the most successful group of mammals on Earth; they represent more than half of all living mammal species and are the most numerous with an enormous distribution range. Some live underground, others live in trees, but most are purely terrestrial. Many rodents are strictly nocturnal and are seldom noticed; the larger ones such as springhare and porcupines are more visible, as are those active during the day and around sunrise and sunset.

The main rodent groups are porcupines, mole rats, cane rats, dassie rats, springhares, squirrels, dormice, rats and mice. A few interesting and often-sighted species feature in this book.

Porcupine
(Hystrix africaeaustralis)

Look out for porcupines on night drives and in wooded areas where they may be seen feeding on the bark of trees, roots or bulbs. The back and hindquarters of this large rodent are protected by pliable spines, hard sharp quills, and flattened bristly hairs.

It is untrue that porcupines shoot their quills. When approached by a predator, they may rattle them and run backwards or sideways into the aggressor causing the sharp quills to penetrate the skin and frighten it away. The quills are modified hairs, hollow and robust, and are banded in white and black, the classic nocturnal warning colours.

Distribution: Porcupines are widespread throughout the sub-region.

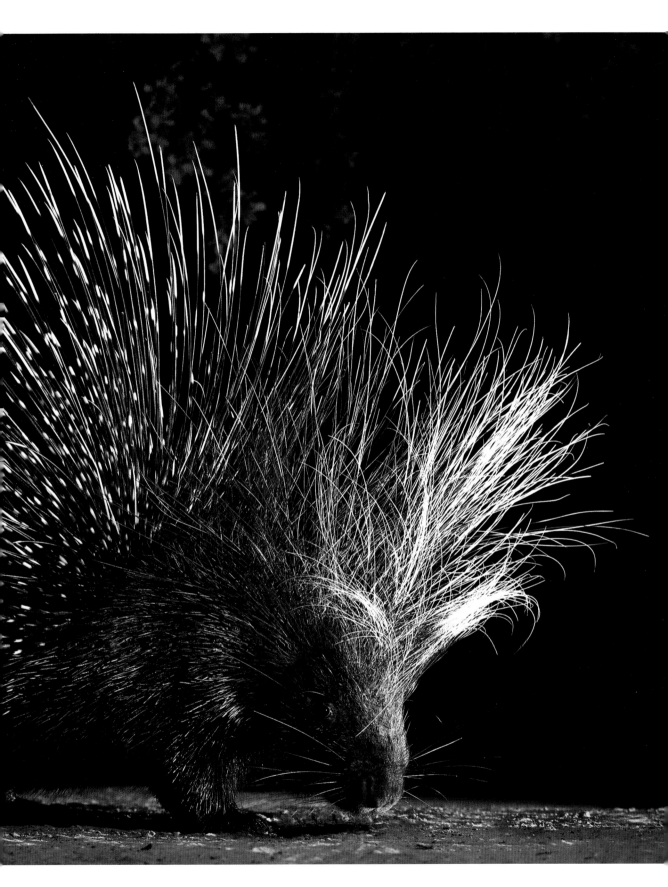

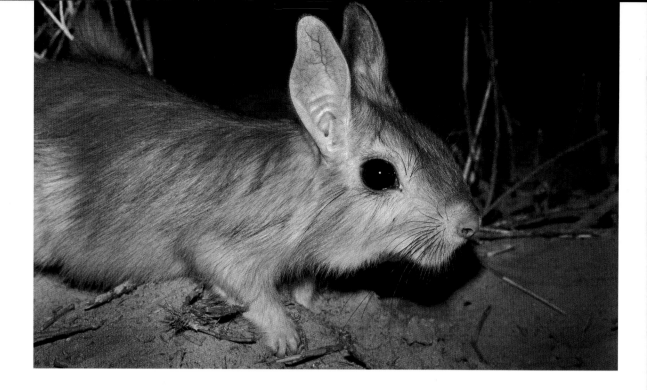

Springhare (above)
(Pedetes capensis)

Springhares bound and hop on their powerful hind legs, propelling themselves forward in a kangaroo-like manner while the tail provides balance. They occur widely in places where the soil is sandy and where they can easily dig burrows. Each animal has a single burrow with two entrances, one of which is a vertical escape route.

Springhares are not reliant on a water source but get all their moisture from dewdrops, rain and the plant material they feed on. Mainly grazers, they manipulate the food with their front feet to direct it into the mouth. They are rodents and can become pests in agricultural areas.

Distribution: Springhares are widespread in the sub-region, except in the southwest and extreme northern sections. They are also not found in eastern Mpumalanga, KwaZulu-Natal and the eastern most parts of the Eastern Cape.

Tree Squirrel (opposite)
(Paraxerus cepapi)

Look for tree squirrels huddling together in the forks of trees, grooming and sunning themselves in the morning sun. They are widespread but occur mainly in well-developed woodland regions, e.g. Mopane savannah.

Although usually a solitary rodent, the tree squirrel may form a family group during the breeding season. One may notice them when they decide to mob an intruder by making a loud chucking sound, while flicking their bushy tail over their body. It forages on the ground but when disturbed it tends to head for the nesting hole, which may mean scurrying up a tree and leaping from tree to tree. Close relatives not featured here are the Striped Tree Squirrel (left), Red Squirrel and Grey Squirrel.

Distribution: The tree squirrel is widespread in woodland in the northeastern parts of the sub-region.

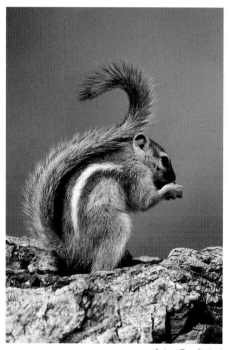

Striped Tree Squirrel

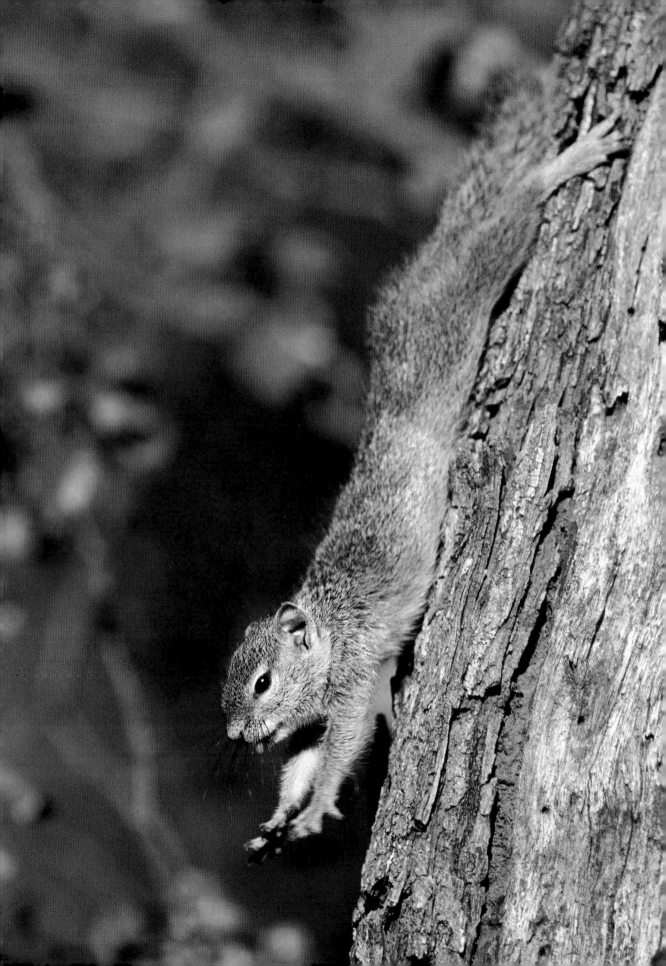

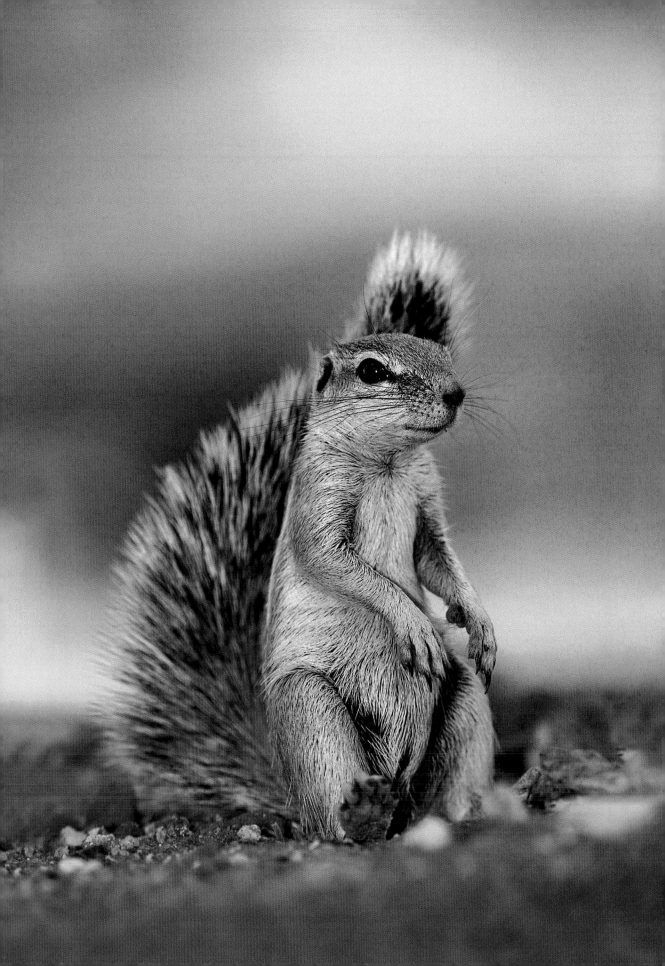

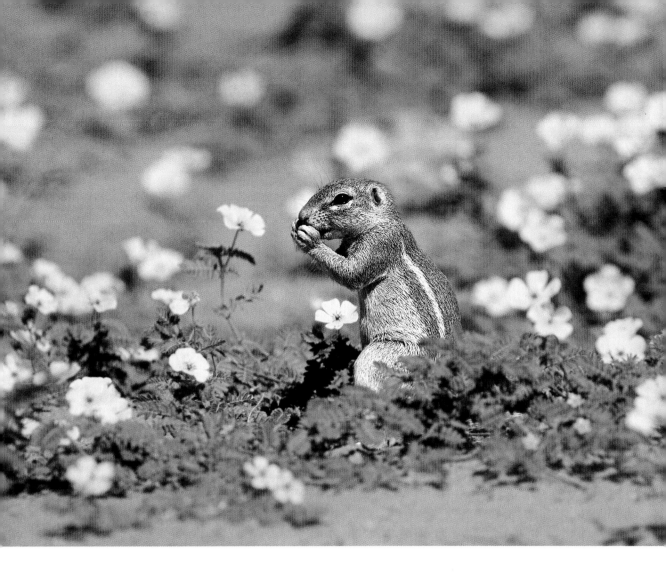

Ground Squirrel

(Xerus inauris)

Ground squirrels are widespread in the drier regions and they prefer open areas with sparse scrub on hard lime soils. They dig extensive tunnel complexes (warrens) that accommodate up to 30 animals. Males have a strict dominance hierarchy and they sleep away from the females in their own burrows. The females in a group share the bringing up of the pups.

The ground squirrels emerge only some time after sunrise and retire well before sunset. When they feed they bend the tail over the back, sheltering the body from the sun. They also use their tails as shields from rain and wind. The squirrels feed on insects, plants, seeds, bulbs and tubers.

Ground squirrels communicate danger, alarm, distress or aggressive feelings by uttering different calls. When communicating with their young, they utter softer sounds. When encountering a snake, they will usually harass it until it becomes unnerved and leaves the area.

Distribution: The ground squirrel occurs only in the drier areas of the central and western parts of the sub-region.

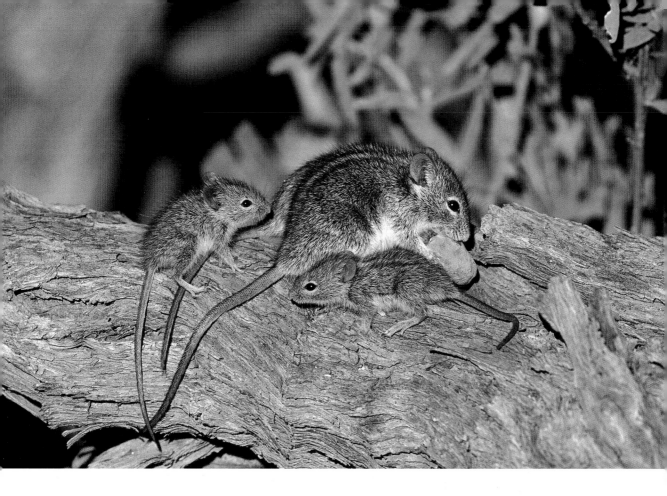

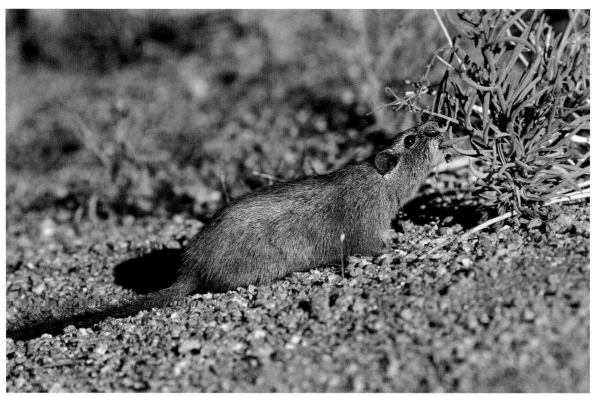

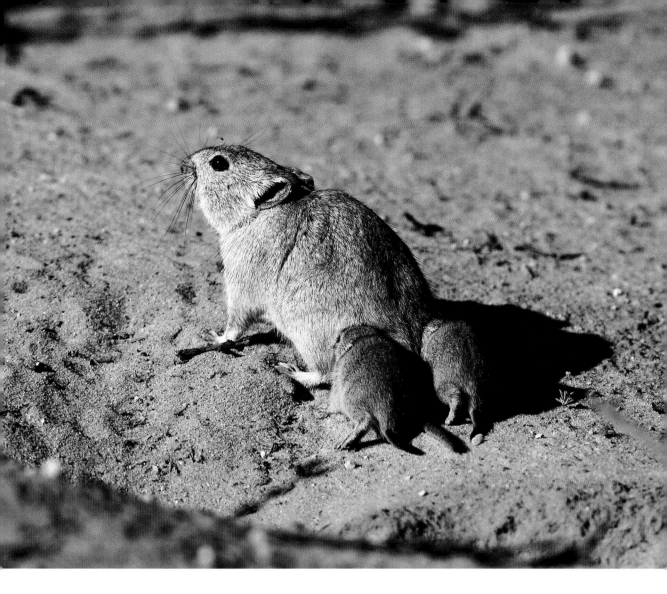

Brants' Whistling Rat (above)
(Parotomys brantsii)

The whistling rat is often encountered on game drives in the Kgalagadi Transfrontier Park in the early mornings when they are most active. They are often seen sunning themselves at burrow entrances. They live on stems and leaves of succulent plants.

Distribution: The whistling rat favours the semi-arid southwestern parts of the sub-region where the ground is dry and sandy.

Striped Mouse (opposite top)
(Rhabdomys pumilio)

The striped mouse is often seen on game drives after good summer rains. It serves as a food source for raptors and carnivores. Since they are diurnal they are still active until midmorning. The four distinct longitudinal stripes on the back are distinguishing characteristics.

Distribution: This mouse is widespread in the southern parts of the sub-region.

Dassie Rat (opposite)
(Petromys typicus)

This diurnal rat lives in family groups. To see one on a game drive is quite special in the Richtersveld National Park or any place in the western Namib where rocky shelters offer protection. They are often seen sunning themselves or jumping from rock to rock with great agility. Squirrel-like, they lack the bushy tail and are darker in colour, ranging from chocolate brown to dark grey.

Distribution: The dassie rat occurs all along the dry western extremity of the sub-region where there are rocks, from South Africa northwards to Angola.

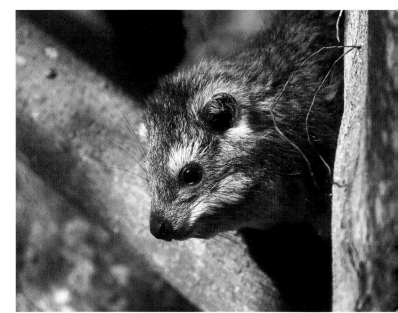

Tree Hyrax

The closest (yet very remote) relatives of hyraxes are elephants and dugongs. The relationship between the three groups is evident in the structure and patterns of the teeth, while other external features do not necessarily show much of a likeness. Like elephants, hyraxes have only one pair of enlarged upper incisors with a considerable space between them. All three groups lack canines. The molars are ridged and well developed to grind tough plant food rich in cellulose.

Rock Hyrax/Dassie
(Procavia capensis)

These small tailless creatures with their long bodies and short legs look like rodents but they have incisors that are modified into tusks like those of an elephant.

They inhabit rocks all over Africa, favouring those with a good north facing view, that are away from prevailing winds.

After leaving their shelters in the morning, hyraxes love to sunbathe and then later move down to feed on plants of all kinds in the area. The feet are well padded with glandular tissue to keep them moist for better traction when negotiating steep smooth rocks or tree trunks. The front feet have four digits, the back only three.

Distribution: The dassie is found on rocky outcrops over large parts of southern Africa. They are not found in the desert and central semi-arid areas that do not have rocky outcrops, or in forests and the lowlands of Mozambique.

Three hyrax species occur in southern Africa of which the rock hyrax is the commonest. The others are the Yellow-spotted Rock Dassie and the Tree Hyrax (above).

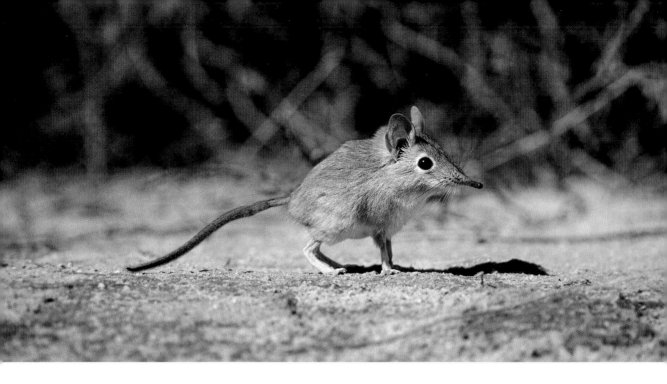

Elephant shrews occur nowhere else but in Africa. At first glance they may resemble true shrews and even rodents, yet they are very different. Only eight species occur in southern Africa. It may seem unusual to include these small creatures in a game drive book, but once sighted, these endearing creatures can offer hours of bush entertainment.

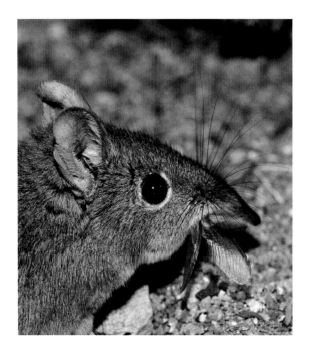

Elephant Shrew
(Family Macroscelididae)

These exceedingly mobile rodent-like mammals live on insects and move with lightning speed when they pursue prey or when running along paths from one shelter to the next. They have extraordinarily long, thinly-tapering, pink tongues to flick up insect prey. Their long trunk-like snouts as well as their broad, mobile, upright ears and large round eyes distinguish them clearly from true shrews and rodents.

When suddenly alarmed, they may jump straight up into the air before they dash into shelter. The different species prefer different habitats – the rock elephant-shrew prefers rocky habitats, while others such as the bushveld elephant-shrew favour sandy places, and the four-toed elephant-shrew inhabits the forest with dense undergrowth and scrub.

Elephant shrews drum their hind feet rapidly on the ground when alarmed; each species has its own particular drumming rhythm.

Only one species occurs in southern Africa.

Distribution: Elephant shrews are endemic to Africa and almost totally restricted to the sub-region. In the western parts of the sub-region the round-eared elephant shrew occurs in open country, the western rock elephant shrew on rocky outcrops except in desert areas and the bushveld elephant shrew in the arid Kalahari. The eastern rock elephant shrew, the short-snouted elephant shrew (also in north-eastern Namibia) and the Peters' short-snouted elephant shrew occur mainly towards the east. The Cape rock elephant shrew occurs in the far Western Cape with another population as well in the Eastern Cape between Port Elizabeth and Richmond.

South African Hedgehog
(Atelerix frontalis)

Only one hedgehog species occurs in southern Africa. These endearing little creatures are unmistakable because of the short spines covering most of the body and the dark-brown hair. A conspicuous white band runs across the forehead and the snout is sharply pointed. They snuffle and grunt noisily while they forage, feeding on anything from vegetable matter to invertebrates, small mice, birds' eggs and lizards. They may be sighted on night drives or during the day after rains.

Distribution: Hedgehogs occur in two distinct areas within the sub-region – northern Namibia and the area from Zimbabwe, through the eastern parts of Botswana and down the central parts of South Africa almost to Port Elizabeth.

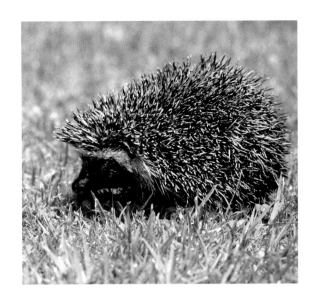

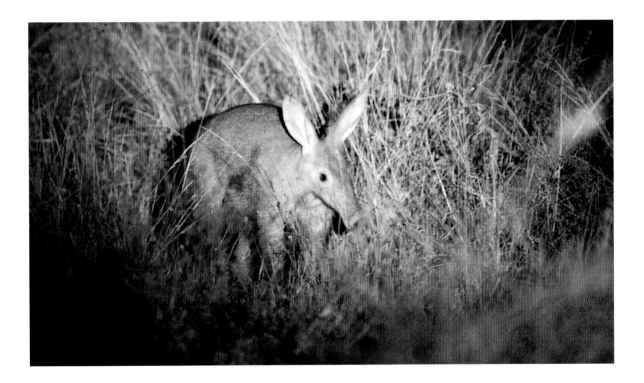

The aardvark is the only surviving species and it has no close living relatives.

Aardvark/Antbear
(Orycteropus afer)

The aardvark only starts foraging late at night and is therefore seldom seen on drives. Although these animals have pig-like snouts, they are not related to pigs at all. They use their powerful forelegs to excavate burrows where they live and also to excavate the nests of formicid ants and, to a lesser extent, termites.

The aardvark locates its food source by its acute sense of smell complemented by a good sense of hearing. Their large ears are movable and help to detect movement and the presence of danger. Their eyesight, however, is very poor.

Distribution: The aardvark is widespread throughout the sub-region but is not found in forests and desert.

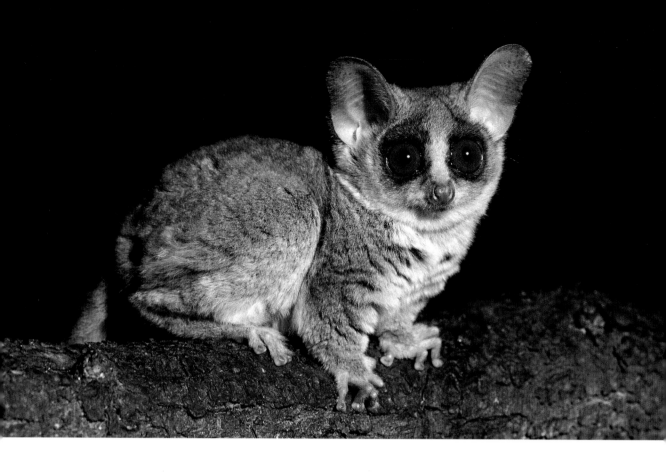

In the sub-region there are two primate groups – the galagos, and the monkeys and baboons – each with three species. Galagos are commonly known as bushbabies and in Afrikaans as 'nagapies' – 'little nocturnal monkeys'. They are small and have large round eyes, which are almost immovable within their sockets. They show limited facial expression, drink by lapping, and the females have two pairs of teats. With opposable thumbs and a big gap between the index finger and the others, galagos are well adapted for living in trees. Monkeys and baboons are much larger and intensely social. The vervet monkey is the most prevalent African monkey, while the chacma baboon has an extremely wide distribution and occurs almost throughout the sub-region.

Lesser Galago/Bushbaby
(Galago moholi)

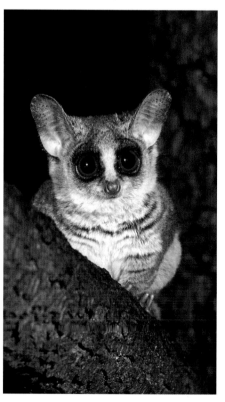

Look for this tiny primate in woodland with typical acacia stands. Acacias are a source of gum and have a rich insect life, both important food items for the bushbaby. Its eyes are noticeably large in relation to its head.

It lives in the dense canopies of trees, resting during the day in groups of up to six on a platform-like nest. It sleeps curled up on its side, covered by its tail. The nests are constructed from leaves or tangles of vegetation, often in holes of trees. It is extremely agile and able to leap a few metres at a time. On the ground it hops, using its hind legs only.

Distribution: The lesser galago inhabits woodland savannah throughout almost the entire northern and upper eastern parts of the sub-region.

180

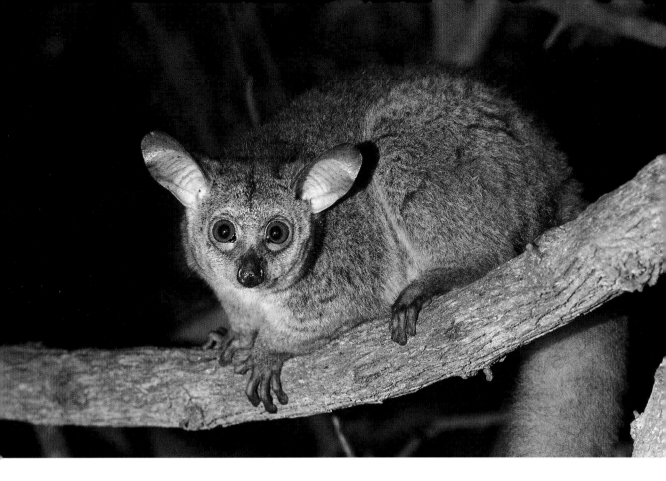

Thick-tailed Bushbaby
(Otolemur crassicaudatus)

This animal is associated with well-developed woodland where there is tree gum to be found. It is often heard in rest camps at night. Its raucous, crow-like cries attract attention, not only from their own companions, but also from rivals. It rests in nests in trees during the day and emerges after sunset, first to groom and then to forage.

Their eyes are smaller in relation to their head size than the lesser galago, but they also shine brightly in the darkness with a reddish glow if they are caught in a beam of light. They run along branches, with short jumps where necessary. On the ground they move on all fours with hindquarters and the tail held high.

Distribution: The thick-tailed bushbaby occurs in forests and thickets in the eastern and northeastern parts of the sub-region.

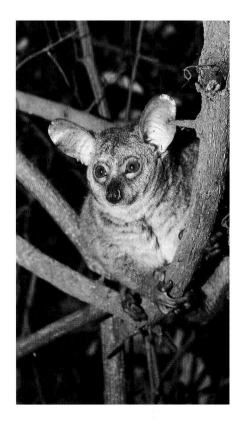

Vervet Monkey
(Cercophitecus pygerythrus)

Monkeys are often found in vegetation close to streams or rivers. They live in troops of family groups, favouring areas with trees for shelter, and they eat mostly plant material. They also eat insects, lizards, birds' eggs and nestlings.

The troop has a dominant male that maintains his status with grimacing and threatening gestures. Grooming is a way of cleaning and neatening the fur, getting rid of ticks, scabs, flakes of skin and salty deposits caused by perspiration. But the activity is also a way of building bonds and alliances between individuals, and reinforcing hierarchies.

Distribution: The vervet monkey occurs in woodland savannah throughout the entire sub-region, i.e. the northern parts (Namibia, Caprivi, Chobe, Okavango, Zimbabwe) and eastern parts (Mozambique, north-eastern South Africa down to the south) and along the Orange and Vaal rivers.

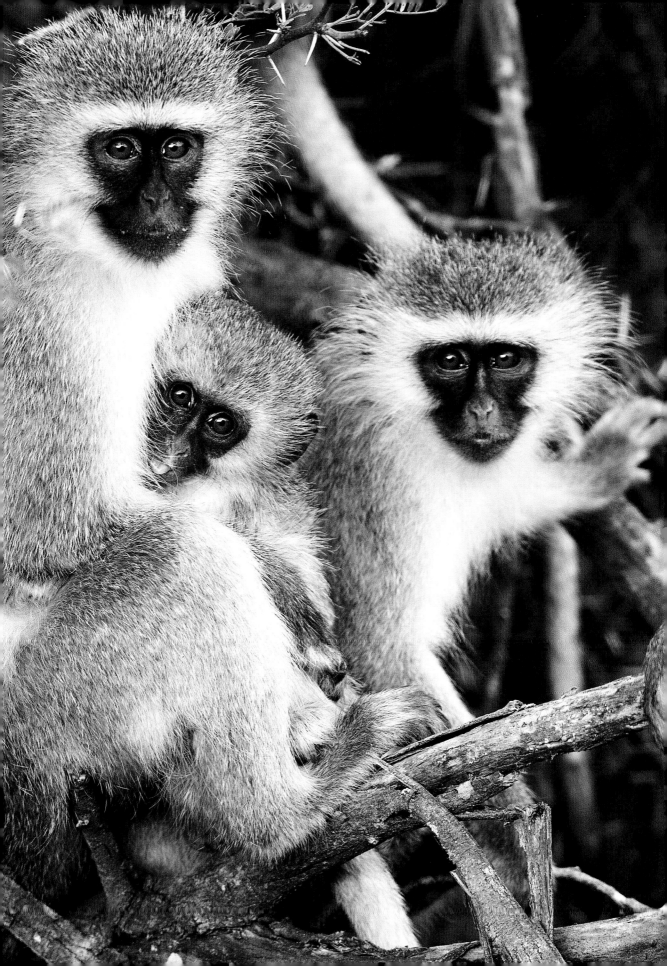

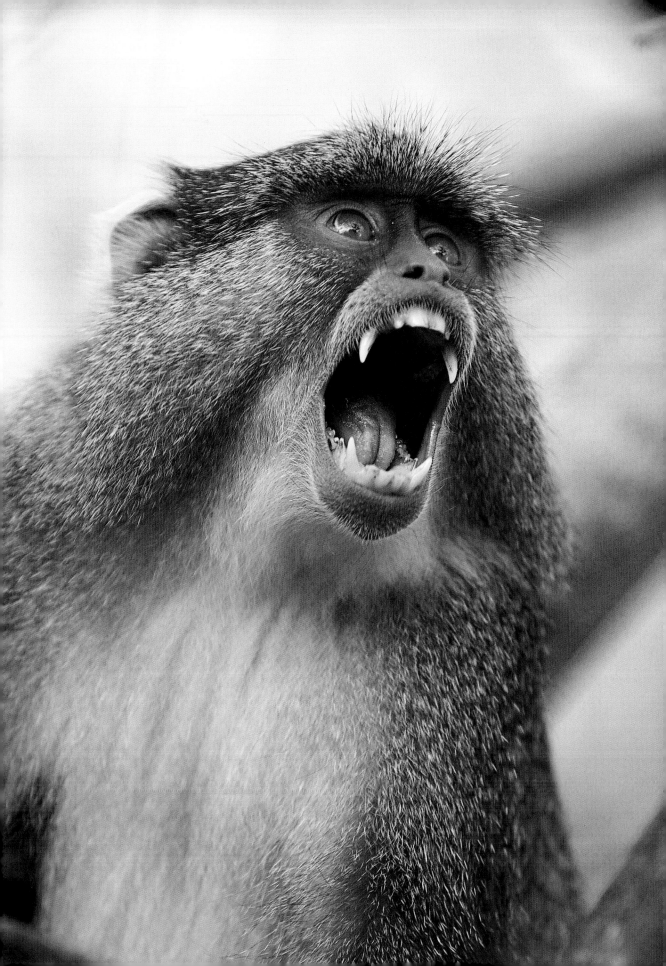

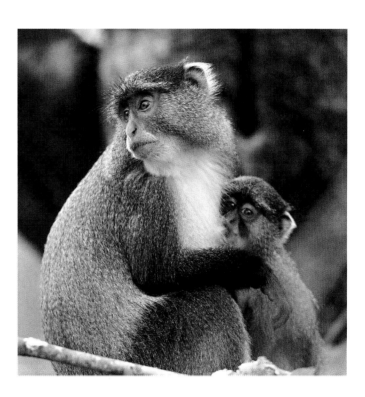

Sykes or Samango Monkey

(Cercopythecus albogularis)

The Sykes monkey resembles the vervet monkey but it is slightly larger, occurs only in the eastern part of the sub-region and is confined to a forest habitat. It is also darker in colour, with the shoulders, limbs and tail in black; its back down to its tail is suffused with a reddish brown colour.

It lives in troops of up to 30 and the adult males vocalise with a loud booming call when they encounter another troop. While foraging, females may chuckle and chatter. Alarm calls are emitted when danger is suspected. The females and juveniles utter a high-pitched bird-like call when disturbed.

Distribution: The Sykes monkey occurs only in forested areas on the eastern parts of the sub-region.

185

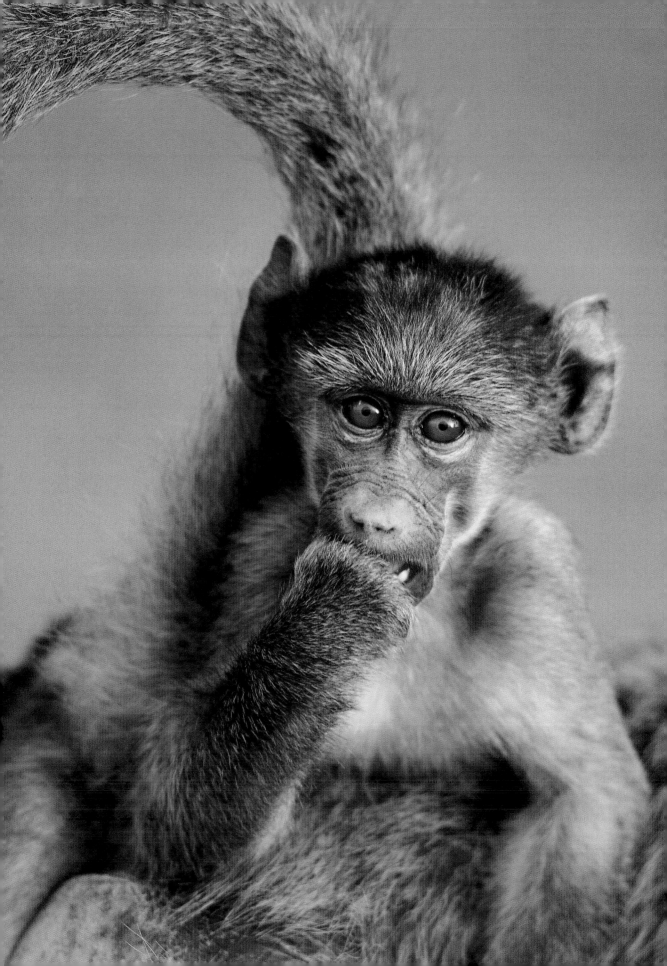

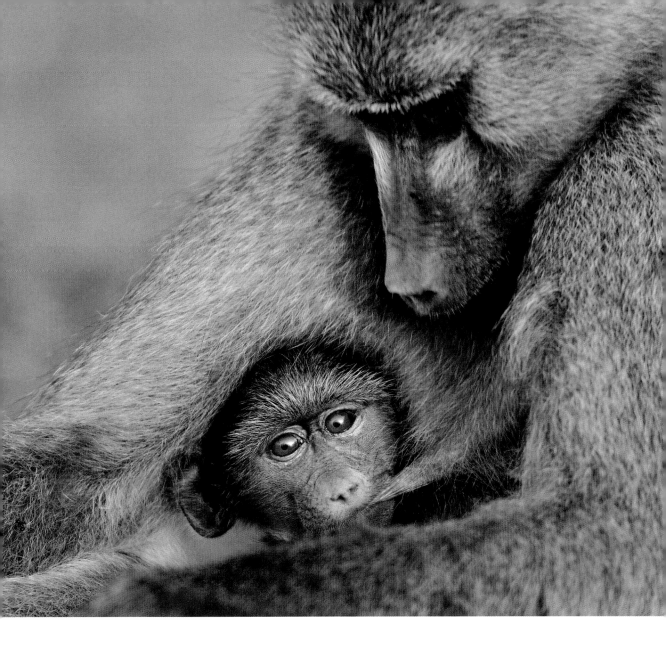

Chacma Baboon
(Papio ursinus)

This species occurs throughout southern Africa's savannah areas, wherever there is water and secure sleeping places. Baboons are often seen as the troop moves from its sleeping tree to foraging grounds. They eat almost anything – grasses, seeds, flowers, fruits, tubers and bulbs, insects, frogs, reptiles, eggs and even small mammals.

When a troop is feeding or on the move, certain individuals, usually males, will climb on to vantage points to scan the environment for potential danger. Loud barking is usually an alarm call that warns the troop of danger. These lookouts also help to protect the juveniles by keeping them from straying.

Distribution: This baboon is widely located over the entire sub-region except in very arid parts.

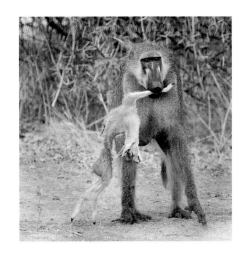

Map of Biomes in the Southern African Sub-region

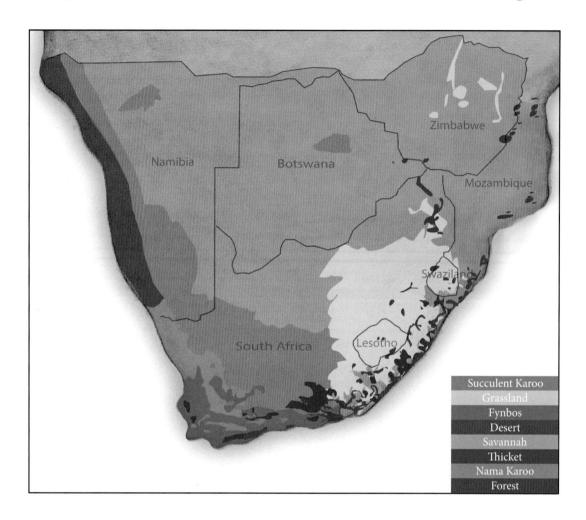

Legend:
- Succulent Karoo
- Grassland
- Fynbos
- Desert
- Savannah
- Thicket
- Nama Karoo
- Forest

The physical nature of any area in southern Africa is determined by its geology and topography, which in turn influences the climate. The two climatic factors rainfall and temperature determine which plants will occur; these plants attract the plant-eating animals that will feed on them and these animals in turn become the prey of predatory carnivores. These components form the basis of plant and animal distribution patterns in the sub-region.

Such an area with a similar geological history and climate that gives rise to distinctive plant and animal communities is called a biome. In the sub-region seven (some say eight) such biomes can be distinguished. They are: Desert, Succulent Karoo, Nama Karoo, Savannah, Forest, Grassland and Fynbos. Albany Thicket is regarded as an eighth biome by some scientists.

Mammals have developed physiological and behavioural adaptations to enable them to survive in the different biomes. Some have a wide range of tolerance for extreme physical conditions and are found in various habitats. Others can survive only in areas that meet their specific requirements.

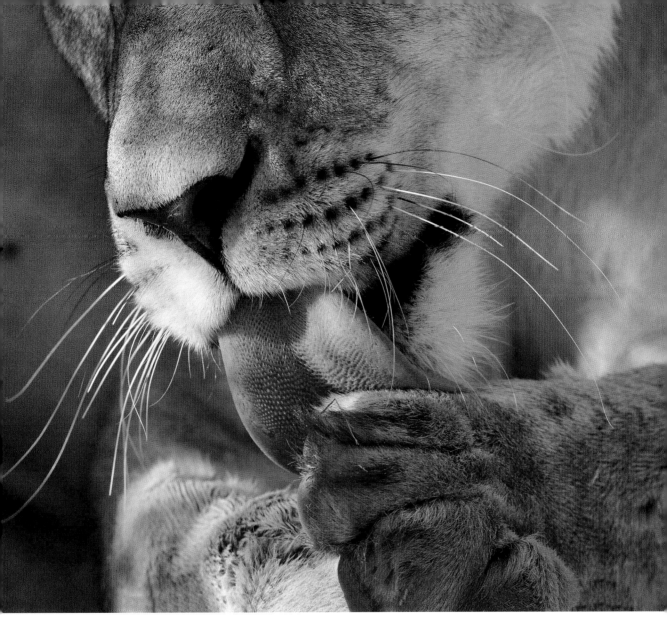

The Desert biome: the mean annual rainfall ranges from 13mm in the west to 85mm in the east. The dominant plant forms are annuals.

The Succulent Karoo biome: the mean annual rainfall here is 20mm – 290mm, falling mostly during winter, but in some places during summer. The dominant plant forms are dwarf shrubs.

The Nama-Karoo biome: the mean annual rainfall here is 100mm – 520mm in summer and autumn. The dominant plant forms are dwarf shrubs and grasses.

The Savannah biome: the mean annual rainfall is 230mm – 500mm, mainly in summer and autumn. The dominant plant forms are grasses, shrubs and trees.

The Forest biome: the mean annual rainfall is 525mm in winter and 725mm in summer. No frost occurs. The dominant plant forms are evergreen tall trees.

The Grassland biome: the mean annual rainfall varies from 400mm to 2 000mm. Frost occurs 30 to 180 days per year. The dominant plant forms are grasses.

The Fynbos biome: the mean annual winter rainfall here is 210mm – 3 000mm, with mist precipitation as well as actual rain. The dominant plant forms are evergreen shrub-like plants with small firm leaves and woody plants with hard, broad and leathery leaves.

The Albany Thicket biome: the mean annual winter rainfall here is 450mm – 500mm. The dominant vegetation is shrubland, low forest, evergreen succulents and thorny shrubs.

National Parks and Major Game Reserves in Southern Africa

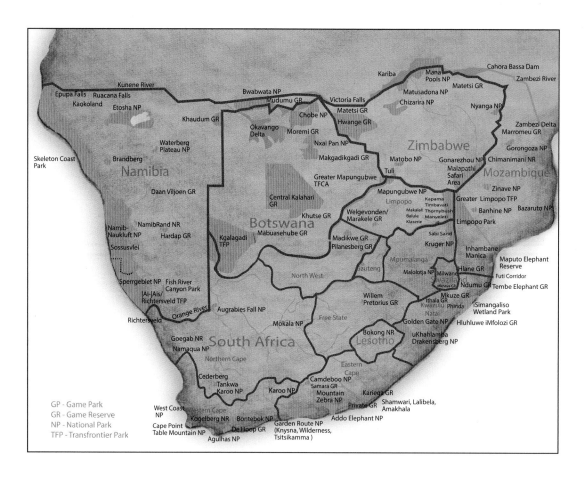

TRANSFRONTIER PARKS IN SOUTHERN AFRICA

Established Transfrontier Parks (TPs) and Transfrontier Conservation Areas (TFCAs):

|Ai-|Ais/Richtersveld TP; Kgalagadi TP; Great Limpopo TP; Kavango/Zambezi TFCA; Lubombo TFCA; Maloti-Drakensberg TFCA.

In process of establishment and at a conceptual stage*:

Chimanimani TFCA; Greater Mapungubwe TFCA; Iona-Skeleton Coast TFCA; Lower-Zambezi-Mana Pools TFCA.*

SOUTH AFRICA

Established National Parks:

Greater Addo Elephant; Agulhas; Augrabies; Bontebok; Camdeboo; Garden Route (Knysna, Tsitsikamma, Wilderness); Golden Gate Highlands (QwaQwa); Karoo; Kgalagadi Transfrontier Park (shared with Botswana); Kruger; Mapungubwe; Marakele; Mokala; Mountain Zebra; Namaqua; Table Mountain; Tankwa; West Coast; |Ai-|Ais/Richtersveld Transfrontier Park (shared with Namibia).

Other established large Game Reserves:

Makalali; Balule; Klaserie; Kapama; Timbavati; Thornybush; Andover; Manyeleti; Sabi Sand; Blyde River Canyon; Lepalala; Waterberg; Madikwe; Pilanesberg; iSimangaliso; Mkhuzi; Phinda; Ithala; Tembe; Ndumo; Hluhluwe-iMfolozi; uKhahlamba-Drakensberg; Nambiti; Kariega; Shamwari; Lalibela; Amakhala; Samara; De Hoop; Kogelberg; Goegab.

BOTSWANA

Established National Parks and established Game Reserves:

Chobe; Makgadikgadi/Nxai Pans; Kgalagadi Transfrontier Park (shared with South Africa); Central Kalahari; Khutse; Moremi.

ZIMBABWE

Established National Parks:

Chimanimani GR; Chizarira NP; Gonarezhou NP; Hwange GR; Lake Kariba; Mana Pools NP; Matobo NP; Matusadona GR; Nyanga NP; Victoria Falls; Zambezi.

Other established Safari Areas:

Malapati Safari Area; Matetsi; Tuli Block.

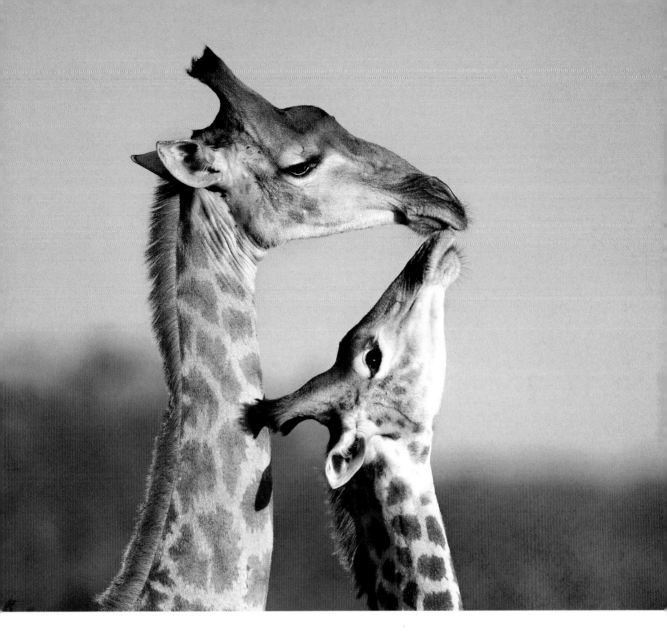

NAMIBIA

Established National Parks and other established Game Reserves:

|Ai-|Ais/Richtersveld (shared with South Africa); Bwabwata NP; Etosha NP, Mudumu NP, Hardap, Khaudum Game Park, Namib Naukluft Park; Namib Rand Nature Reserve; Sperrgebiet Park; Skeleton Coast Park; Tsaobis Leopard Nature Park; Waterberg Plateau GR.

MOZAMBIQUE

Established National Parks and Conservation Areas:

Banhine; Bazaruto; Gorongosa; Limpopo; Quirimbas Archipelago; Zinave; Maputo Elephant Reserve; Marromeu Buffalo Reserve; Chimanimani National Reserve; Futi Corridor; Coutada 4 – 15 in Manica and Sofala.

SWAZILAND

Established National Park and other Conservation Areas:

Hlane Royal National Park; Mlilwane Wildlife Sanctuary; Mkhaya GR; Malolotja.

LESOTHO

Established National Game Reserve and Conservation Area:

Bokong Nature Reserve; Maloti-Drakensberg Transfrontier Conservation Area.

Table of Comparison: Mammals of Southern Africa

	Male size: SH or NT; cm	Male mass/ weight kg	Gestation period d or m	Active period	Life expectancy years
Killers and scavengers					
Black-backed Jackal	SH 38cm	8kg	60–65d/2m	(o) (10y
Side-striped Jackal	SH 40–48cm	9kg	57–60d/2m	(o) (10y
African Wild Dog	SH 75cm	25kg	70d/2.5m	o	10y
Spotted Hyena	SH 79.4cm	62.5kg	110 d/4m	(o) (20–25y
Brown Hyena	SH 70–80cm	40kg	90d/3m	(o) (20–25y
Lion	SH 1200cm	190kg	105d/3.5m	(o) (20y
Leopard	SH 77cm	63kg	106d/3.4m	(o) (20y
Cheetah	SH 90cm	65kg	90–98d/3m	o	15y
Caracal	SH 48cm	13kg	62–81d/2–3m	(o) (12y
Aardwolf	SH 50cm	9kg	90–100d/3m	(o) (25y
Bat-eared Fox	SH 40cm	4kg	60–75d/2.3m	(o) (?
Cape Fox	SH 30cm	3kg	52d/1.7m	(o) (10y
Serval	SH 60cm	11kg	73d 2.4m	(o) (12–17y
African Wild Cat	SH 35cm	5.1kg	62d/2m	(12–18y
Black-footed Cat	NT 43cm	1.7kg	63d/3m	(?
Large-spotted Genet	NT 95cm	1.8kg	70d/2.6m	(9–10y
Small-spotted Genet	NT 105cm	2.6kg	70d/2.5m	(10y
African Civet	NT 35cm	16kg	80d/2.7m	(15y
Striped Polecat	NT 56cm	0.97kg	36d/1.1m	(?
African Striped Weasel	NT 41cm	2.6kg	36d/1.1m	(?
Honey Badger	NT 95cm	12kg	70d/2m	(o) (24y
Cape Clawless Otter	NT 1.3cm	20kg	61d/2m	o (14y
Spotted-necked Otter	NT 91cm	28kg	60d/2m	o	?
Suricate	NT 55cm	0.62kg	70d/2.5m	o	?
Slender Mongoose	NT 65cm	0.715kg	56–63d/2m	o	15y
Banded Mongoose	NT 33cm	1–2kg	56–63d/2m	o	13y
Water Mongoose	NT 85cm	3.4kg	72d/2.5m	o	
Dwarf Mongoose	NT 40cm	0.4kg	54d/2m	o	10y
Cape Grey Mongoose	NT 65cm	0.9kg	?	o (()	?
Yellow Mongoose	NT 60cm	0.8kg	60d/3m	o	?
White-tailed Mongoose	NT 110cm	4.49kg	?	(12y
The Giants					
African Elephant	SH 3450cm	6000kg	616d/22m	o (60y
Hippopotamus	SH 1500cm	1546kg	225–257d/8m	(o) (54y
White Rhino	SH 1800cm	2000kg	480d/16m	o (45y
Black Rhino	SH 1600cm	1000kg	460d/15m	o (45y
Giraffe	SH 3000cm	1192kg	457d/15.2m	o (()	28y
African Buffalo	SH 1700cm	750kg	343d/11.5m	o (25y
Plains Zebra	SH 1300cm	313kg	360d/12m	o (35y
Cape Mountain Zebra	SH 1300cm	250kg	364d/12m	o (20y
Hartmann's Mountain Zebra	SH 1500cm	300kg	364d/12m	o (20–26y

Antelopes

Greater Kudu	SH 1450cm	220kg	270d/9m	o (11y
Eland	SH 1700cm	1034kg	274d/9m	o (12y
Sitatunga	SH 1250cm	115kg	220d/7m	o (()	13y
Bushbuck	SH 79cm	80kg	180d/6m	(o) (9y
Nyala	SH 106cm	106kg	220d/7m	(o) (9y
Springbok	SH 75cm	41kg	168d/5.4m	o (19y
Impala	SH 90cm	44kg	196d/6.5m	o	?
Blue Wildebeest	SH 1500cm	249.8kg	250d/8.4m	o (?
Black Wildebeest	SH 1200cm	134kg	239–262d/8.3m	o (20y
Red Hartebeest	SH 1300cm	150kg	240d/7.7m	(o) (18y
Tsessebe	SH 1260cm	130kg	240d/8m	o (9y
Blesbok	SH 95cm	70kg	240d/8m	o	?
Bontebok	SH 90cm	60kg	234d/8m	o	12–15y
Roan Antelope	SH 1400cm	270kg	276d/9m	o (19y
Sable Antelope	SH 1350cm	230kg	266d/8m	o (9y
Oryx or Gemsbok	SH 1200cm	240kg	264d/8m	o (18y
Waterbuck	SH 1300cm	270kg	280d/8.5m	o (12y
Southern Reedbuck	SH 900cm	70kg	225d/8m	(o) (9y
Red Lechwe	SH 1000cm	120kg	225d/8m	o (15y
Puku	SH 800cm	75kg	240d/8m	o (?
Grey Rhebok	SH 80cm	30kg	261d/9m	o	12y
Mountain Reedbuck	SH 75cm	31kg	240d/8m	o (10y
Common Duiker	SH 50cm	16.2kg	191d/6.3m	o (9y
Red Duiker, Blue Duiker	SH 43cm	11.7kg	210d/7m	o	9y
Klipspringer	SH 60cm	10.6kg	150–225d/5–7m	o	?
Sharpe's Grysbok	SH 45cm	7.7kg	210d/7m	o (?
Cape Grysbok	SH 54cm	10kg	192d/6m	(o) (?
Steenbuck	SH 50cm	10.9kg	168–173d/6m	o (9y
Oribi	SH 58cm	15kg	210d/3m	o (()	?
Damara Dik-dik	SH 58cm	5kg	160d/5.5m	(o) (?
Suni/ Livingstone's Antelope	SH 35cm	5kg	172d/6m	o (?

Other Mammals

Common Warthog	SH 68cm	79kg	182d/6m	o	20y
Bushpig	SH 70cm	72kg	119d/4m	(20y
Ground Pangolin	NT 100cm	13.3kg	139d/4.7m	(12y
Rock Hyrax	NT 58cm	5.8kg	230d/8m	o	14y
Scrub Hare	NT 55cm	2kg	42d/1.4m	(5–6y
Cape Hare	NT 45cm	1.6kg	42d/1.5m	(?
Springhare	NT 35cm	3kg	75d/2.5m	(8y
Cape Porcupine	NT 100cm	11.5kg	93d/3m	(15–20y
Ground Squirrel	NT 45cm	0.65kg	45d/1.5m	o	?
Tree Squirrel	NT 35cm	0.2kg	56d/1.8m	o	15y
Chacma Baboon	SH 75cm	32kg	183d/6m	o	30–45y
Vervet Monkey	NT 114cm	5.5kg	165d/5.5m	o	30y
Samango Monkey	NT 1400cm	9.3kg	140d/4.5m	o	?
Lesser Bushbaby or Galago	NT 37cm	1.65kg	121d/4m	(14y
Thick-tailed Bushbaby	NT 71cm	1.2kg	132d/4.2m	(15y
Aardvark	NT 1700cm	45kg	243d/8m	(10y

Index and Distribution Maps

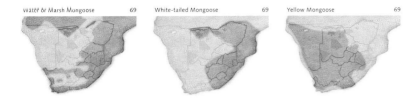

The Giant Herbivores 71

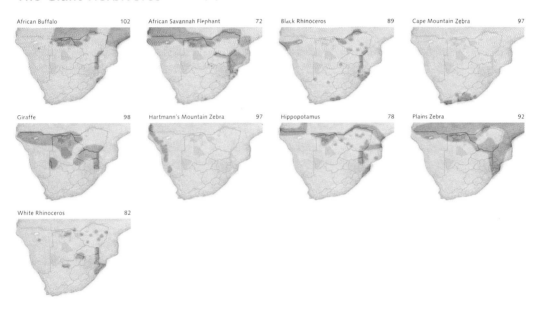

The Antelopes 107

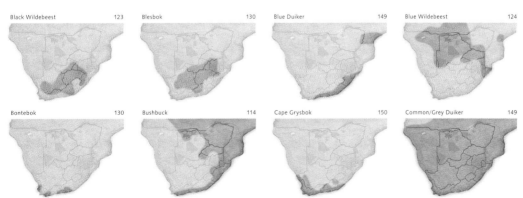

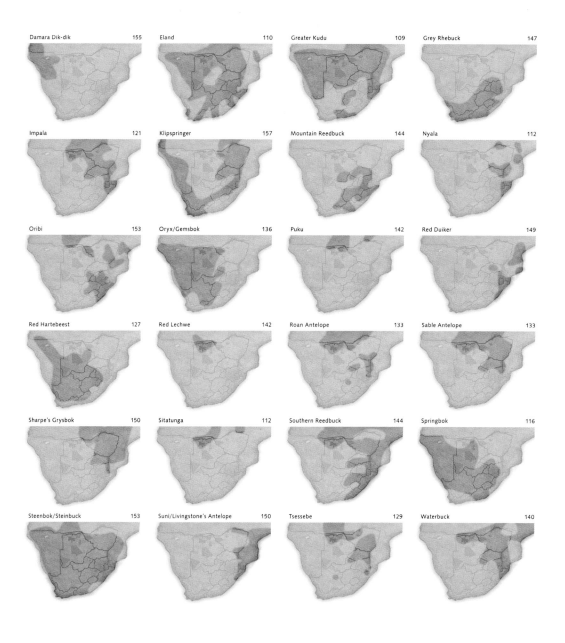

Damara Dik-dik	155	Eland	110	Greater Kudu	109	Grey Rhebuck	147
Impala	121	Klipspringer	157	Mountain Reedbuck	144	Nyala	112
Oribi	153	Oryx/Gemsbok	136	Puku	142	Red Duiker	149
Red Hartebeest	127	Red Lechwe	142	Roan Antelope	133	Sable Antelope	133
Sharpe's Grysbok	150	Sitatunga	112	Southern Reedbuck	144	Springbok	116
Steenbok/Steinbuck	153	Suni/Livingstone's Antelope	150	Tsessebe	129	Waterbuck	140

Other Mammals 159

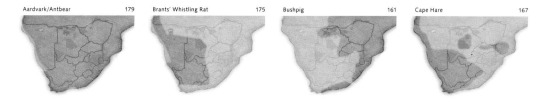

| Aardvark/Antbear | 179 | Brants' Whistling Rat | 175 | Bushpig | 161 | Cape Hare | 167 |

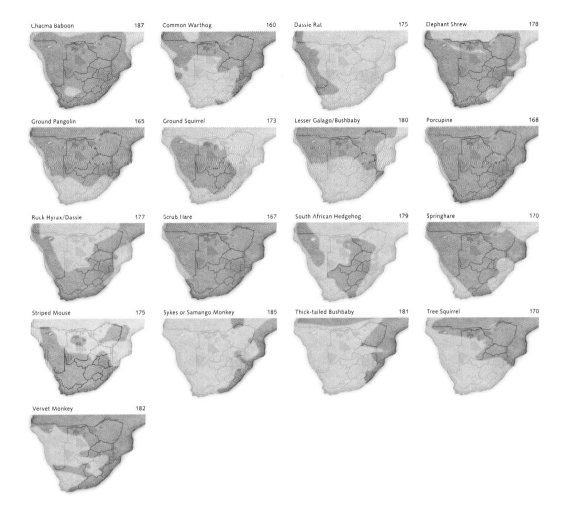

Chacma Baboon 187

Common Warthog 160

Dassie Rat 175

Elephant Shrew 178

Ground Pangolin 165

Ground Squirrel 173

Lesser Galago/Bushbaby 180

Porcupine 168

Rock Hyrax/Dassie 177

Scrub Hare 167

South African Hedgehog 179

Springhare 170

Striped Mouse 175

Sykes or Samango Monkey 185

Thick-tailed Bushbaby 181

Tree Squirrel 170

Vervet Monkey 182

maps 190

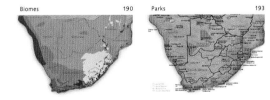

Biomes 190

Parks 193

Bibliography

Carnaby, Trevor. 2006. *Beat About the Bush. Mammals.* Jacana Media.

Carruthers, Vincent. 2000. *The Wildlife of Southern Africa. A Field Guide to the Animals and Plants of the Region.* Struik Publishers.

Estes, Richard D. 1993. *The Safari Companion.* Russel Friedman Books.

Fourie, Johan. 1995. *Mammals of the National Parks.* Struik Publishers.

Liebenberg, Louis. 2000. *A Photographic Guide to Tracks and Tracking in Southern Africa.* Struik Publishers.

Mills, Gus and Hes, Lex.1997. *The Complete Book of Southern African Mammals.* Struik Winchester.

Skinner, JD & Chinimba, CT. 2005. *The Mammals of the Southern African Subregion.* Cambridge University Press.

Smithers, Reay HN. 1983. *The Mammals of the Southern African Subregion.* Pretoria, South Africa: University of Pretoria.

Stuart, Chris & Tilde. 1997. *Field Guide Mammals of Southern Africa.* Struik Publishers.

Stuart, Chris & Tilde. 1998. *A Field Guide to the Tracks & Signs of Southern and East African Wildlife.* Southern Publishers.

ISBN: 978-0-9946924-8-1
Revised and updated edition
Published by **HPH Publishing**
50A Sixth Street
Linden, Johannesburg
South Africa
info@hphpublishing.co.za
www.hphpublishing.co.za
Tel: +27 86 171 0327
First published in 2018
Copyright © **HPH Publishing**
Text by Ingrid van den Berg
Photography by
Heinrich van den Berg, Philip & Ingrid van den Berg
Except cover: Jaco Powell
p60, p61, p153, p170 (top): Africa Imagery
p114: Jordi Fernandez Balague
Edited by John Deane and Gillian Paizes
Proofread by Gillian Paizes
Design, typesetting and reproduction by Heinrich van den Berg
Printed and bound in Malaysia by TWP Sdn Bhd.